The
Artist's
Journey

The Artist's Journey

The Travels That Inspired the Artistic Greats

Travis Elborough

WHITE LION
PUBLISHING

Contents

Introduction

The Swiss artist Paul Klee once suggested that drawing was simply taking a line for a walk. A walk, however, can only take you so far. In the interest of expanding his own horizons, Klee embarked on a *Bildungsreise* (a voyage of personal growth and discovery, by train, boat and car, with a fair bit of shoe leather thrown in for good measure) that led to a breakthrough in his art. Klee's trip is a prime example of the kind plotted in this atlas – a gazetteer of sorts to journeys undertaken and places visited by artists of various stripes at different stages of their lives. For some, like Klee, travel was to prove a turning point.

A change of scene and the chance to take in different surroundings and become acquainted with unfamiliar faces and customs can be a spur to fresh creativity; the journey itself a stepping stone to going somewhere else artistically. Nevertheless, painters, not unlike poets, tend to be peripatetic types. They are forever on the hunt for new things to commit to paper or canvas and also willing to go the distance (literally and figuratively) to obtain commissions or sell their wares. And so it is that several entries here recount artistic adventures funded by aristocratic coin or institutional dime or in the hope of commercial gain. Though, as we shall see in more than one instance, the cost to the artist of undertaking such ventures could often be high, both personally and professionally.

Travel until comparatively recently could be arduous and dangerous. In centuries gone by the artist might be heading to lands that were only sketchily mapped and that few others concerned themselves with; their subsequent depictions of such out-of-the-way territories and strange wildlife possibly just as thrilling in their day as the first satellite images beamed in from the moon in more recent times.

During periods when a whole continent might be plunged into conflict, an oddly dressed foreigner who stopped to sketch a local landmark might be viewed with suspicion or outright hostility. Conversely, the destination arrived at could be a place of comfort, safety or refuge and the balm offered a necessary condition for continuing to paint or draw.

If often leading raffishly Bohemian existences on the fringes of polite society and scandalizing in life and art, the painterly are often surprisingly orderly in routine. A notable number here were drawn, like migrating birds, back to the same places over and again. In due course that locale would then grow to become synonymous with the artist themselves or be seen in retrospect to characterize a key period of their output.

Maps themselves are drawn and as with most paintings and pictures are attempts to represent three-dimensional reality on a flat surface. (Though some of the artists featured here also engaged with sculptural and the conceptual forms.) The atlas therefore seems an ideal format to examine the connections between those individuals who have helped us see the world and ourselves differently and the places that inspired them. Their ambits are mapped with lines on paper, my own and those of the cartographer, whether they walked, rode, sailed, took the train, drove or flew. The coordinates are set by their directions of travel. Though the routes charted are ones that naturally take their course through the artists' sometimes wayward lives and the broader cultural landscape, the journeys we hope are as pleasurable as the end destination.

Jean-Michel Basquiat Seeks Connections in Côte d'Ivoire and Benin

In 1983, and aged only twenty-two, Jean-Michel Basquiat (1960–1988) became one of the youngest artists ever to be exhibited at the Whitney Biennial in New York. He emerged alongside the likes of Keith Haring from the streetwise pop-cultural underground of the Lower East Side in the late 1970s. Basquiat initially made his mark as a graffiti artist with the tag SAMO (an abbreviation for Same Old Shit) and as a musician performing alongside the future actor and film director Vincent Gallo in the art rock band Gray in such legendary New York punk clubs as Max's Kansas City and CBGB. (The band's name was a nod to the *Gray's Anatomy* textbook, a childhood gift, that had served as a perennial source of inspiration to Basquiat.)

From appearing in the 1981 video for Blondie's hit song 'Rapture', dating a then-unknown Madonna and producing the hip hop single 'Beat Bop' by Rammellzee and K-Rob in 1983, to collaborating on exhibitions with Andy Warhol and modelling for the fashion label Comme des Garçons, Basquiat was to be the first American artist of African descent to achieve global success and become an international celebrity. But within five years of his showing at the Whitney Museum of American Art he was dead, killed by a heroin overdose on 12 August 1988. His premature death came just weeks before he was intending to make a second trip to Africa, having accepted an invitation to join the artist Ouattara Watts in Côte d'Ivoire, the two painters having met earlier that year in Paris where a Basquiat solo exhibition was being staged at the Galerie Yvon Lambert.

Basquiat had made his first – and what would prove to be only – visit to Africa two years earlier. Of Haitian-Puerto Rican heritage, Basquiat had often evoked African themes, subjects and iconography, deploying Egyptian-style hieroglyphs, for instance, in paintings such as *The Nile* and *Gold Griot*. In October 1984, though, his friend the hip hop artist Fab 5 Freddy (Fred Brathwaite) had introduced him to Robert Farris Thompson, an art historian at Yale University who had recently published his groundbreaking book *Flash of the Spirit: African and Afro-American Art and Philosophy*. Thompson's study would join *Gray's Anatomy* as a key sourcebook for Basquiat, the artist from now on frequently referencing its text and illustrations in his work. The book also increased Basquiat's interest in connecting with his African roots. He subsequently asked Bruno Bischofberger, his art dealer and the man who'd initiated his working relationship with Warhol, to broker an exhibition at the French Cultural Institute in Abidjan, the de-facto capital of Côte d'Ivoire.

Basquiat, his then girlfriend Jennifer Goode and her brother Eric arrived in Abidjan in August 1986. Bischofberger joined them in time for the opening of a show that would include the

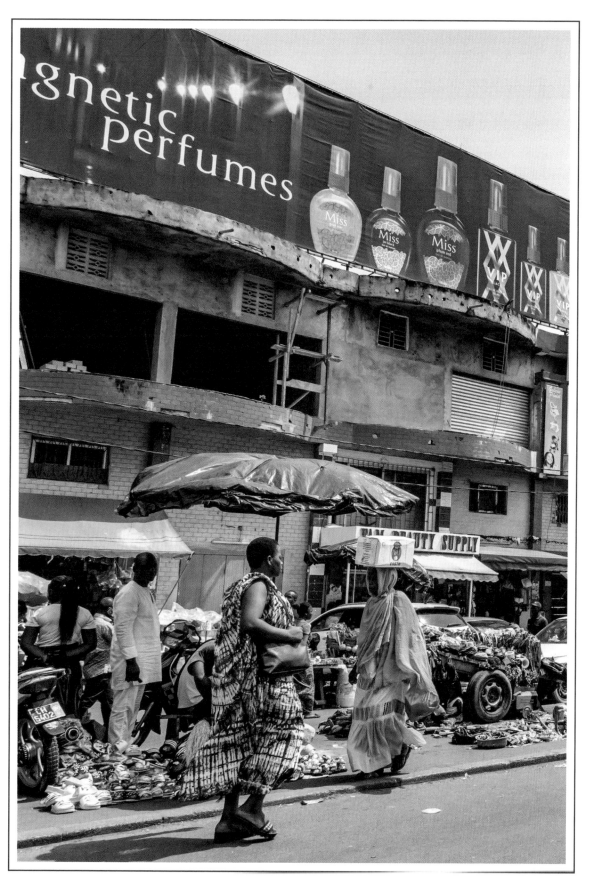

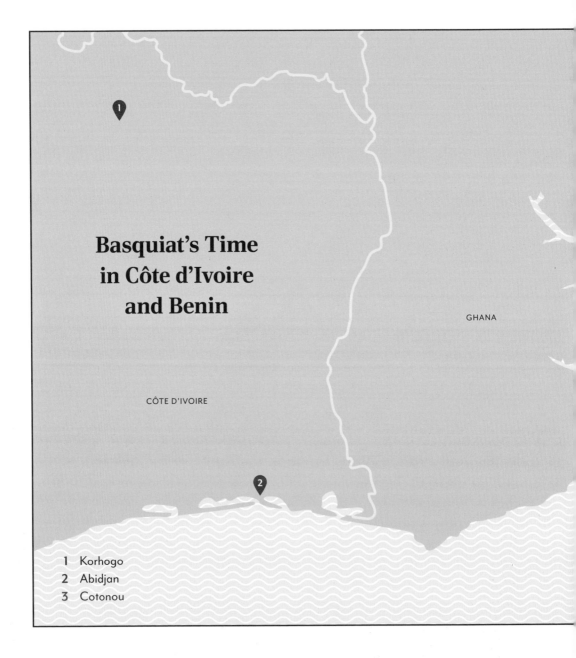

Basquiat's Time in Côte d'Ivoire and Benin

GHANA

CÔTE D'IVOIRE

1 Korhogo
2 Abidjan
3 Cotonou

◀ PREVIOUS PAGE Abidjan, Côte d'Ivoire.

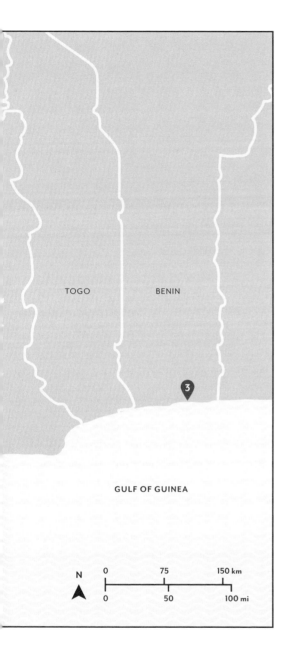

TOGO

BENIN

GULF OF GUINEA

N

0 75 150 km

0 50 100 mi

paintings *Charles the First* and *Jawbone of an Ass* on 10 October. The show would run for close to a month. After the show's end, Basquiat, Jennifer, Eric and Bischofberger flew to Korhogo in the north of the country to meet people from the Senufo tribe, before travelling on to Cotonou in Benin.

If, in the opinion of the critic Neely Swanson, the Abidjan show received negative reviews, its visual mix of the profane, the profound and the primitive resonated with a group of local artists working collectively under the banner Vouvou, a derogatory term meaning worthless junk, and Basquiat would serve as a role model for a new generation of painters on the continent.

In the last few months of his all-too-short life Basquiat had attempted to deal with his drug addictions, retreating to Maui in Hawaii, where he kept a studio, to remove himself from temptation, but sadly to no avail. At his memorial service at Saint Peter's Church on Lexington Avenue and 54th Street, Fab 5 Freddy was to recite 'Genius Child', a poem by the Harlem Renaissance writer Langston Hughes. The poem's imagery of an untamed eagle summoned up so much about an artist who'd soared about as high as possible only to be felled by demons that were mostly beyond his own control, but who nevertheless planted the seed for an artistic revolution of sorts in Africa itself.

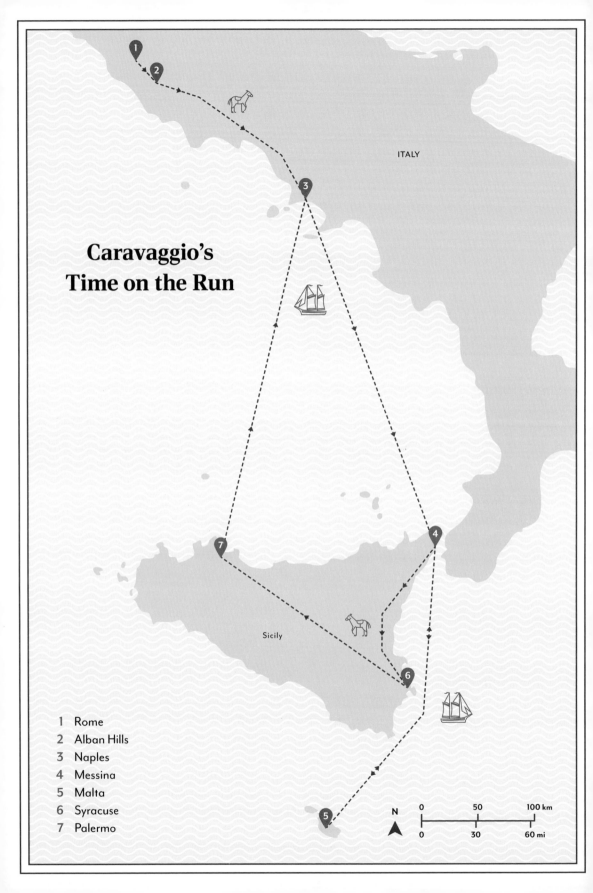

Caravaggio's Time on the Run

ITALY

Sicily

1 Rome
2 Alban Hills
3 Naples
4 Messina
5 Malta
6 Syracuse
7 Palermo

N

0		50		100 km
0	30		60 mi	

Caravaggio Legs It to Malta

On 12 July 1607, the Italian Renaissance master Michelangelo Merisi da Caravaggio (1571–1610) reached Malta after a fraught sea voyage from Naples via Sicily. As his biographer Andrew Graham-Dixon has observed, just why Caravaggio took 'the extraordinary decision to go to Malta' remains 'one of the many puzzles of his later years'.

All we know for certain is that the painter was forced to flee Rome after killing Ranuccio Tomassoni on either the 28 or 29 May 1606. From hereon matters start to get quite hazy. Tradition has always maintained that the notoriously temperamental Caravaggio was in an even testier mood than usual on the day in question. Allegedly, an argument over a lost bet on a tennis match had escalated into a fight, with swords drawn, and Caravaggio stabbed Tomassoni to death in the heat of the moment.

Caravaggio was hot-headed and prone to pulling knives to settle disputes. But it seems more likely now that Caravaggio and Tomassoni were fighting a prearranged duel. And as duelling was a crime punishable by death in papal Rome, the tennis match tale was probably a cover story by their respective seconds to avoid further censure. Caravaggio, though, was still guilty of a capital offence and needed to get out of town fast. He was fortunate to have powerful friends in the ducal Colonna family, who gave him sanctuary in their fiefdoms in Zagarolo and Palestrina, out in the Alban Hills about 32 kilometres/20 miles from Rome. The hope was that if he kept himself scarce while his friends and other influential admirers petitioned the pope on his behalf, the pontiff might eventually grant a pardon.

Of the pictures he completed while there, one of the most telling was a representation of David, the Old Testament giant slayer, with the head of Goliath, his victim. Caravaggio had painted it in the hope it might meet the approval of Scipione Borghese, the chief administrator of papal justice, the picture essentially serving as a coded plea in oils for his own clemency.

If Caravaggio could boast some important friends, he was also a man with some equally impressive enemies. With voices being raised against him in Rome, it became prudent that he moved further beyond the reach of papal justice. By 6 October 1606 he'd arrived in Naples, a maritime metropolis three times the size of Rome that was under Spanish-Habsburg rule, the city then serving as the capital of The Kingdom of the Two Sicilies. Significantly, the Colonna family held land and influence here and it's likely Caravaggio stayed in one or other of the palatial residences in the city.

Despite his status as a killer on the run, Caravaggio continued to be in demand as an artist. The most prodigious commission he

received during this time was an order to produce a monumental painting for the altar of a new church in the centre of Naples, the Pio Monte della Misericordia. Its subject was to be the Seven Acts of Mercy but its figures from the Bible and classical mythology were to be rendered as if jostling for position on a single Neapolitan street. The painting, fittingly, still hangs in the same city church today. Not long after this was completed, he was commissioned to produce another altar painting depicting the Flagellation of Christ for a chapel in a Dominican monastery. This picture too remains in Naples, though in more recent times its home has been the Museo di Capodimonte.

Caravaggio alas was unable to linger anything like as long as he would have liked in the city. By the summer news of fresh charges alleging that in absentia he'd paid an assassin to take out a rival in Rome reached him and in June he took the seemingly unlikely step of lighting out for Malta.

A rocky and hilly archipelago in the Mediterranean Sea lying 93 kilometres/58 miles south of Sicily and 299 kilometres/186 miles north of the African coast, Malta had remoteness in its favour. It was also unique in Catholic Christendom then, the island a sovereign state governed by a religious fraternity. The Knights Hospitaller of Saint John of Jerusalem had been founded during the Crusades as a monastic medical order but rapidly developed into a formidable and bloody militia with a complex chivalrous code. Their emblem, an eight-pointed cross, designated the obligations of the knights to 'live in truth, have faith, repent one's sins, give proof of humility, love justice, be merciful, be sincere and whole-hearted, and to endure persecution'.

Malta, which had been granted to the order in 1530 by the Holy Roman Emperor Charles V, and which had been besieged by the Turks in 1565, was effectively a floating fortress. Its capital, Valletta, dominated by the grand Cathedral of Saint John, was defended to the hilt, and entry to the island was fiercely policed. It appears likely that one of Caravaggio's Romano-Genoese patrons helped broker a deal where in exchange for his services as an artist, the painter might eventually obtain the rank of brother and knight of obedience, and thereby be exempt from papal justice. The painter was to produce a devotional picture of Saint Jerome for the knight Ippolito Malaspina, along with two portraits of the island's sovereign Grand Master Alof de Wignacourt in armour, of which only one survives. What Graham-Dixon judges to be his most tragic painting was also completed on Malta: another huge altar painting, on this occasion a representation of Saint John the Baptist, the knights' patron saint, for the cathedral.

▶ *The Seven Acts of Mercy.*
 Altar paintiing, Pio Monte
 della Misericordia, Naples.

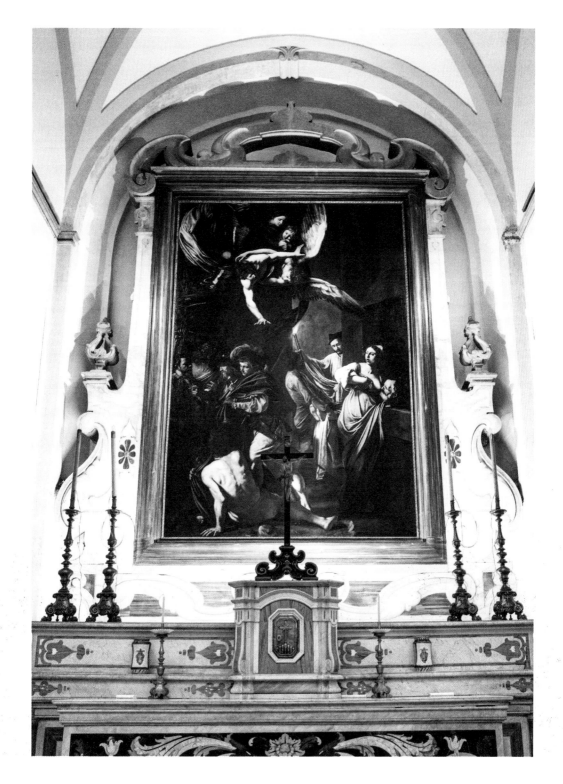

Things appeared to be going swimmingly for Caravaggio. But Malta was a place dominated by rules and petty regulations. All the knights were supposedly bound by vows of poverty and celibacy, though the Grand Master lived in considerable comfort and brothels did a roaring trade. Perhaps almost inevitably, Caravaggio chafed against such restrictions and after crossing a fellow knight he was imprisoned in Fort St Angelo in Birgu, Malta. Somehow he managed to escape and was ferried to Sicily.

Over the next year, the painter shuffled on from Messina to Syracuse and then Palermo, before eventually returning to Naples, where he came close to being killed in a brawl outside the Taverna del Cerriglio. Death came not long after. He succumbed to a fever while 'traversing the notoriously malarial coast toward Porto Ercole' on 18 July 1610. He was thirty-eight, and in retrospect it seems almost a miracle that Caravaggio lived that long, continuing to churn out masterpiece after masterpiece while on the run and living under constant threat of execution.

◀ Valletta, Malta.

Mary Cassatt Makes an Impression in Paris

It was the composer George Gershwin who set the phrase 'an American in Paris' to song, his jazz-inflected tune in turn inspiring the 1951 Hollywood musical of the same name. Gershwin had first visited Paris in 1926, the year that Mary Cassatt (1844–1926) died. Cassatt, however, who had exhibited with the French Impressionists and lived, worked and loved in the French capital for over sixty years, was in many respects an atypical American expat. In the opinion of the art historian Nancy Mowll Mathews, she 'more than any other American artist in Paris' of her time conducted 'her life and work in the French manner' and became the ultimate insider of the Parisian art world. Cassatt's talent ensured that her work was first exhibited at the Salon, the official art exhibition of the Académie des Beaux-Arts, in 1868, and eight years later Edgar Degas would invite her to join the Impressionist group. In 1904, when her American alma mater, the Pennsylvania Academy of the Fine Arts, wanted to award her a prize, Cassatt turned them down. However, she happily accepted a Chevalier de la Légion d'Honneur, the highest French order of merit, in the same year. The order was presented to Cassatt by her friend the French statesman Georges Clemenceau, who saluted her as one of the artistic glories of France.

Yet Cassatt never gave up her American friends or associations and went to her grave an American citizen. As Mathews notes, 'there is not a single account or reminiscence by her, or about her, that does not highlight her Americanness'. To a degree, she was highly representative of a recognizable type of American in this era: those, who by dint of class, family wealth and inclination (and in her case, additionally, artistic ambition) wound up in Paris. Still her work initially confounded critics in her homeland. A pundit for the *New York Times* reviewing her debut appearance alongside Degas in the 1879 Impressionist exhibition was to write, 'I feel sorry for Mary Cassatt; she is a Philadelphian, and has had her place in the Salon – a great triumph for a woman and a foreigner; but why has she thus gone astray?'

Practically since the day she was born (in Allegheny City, in Pennsylvania), Mary had been told that the Cassatts were descended from French Huguenots. Investors and land speculators, her father's forebears had scaled the upper ranks of American society by the time of the American Revolutionary War. Her mother, Katherine, was from a Scots-Irish clan of doctors and bankers and had attended a French school in Pittsburgh and so was fluent in the language. Once Mary's financier father, Robert, had amassed what he deemed a sufficient fortune of his own, a feat achieved at just forty-two years of age, he retired and packed the whole family off to Europe in 1850. Mary was therefore only six when she first clapped eyes on Paris; the Cassatts living there for two years before moving on to Heidelberg and Darmstadt in Germany. Mary was educated in local schools, where she picked up both French and German and received lessons in art and music.

The Cassatts were to return to America in 1855, living mostly in Philadelphia. Aged sixteen, Mary was to enrol at the Pennsylvania Academy of the Fine Arts. However, her dream of continuing her education in Paris – a dream shared by many of her peers – had to be put on hold until the end of the American Civil War, when transatlantic travel became possible again. She finally returned to Paris in 1865 and began studying at the studio of Jean-Léon Gérôme, who had recently been made a member of Institut de France. (At that time, women and foreigners both were barred from attending the École Nationale Supérieure des Beaux-Arts itself.)

American students of Cassatt's ilk tended to cluster around the Palais des Beaux-Arts or the ninth arrondissement near place Pigalle. However, the centre of their universe was the Louvre, as all students were expected to spend time copying and studying works from the past. In 1879, Degas produced the print *Mary Cassatt at the Louvre: The Etruscan Gallery* in which the elegantly attired American is shown looking intently at the ancient Sarcophagus of the Spouses, perhaps suggesting that Cassatt never gave up the habit.

Another port of academic call for art students was the Musée du Luxembourg, with its contemporary holdings and cycle of Medici paintings by the Dutch master Peter Paul Rubens. The nearby Jardin du Luxembourg too was a popular place to socialize for international students.

After about a year, Cassatt was to pursue her studies in Écouen, about 19 kilometres/12 miles to the north of Paris, joining the colony of French and foreign artists orbiting the school operated by Pierre Édouard Frère, then the leading French

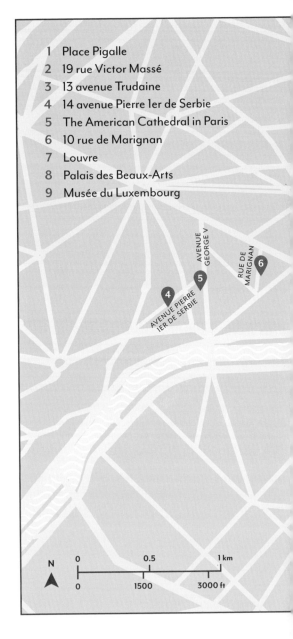

1 Place Pigalle
2 19 rue Victor Massé
3 13 avenue Trudaine
4 14 avenue Pierre 1er de Serbie
5 The American Cathedral in Paris
6 10 rue de Marignan
7 Louvre
8 Palais des Beaux-Arts
9 Musée du Luxembourg

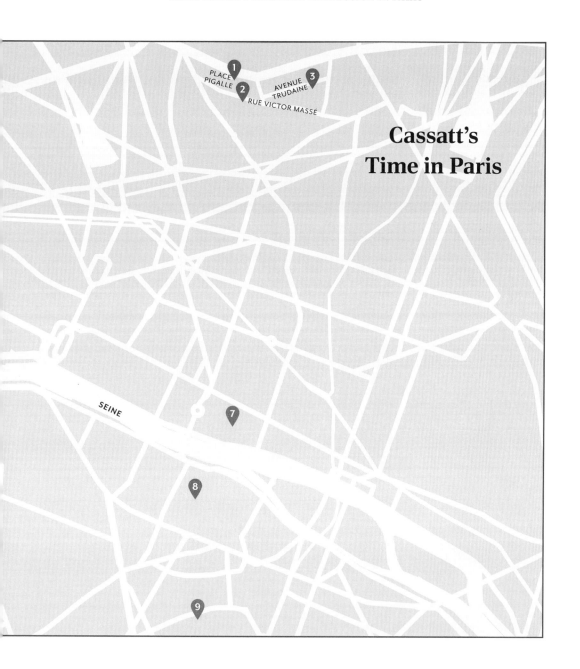

PLACE
PIGALLE

AVENUE
TRUDAINE

RUE VICTOR MASSÉ

SEINE

Cassatt's
Time in Paris

◀ PREVIOUS PAGE Paris.

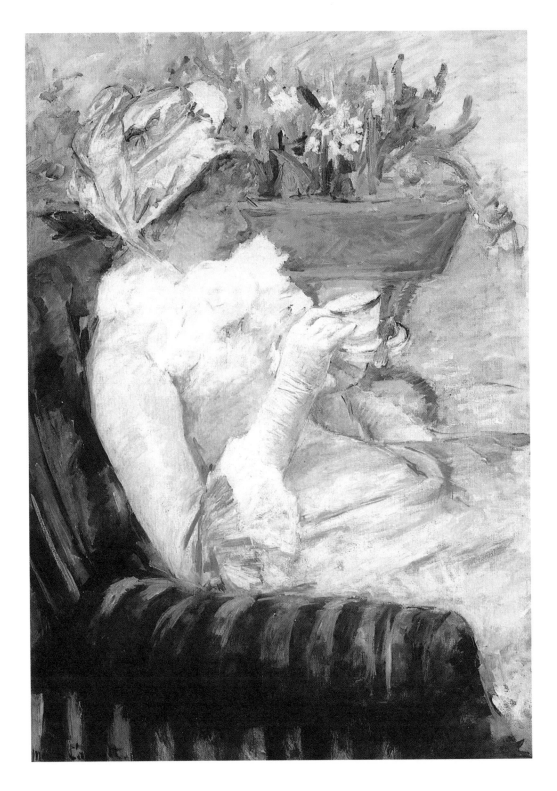

exponent of domestic drama painting. According to Mathews, among artistic American expats, Écouen was considered 'an intellectual getaway'. It was here rather than in Paris that in 1868 Cassatt painted *The Mandolin Player*, a portrait of a mournful-looking girl clutching a stringed instrument, that was to become her first successful submission to the Salon.

The arrival of the Franco-Prussian war two years later forced Cassatt to return to America, where she rejoined her family in Altoona, Pennsylvania. Once the clouds of war and the events of the revolutionary Paris Commune had passed, Cassatt didn't immediately rush back. Between 1871 and 1874, she stopped in the city only fleetingly, heading instead to Parma, Italy, then Spain (which she liked less than she'd hoped but still managed to produce a painting of a bullfighter that proved acceptable to the Salon), Holland and Belgium, before returning to Parma again and then on to Rome.

In the autumn of 1874, after a summer spent studying with French history painter Thomas Couture in Villiers-le-Bel, France, Cassatt was ready for Paris again. She rented an apartment at 19 rue Laval (now rue Victor Massé), and this was to be her base for the next four years. It was here that she held rather fabled tea-party soirées in its ornately decorated surroundings. One regular attendee was May Alcott, the painter sister of the novelist Louisa May Alcott. Alcott was to report that at chez Cassatt she:

... ate fluffy cream and chocolate, with French cakes, while sitting in carved chairs, on Turkish rugs, with superb tapestries as a background, and fine pictures on the walls looking down from their splendid frames. Statues and articles of *vertu* filled the corners, the whole being lighted by a great antique hanging lamp. We sipped our *chocolat* from superior china, served on an Indian waiter, upon an embroidered cloth of heavy material. Miss Cassatt was charming as usual in two shades of brown satin and rep., being very lively and a woman of real genius

One of Cassatt's most famous prints, *The Visitor* from 1881, was to depict a guest being ushered into just such a gathering in a Parisian apartment with a large French window. While *The Cup of Tea*, a portrait in oils of her older sister, Lydia, wearing a shimmery pink dress, relaxing in a chair taking afternoon refreshment – shown to rapturous acclaim at the 1881 Impressionist exhibition – was a close companion piece.

In 1877, her parents and sister decided to settle in Paris, judging that their money would go further in the City of Light than in Philadelphia, the City of Brotherly Love. They were to be joining a community of roughly five thousand Americans who were living in the French capital at that time. Though a far smaller proportion of Paris's twenty million inhabitants than the Belgians, English, Swiss or Italians, the Americans were conspicuous

◀ *The Cup of Tea*, 1880–1.

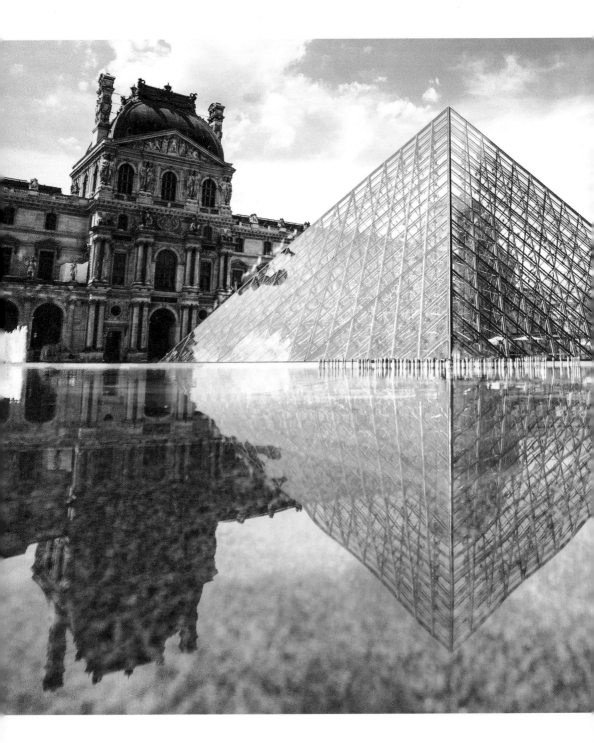

by their wealth, the majority living high and at ease around the Opera District and the rue Scribe where the main American bank was located, as well as other businesses catering for rich Americans. The American Church, or Holy Trinity, (later known as the American Cathedral in Paris) on what was then the avenue de l'Alma (now avenue George V) in the eight arrondissement, and whose rector in the 1870s was a cousin of the American banker J.P. Morgan, was another epicentre of the American expat community.

The Cassatts were to rent an apartment together at 13 avenue Trudaine in the marginally more artistically inclined ninth arrondissement. Here, they were to be visited by her elder brother, Alexander 'Aleck', who as President of the Pennsylvania Railroad was to become one of the wealthiest men in America. He and his family were to be willing sitters for Mary. Her studies of Aleck's wife and her four children gave rise to a whole new series of mother and child pictures. Neither Mary nor her sister Lydia appeared ever inclined to marry; the American Civil War, which wiped out some 600,000 men, perhaps did them something of a favour.

Lydia's death from kidney disease in 1882 was another blow Mary had to absorb. In its wake, in 1884, she and her parents were to move to another apartment at 14 rue Pierre Charron (now avenue Pierre Ier de Serbie). By 1887, her parents' increasing infirmity led her to seek accommodation in a building with an elevator at 10 rue de Marignan, which was to remain Mary's Parisian home for the rest of her life. She died, aged eight-six, at her country house, the Château de Beaufresne, in Picardy.

◀ The Louvre Pyramid, Paris.

Cézanne's Express Journey between Paris and Provence

FRANCE

N

0	50	100 km
0	30	60 mi

1 Paris
2 Marseilles
3 Aix-en-Provence

Paul Cézanne Aches for Aix-en-Provence

Paul Cézanne (1839–1906) has been hailed as the father of modern art for his break with Impressionism and further innovations in form across all genres, from portraits and still lifes to landscapes in oils and watercolours, paving the way for the Cubism of Pablo Picasso and full-blown abstraction in the twentieth century. He lived through a period of rapid and momentous social and political change, and one of the most fundamental developments to affect his art was to be the expansion of the railways in his native France in the 1850s.

Unlike his compatriots and contemporaries Pierre-Auguste Renoir and Édouard Manet, Cézanne travelled little outside France. Biographers have found evidence of only a single trip beyond France and French-controlled Savoy and that was to Switzerland in 1891. There he visited Berne, Fribourg, Vevey, Lausanne, Geneva and Neuchâtel, where he spent the bulk of his time. The Swiss scenery appears to have failed to stir his imagination and he left two unfinished canvases of local views behind when he checked out of his hotel in Neuchâtel.

However, until the last years of his life, a journey that Cézanne continuously made was to shuttle back and forth between Paris and his beloved Provence in the south-eastern corner of France. This dual life – one that was vital to his growth as an artist – was only made possible by an express train service that ran between the French capital and Marseilles, slashing a previously arduous journey overland or around the coast by boat to a mere twenty hours. This enabled Cézanne, who was a restless and anxious person at the best of times, and who had an almost morbid fear of attachments, to take off for either place almost on a whim once he tired of his surroundings.

Sometimes Cézanne would remain in Paris or its broader environs (Auvers-sur-Oise, Chantilly and Fontainebleau) for a year or two without returning to Provence. Likewise there were lengthy periods when he eschewed the distractions of the French metropolis entirely and stayed in the south. But this pattern of cross-country living was established almost at the outset of his career, after a disappointing first spell in Paris in 1861, and continued until the 1890s.

Cézanne had been urged to come north to Paris by his old school friend the novelist Émile Zola, who had moved there three years earlier intent on making a literary name for himself. At that time, Cézanne was studying law, largely to appease his father, Louis-Auguste, who thought art a financially perilous and unworthy profession for his son. It was a subject that he quickly grew to hate and was temperamentally almost entirely unsuited to. It took the intervention of his mother

and sister, Marie, to eventually persuade Louis-Auguste to let Cézanne at least try and follow his preferred path by enrolling at the Académie Suisse, an informal art school in Paris. Here he was to meet Claude Monet and Camille Pissarro, the future pioneers of Impressionism, who along with Zola also came to frequent the Café Guerbois, a celebrated haunt of Bohemian writers and artists on avenue de Clichy.

Prior to this trip Cézanne had never travelled more than a few miles from Aix-en-Provence, and he undertook that first train journey north, through the valley of the Rhône, in April 1861 in the company of his father and sister, who were to spend a few weeks in Paris helping him to settle in. The family was to lodge together in a small hotel in the rue Coquillière near Les Halles until Cézanne found digs of his own on the Left Bank in the rue des Feuillantines.

The Louvre was to become one of Cézanne's most treasured resources in Paris, and during this opening sojourn he visited it almost daily to study and sketch the Old Masters in its collection. However, it was not long before he began missing the sunlight, Aleppo pines and russet-tinged mountain scenery of Provence and suffered a paralysing crisis of confidence over his own painting.

An exasperated Zola, who noting his friend's obstinacy was to comment that to 'convince Cézanne of anything' was 'like trying to persuade the towers of Notre Dame to dance a quadrille'. He recalled that 'no sooner had he arrived' in Paris 'than he talked of returning to Aix'. And by the autumn of 1861, Cézanne was not only back in Aix but also had swallowed his pride and accepted a position as a clerk in his father's bank.

◀ Provence, France.

Try as he might, however, he couldn't quite settle to the tedium of a life in banking and was reprimanded for drawing in the margins of the firm's ledgers. He was eventually allowed to return to Paris and resume his studies at the Académie Suisse, and he was to ping-pong between Paris and Provence pretty much from then on. Although once in Provence he was often far from settled, choosing to flit about. Moving, for instance, from Aix to Gardanne, an ancient hill town 8 kilometres/5 miles away that was crowned by an old ruined church, which the artist immortalized in his paintings *Gardanne* and *The Village of Gardanne*. From Gardanne he went to the little fishing port of L'Estaque, where he hid out during the Franco-Prussian War and later painted *The Bay of Marseille, Seen from L'Estaque*. And then from L'Estaque he travelled back to Aix.

The planes of Montaiguet, the rocks and farmsteads in Le Tholonet and the cavernous

▼ Paul Cézanne painting in Provence, France, c.1904.

▶ *The Village of Gardanne*, 1885–6.

quarries and curious outbuildings at Bibémus were other local sites that attracted his painterly attention.

But the centre of Cézanne's world in Provence for over forty years was to be Jas de Bouffan, a country mansion and farm estate just outside Aix that had once belonged to the provincial governor and that his father purchased in 1859. Cézanne would complete thirty-seven oils, including *The Neighbourhood of Jas de Bouffan*, and some sixteen watercolours of the house and its surroundings. Farm labourers and an old gardener, known as le père Alexandre, from his father's estate were to pose as models for a series of five masterful paintings of rustic labourers playing

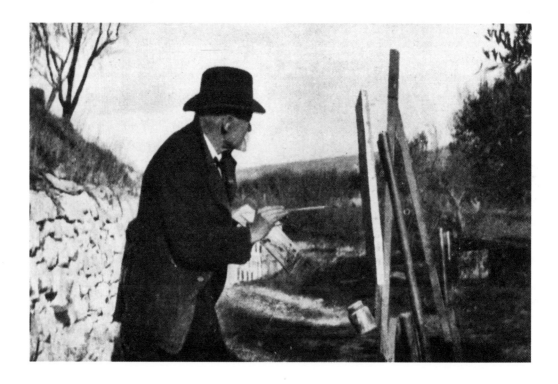

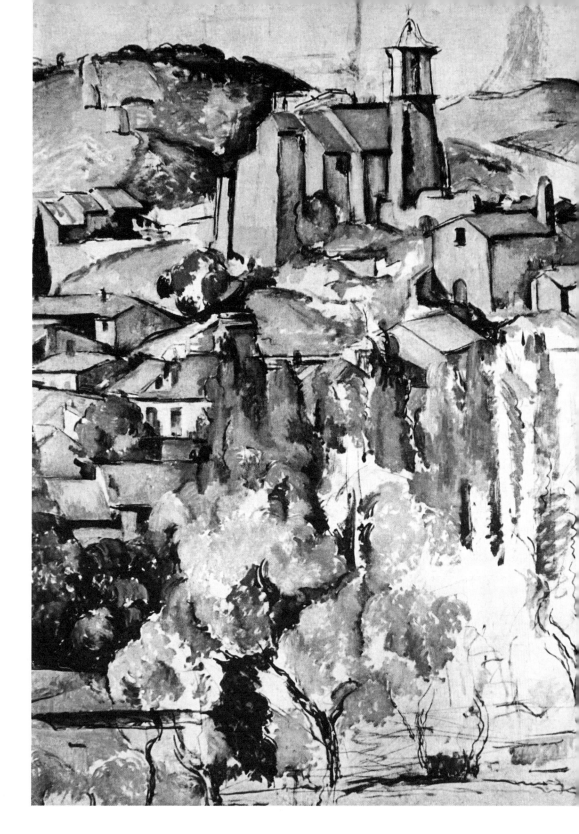

cards in battered hats and smoking long-stemmed clay pipes that he made in the 1890s.

Along with its ready supply of peasant models, an alley of chestnut trees and its vineyards, Jas de Bouffan was gifted with fine views of Mont Sainte-Victoire, the dramatic grey limestone mountain that dominates the valley of Aix. At its top was the ruined chapel of Calmaldules and near the summit was the Gouffre du Garagaï, a bottomless pit that in more youthful days Cézanne and his friends had risked life and limb clambering into. As a frail old man, he was still, in effect, trying to conquer the mountain. He painted it repeatedly in his twilight years, though latterly he resorted to watercolour to capture its rugged contours as his diabetes frequently left him too

weak to manage oils. The art historian Kenneth Clark, however, is not alone in judging such late watercolours as *Mont Sainte-Victoire* among the most perfect of Cézanne's works.

Jas de Bouffan was sold in 1899, shortly after the death of Cézanne's mother, and the artist resolved to settle permanently in Provence, visiting Paris only once more in 1904. Now an exceedingly rich man thanks to his inheritance, he was to rent an upper-floor apartment with a north-facing attic that he turned into a studio at 23 rue Boulegon in Aix. His cooking and other household needs were met by a loyal housekeeper, Madame Bernard.

The attic, however, proved insufficient to his needs. Hankering after a workroom in the country, he bought a simple property on a hillside about

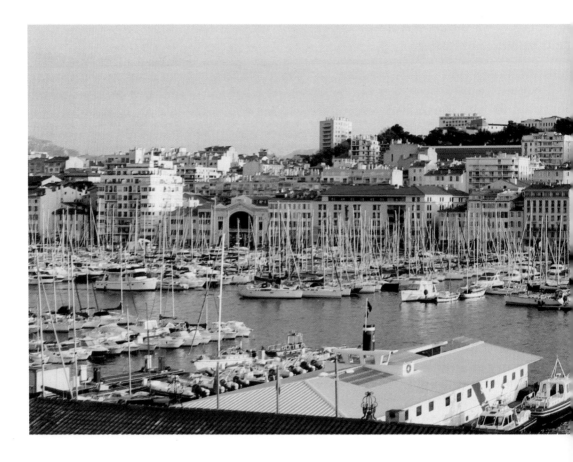

1 kilometre/½ mile north of Aix, off the stony country road (itself the subject of a watercolour, *Chemin des Lauves: The Turn in the Road*) and commissioned a local architect to tear it down and replace it with a purpose-built studio. It was here that Cézanne would devote himself to his art unstintingly, and in 1905, with nothing further to distract him, he completed *The Bathers*, a picture he'd laboured on for ten years.

On 15 October 1906, while out in a field and completely absorbed in his work, Cézanne got caught up in a violent rainstorm. Suffering a seizure, he collapsed and was fortunate to be spotted by a man out walking, who brought him home. The next day, the painter got up determined to complete a portrait of his gardener Vallier. But no sooner had he started then he felt unwell and had to retire to bed and never rose from it again. He died on 22 October 1906. His estranged wife and his son, Paul, had been summoned from Paris but arrived too late. Cézanne at the end was failed for once by the express line he'd relied on for so many years.

▼ Marseilles, France.

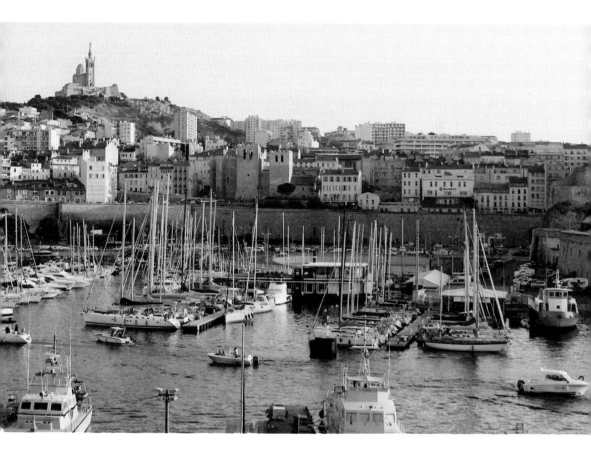

Salvador Dalí Takes Manhattan by Surrealist Storm

Named after El Salvador – the divine Christian Saviour, Jesus Christ – the moustachioed Surrealist Salvador Dalí (1904–1989) would duly come to anoint himself the deliverer of art, both ancient and modern, from evil and all other sins into the bargain. Such egotism came naturally to an artist whose stated ambition at the age of seven was to be Napoleon, though he subsequently claimed to soon realize that being Salvador Dalí itself was frankly more than enough to be getting on with.

Dalí was born in Figueres, Spain, a town in the province of Girona, about 130 kilometres/80 miles from Barcelona. The landscape of his native Catalonia would provide the backdrop to many of his greatest paintings, especially a stretch of the coast running from Cap de Creus to L'Estartit, which contains the fishing village of Cadaqués, where the artist kept a house for over fifty years. *The Spectre of Sex Appeal*, for instance, presents an impression of the jagged rocks of Cadaqués bay that is almost photo-real and yet fantastically surreal at the same time. Yet like his compatriot and contemporary Pablo Picasso, Dalí would need to leave Spain to further his artistic career. At the age of twenty-two, he moved to Paris, and thanks to Picasso was quickly inducted into the Surrealist group of artists and writers; a band of avant garde absurdist fellow travellers who met

weekly in Montparnasse and counted the German painter Max Ernst, the French novelist André Breton and the French poet Paul Éluard as leading lights. But it was Éluard's Russian-born wife Elena Diakonova, nicknamed Gala, who immediately turned Dalí's head and subsequently became his lifelong muse and companion.

Seducing another artist's wife would prove only a comparatively minor misdemeanour in Surrealist circles. Expulsion from the group would eventually come following Dalí's increasingly megalomaniacal pronouncements and his seeming public endorsement of Adolf Hitler. Such a stance is hard to stomach but it is also hard to know if Dalí intended it as anything other than provocation, since the majority of the Surrealists leaned left politically. In either case, it remains pretty indefensible. But by then Dalí had, in any case, discovered America and was starting to experience real financial success following what would become the first of many trips to New York. Dalí's shameless avarice was soon mocked by his former Surrealist compadres; Breton juggling the letters of his name to produce the cutting anagram Avida Dollars. Cruel as it was, this jibe proved on the mark; later in his career Dalí was happy to hawk Alka-Seltzer for a ready buck.

Dalí's opening transatlantic odyssey had been initiated by Caresse Crosby, a formidable

American socialite, Bohemian, publisher and patron of the arts who held the first patent on the brassiere. Salvador and Gala had been introduced to Crosby in Paris by the Surrealist writer René Crevel and came to enjoy spending weekends at the wealthy Bostonite's French country house, Le Moulin du Soleil, in the forest of Ermenonville. As Dalí was to recall in his autobiography, *The Secret Life of Salvador Dalí*, it was there, with Cole Porter's 'Night and Day' never off the phonograph, that the artist encountered images of America in glossy magazines such as the *New Yorker* and *Town and Country*. Images that, as he put it, he came to 'sniff, so to speak, with the voluptuousness with which one welcomes the first whiffs of the inaugural fragrances of a sensational meal of which one is about to partake'.

If Dalí was enamoured by the look of America, 'the prospect of travelling by sea to a country whose language he didn't speak' left him 'rigid with fright' according to his biographer Meredith Etherington-Smith. But a solo exhibition was planned with Julien Levy, the forward-looking art dealer who'd included Dalí's now-iconic melting-clocks painting, *The Persistence of Memory*, along with works by Jean Cocteau and Max Ernst, in the first show of Surrealists ever staged in America at his gallery at 602 Madison Avenue, New York, in January 1932. With Picasso said to be putting some money up to help with their fare, Crosby was finally able to persuade Salvador and Gala to join her on board the SS *Champlain*, sailing from Le Havre to New York, on 7 November 1934. This would allow the artist to oversee the conveying of his pictures to the United States and attend the exhibition opening himself on the 21 November.

On the day of departure, Crosby agreed to meet the Dalís on the boat-train but found Salvador cowering in a third-class compartment

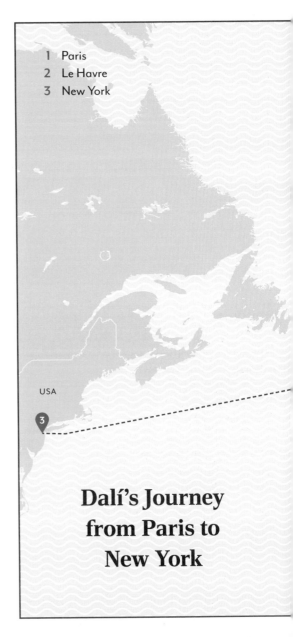

1 Paris
2 Le Havre
3 New York

USA

Dalí's Journey from Paris to New York

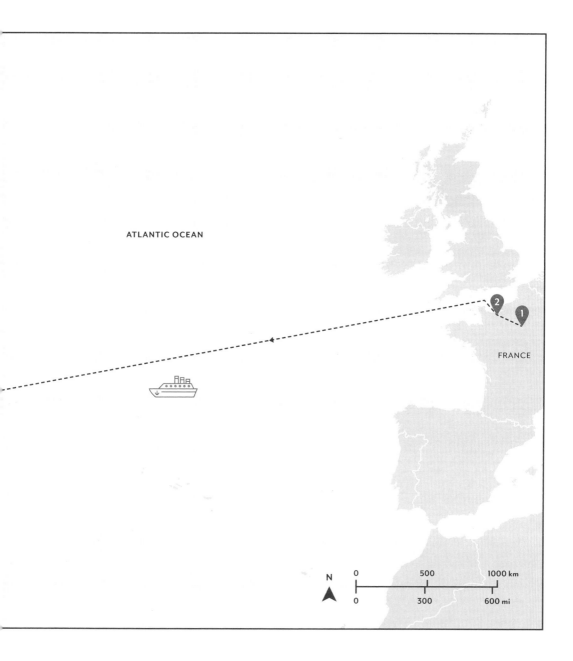

ATLANTIC OCEAN

FRANCE

N

0		500		1000 km
0		300		600 mi

◀ PREVIOUS PAGE New York.

close to the engine surrounded by his canvases, all of which appeared to be tied to his person with string. Fearing thieves would make off with one of his precious paintings, he refused lunch as it had to be eaten in the dining car. Once on board the SS *Champlain*, the artist was no more relaxed. Barely leaving his third-class cabin for the entire voyage, Dalí insisted that he and Gala wore cork life jackets whenever they ventured up on deck. Invited to join Crosby for dinner at her first-class table, they both arrived swathed in overcoats, Dalí, in addition, wearing several woollen sweaters underneath and a pair of mittens on his hands.

Dalí, nevertheless, intended to make a big splash on arrival and had organized for a broadsheet declaring 'New York Salutes Me!' to be distributed on the quayside. Known to be good for copy, as much for the outrageousness of her wardrobe as her scandalous love life, Crosby's presence was to ensure the boat was met by gentlemen of the press seeking society gossip to fill column inches. With Crosby, who was wearing a racy black velvet skirt and flanked by two black whippets on leads, acting as his interpreter, however, the hacks were treated to an impromptu lecture on contemporary art by Dalí. The painter tore the paper wrapping off one of his canvases to reveal a portrait of his wife and proceeded to expound on his reasons for depicting Gala with a lamb chop on each shoulder. Baffled but entertained, the newsmen lapped it up. Typical of the coverage generated was an item in that night's *New York Evening Journal* headed 'Painter Here With Chop on Shoulder'. All of which was to ensure Dalí quickly become the talk of the town. His exhibition of twenty-two main works, along with sundry other objects (assorted plaster casts and an 'aphrodisiac' dinner jacket adorned with shot glasses that each contained a dead fly) was an immediate hit with the critics and the public. A party to toast its success was held on the closing night, on 10 December, at the Casa de las Españas, the hub of Spanish culture in New York.

The Dalís were to stay in the Hotel St Moritz at 50 Central Park South, on the east side of Sixth Avenue in Midtown, Manhattan, then only four years old and considered one of the most modern and cosmopolitan hotels in the city. Crosby opened her address book and the couple's diary was filled with introductions to, and engagements with, swanky New York socialites.

On 18 December, Dalí left Manhattan, briefly venturing to Hartford, Connecticut, where he spoke at the Wadsworth Atheneum. On 11 January 1935, he appeared at New York's Museum of Modern Art (MoMA) and outlined his approach to art, largely advancing the view, held with ever greater conviction as the months passed, that he alone was the only true exponent of Surrealism.

Due to leave America on board the SS *Île de France* on 19 January, the Dalís, aided by Crosby, staged a lavish fancy dress ball at Le Coq Rouge, a plush restaurant at 65 East 56th Street, the night before they sailed. Guests, who had to stump up for a ticket and fork out for their own food and drink, were expected to come dressed as

▶ Salvador and Gala Dalí arriving in New York on the SS *Champlain*, 1934.

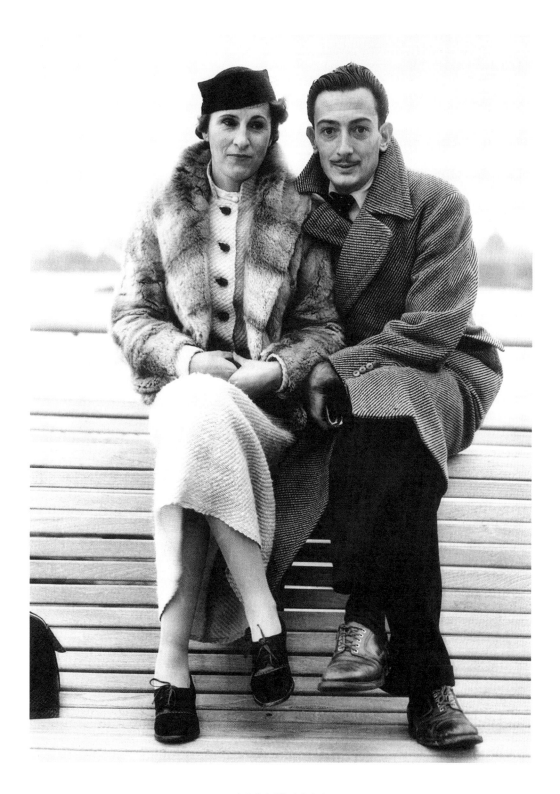

a recurring dream, and the whole event was billed as The Dream Ball. The staff of the restaurant were given a Surrealist makeover and props and costumes were acquired by Dalí and Crosby in local dime stores. Waiters served in paste tiaras and the doorman wore a wreath of pink roses instead of a peaked cap. Entering the restaurant involved passing a 45 kilogram/100 pound block of ice tied up with a ribbon, and once that was cleared prospective diners and dancers were greeted by the sight of a cow's carcass, its hollowed-out stomach filled with a wind-up gramophone playing French tunes.

Dalí, dressed as a corpse with bandages wrapped around his head, presented a macabre spectacle. Gala looked equally ghoulish, her black headdress augmented with a ravaged doll, its wounded forehead painted with ants and its skull gripped by a lobster's claw. Dalí was to claim his wife's costume represented a Freudian complex. But others took it as some kind of statement about the recent kidnapping and murder of the aviator Charles Lindbergh's baby son and judged it in very poor taste. The incident, however, was soon forgotten and the ball came to be chalked up as another triumph in terms of publicity. After a short stop back in Paris, the couple decamped to Cadaqués, where Dalí wasted no time in getting down to work on a painting that reflected his growing fascination with, and arguably, desire for, American celebrity, *Mae West's Face Which May Be Used as a Surrealist Apartment*.

Two years later, Dalí was back in New York, where his reception was even more rapturous. His face, photographed by Man Ray, was to make the cover of *Time* magazine, one of those glossy publications that had opened his eyes to America in the first place.

With the outbreak of the Second World War, Dalí was to call New York home, living in the city from 1940 (the year MoMA staged his first retrospective) to 1948. He returned to winter in New York for close to forty years after that, putting up in a private suite (Room 1610) in the St Regis Hotel on East 55th Street. Staff and the general public were alerted to his arrival each year, no longer by broadsheet, but by the sound of him bellowing 'Dalí ... Is ... Here!' the moment he stepped through the lobby doors.

Once called upon to explain his popularity in America, the artist argued that his preoccupation with sex and death and his use of timepieces might hold the key. 'What the American people', he maintained, 'love best is, first of all, blood – you have all seen the great American films, especially the historical ones. There are always scenes where the hero is beaten up in the most sadistic manner and where one witnesses veritable orgies of blood! Secondly, the soft watches. Why? Because Americans are constantly checking their watches. They are always in a hurry, a terrible hurry, and their watches are terribly stiff, tough, and mechanical. So the day Dalí painted his first soft watch brought instant success! ...'

◀ New York.

Marcel Duchamp Becomes Obsessed with Chess in Buenos Aires

Often hailed as the godfather of conceptual art, Marcel Duchamp (1887–1968), an artist closely associated with the major turns in early twentieth-century modernism from Futurism and Cubism to Surrealism, pioneered the idea of the 'ready-made' when he exhibited an ordinary bicycle wheel under the title *Bicycle Wheel* in 1912. He caused further controversy five years later when he submitted a urinal signed 'R. Mutt' and entitled *Fountain* to the first annual exhibition of the Society of Independent Artists in New York. The organizers rejected the piece, which only increased its notoriety.

Following the outbreak of the First World War, although exempt from military service, Duchamp left Paris and crossed the Atlantic in 1915. Within two years of his arrival in New York, the previously isolationist United States had joined the war, largely in response to renewed attacks by German submarines on American ships in the Atlantic. Such threats remained an issue when Duchamp and his lover Yvonne Chastel, the ex-wife of his close friend the painter Jean Crotti, set sail from New York on a small, slow steamer bound for Buenos Aires on 14 August 1918. In fact, the SS *Crofton Hall* had not long left New York harbour when its passengers learned that another

American boat had just been torpedoed only a few miles out from Atlantic City, New Jersey. In the event the twenty-seven-day-long journey to Buenos Aires passed entirely uneventfully. In one of the letters Duchamp posted when the ship docked en route in Barbados, the artist reported that he had suffered no seasickness, that the voyage had been delightful, the boat slow and gentle, and that he'd been spending the down time putting his papers in order.

His choice of destination had come as a surprise to almost everyone in New York. Duchamp spoke no Spanish and appeared not to know a soul in Argentina. Once in an interview he claimed that a family friend ran a brothel in Buenos Aires and that was what persuaded him to head south. However, that story has never been verified and bears the distinct whiff of something faintly provocative thought up on the spot to shock or titillate a journalist.

The trip was partially funded by the cash from a commission for a painting from the forward-looking American artist, suffragette, scholar and patron Katherine Dreier. Dreier, who along with the wealthy poet and art collector Walter Arensberg was to remain one of Duchamp's most loyal stateside champions, had requested a new

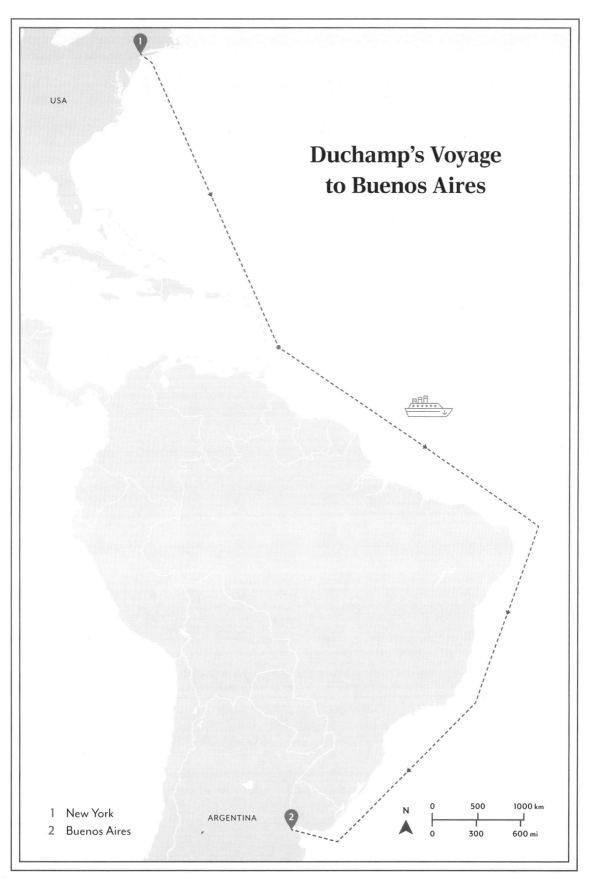

Duchamp's Voyage
to Buenos Aires

USA

ARGENTINA

1 New York
2 Buenos Aires

N

| 0 | 500 | 1000 km |
| 0 | 300 | 600 mi |

picture to hang in her library. This commission took him over six months, even with the aid of Chastel, who was persuaded to undertake much of the actual brushwork on a receding line of coloured forms that run through the spectrum from bright yellow to pale grey and that are its central feature. The spectrum was to be flanked by the shadowy impressions of a bicycle wheel, a hatstand and a cork screw that appeared nods to Duchamp's previous ready-mades. The painting, however, was an immediate disappointment to the artist himself. He later maintained that he never liked the picture, which was to be the last he ever painted, and, tellingly, entitled it *Tu m'*, a contraction of *'tu m'ennuies'*, a crude French phrase which roughly translates as 'you bore me'.

If *Tu m'* and its title heralded a renunciation of painting, equally indicative of his state of mind was a new ready-made, which he described as a multi-coloured cobweb, that was completed with strips of rubber bathing caps just a month before his departure, and which he called *Sculpture for Travelling*.

The main appeal of Argentina to Duchamp was perhaps simply that it was a neutral country. Having fled France due to his self-confessed lack of militarism and lack of patriotism, he'd watched America become ever more militaristic and patriotic since entering the First World War. Both his elder brothers, Jacques and Raymond, who were also artists, had enlisted. Raymond, a talented sculptor forging fresh ground with works that combined the impulses of Auguste Rodin with the innovations of Cubism, had, like Duchamp, qualified for an exemption on health grounds. However, he'd signed on anyway as a medical under officer with the cavalry and would die on 7 October 1918 of blood poisoning after catching a streptococcus infection from a wounded soldier he'd been treating. Duchamp would receive the news of his death in Buenos Aires.

As a parting gift to his friend Florine Stettheimer, Duchamp had drawn a map of the Americas with his journey marked on it as a dotted line that concluded with a swirly question mark but which also gave his expected time in

Argentina to last a rather precise '27 days + 2 years'. While he would inform Jean Crotti that he had the 'intention of staying down there a long time ... several years very likely – which is to say basically breaking completely with this part of the world'.

On arrival in Buenos Aires, Duchamp and Chastel were to rent a modest apartment, number 2 in a building at 1743 Alsina, which still stands today. Duchamp also took another room to serve as a studio in a house at 1507 Sarmiento, which was subsequently demolished, somewhat ironically, to make way for an extension to the San Martín Cultural Centre.

Dreier was to follow them on to Buenes Aires but both she and Chastel, and indeed Duchamp himself, found the machismo of Argentine society and particularly its nightlife off-putting. The artist, commenting about the exclusion of women from many events, would write of 'the senseless insolence and stupidity of the men' in Buenos Aires. Yet he also confessed to finding the place congenial to his art, adding, there 'really is the

scent of peace, which is wonderful to breathe, and a provincial tranquility, which allows, and even forces me to work'.

Shortly before Christmas 1918, and with the war in Europe now over, Duchamp still appeared content and in no rush to return to France, though far from uncritical. 'Buenos Aires does not exist' he wrote, it is '[n]othing but a large provincial town with very rich people without any taste, everything bought in Europe, the stone for their houses included. Nothing is made here ... I have found a French toothpaste that I had completely forgotten about in New York.' Again though, he stated, 'I am basically very happy to have found this entirely different life ... where one finds pleasure in working.'

Among the unrealized projects he initiated in Buenos Aires was to be an exhibition – the first in Argentina – of Cubist art, an attempt to shake up what he perceived to be the backward South

▲ *Tu m'*, 1918.

◀ Buenos Aires.

American scene. He asked his friend Henri-Martin Barzun to select thirty works to show but this plan eventually floundered over the practicalities of shipping the art and finding an appropriate local gallery.

As his letters suggest, to begin with Duchamp worked industriously in Buenos Aires. The stay would see him produce three pieces, two of which were optical experiments that played with ideas of perception. The first, *Hand Stereoscopy*, consisted of two photographs of a seascape onto which Duchamp had drawn pyramids, which when placed in a stereo viewer gave the impression that they were floating on water. The second, *To Be Looked at (from the Other Side of the Glass) with One Eye, Close to, for Almost an Hour*, was a smaller variant of the etched glass pieces that Duchamp had been developing in New York and was comprised of a glass plate patterned with a pyramidal shape and metal strips and a central 'lens' hole that invited the viewer to peer in. The final product of the artist's spell in Buenos Aires was to be a ready-made given as a wedding gift to Crotti on the occasion of his marriage to Duchamp's sister Suzanne. Entitled *The Unhappy Ready-Made*, this took the form of an instruction, which invited the couple to hang a geometry textbook on the balcony of their apartment, so that the wind might solve equations and flip and tear the pages. The newly-weds duly complied with Duchamp's wishes and took a photograph of the book *in situ*, though the volume alas was not to cope long with the Parisian weather and this snap stands as the only record of the piece.

Art, however, was increasingly being neglected in favour of Duchamp's growing obsession with chess. His older brothers had first taught him the game as a boy and in 1911 he'd created a series of drawings of Raymond and Jacques facing one another over a board. In New York, Duchamp had enjoyed regular games with his patron Walter Arensberg. In 1916, he had upped the ante and joined the prestigious Marshall Chess Club, which was then based near Washington Square in New York, and where games went on into the early hours of the morning. But in Buenos Aires he became, in his own words, a chess maniac, and it's difficult not to surmise that there might have been some element of coping with the grief of losing his chess-playing brother in all of this.

As it was he started to play insistently and ransacked local bookshops for chess literature. Going through local magazines, he clipped out articles about the games of the Cuban master José Raúl Capablanca, who was one of the biggest names in chess in South America and had visited Buenos Aires to play a series of exhibition matches and simultaneous games over the summer of 1914. He again joined a club, most likely the Club Argentino de Ajedrez, whose headquarters were at 833 Cangallo, and began taking lessons from one of its most distinguished players.

Writing to Arensberg, Duchamp was to admit that, 'Everything around me takes the shape of the Knight or the Queen, and the exterior world has no other interest for me other than in its transformation to winning or losing positions.' Apologizing for not sending a letter sooner to another correspondent, Duchamp explained that

he hadn't had the time, confessing that 'my attention is so completely absorbed by chess. I play night and day and nothing in the world interests me more than finding the right move. I like painting less and less.'

By the following March, Chastel had become so bored of the situation that she left for France. Dreier, carrying with her the few artistic fruits of Duchamp's time in Buenos Aires and a newly acquired pet cockatoo, headed back to New York just a month later. Duchamp, meanwhile, hung on until June 1919, before booking a passage on the SS *Highland Pride*, an English boat bound for Southampton and Le Havre. The voyage back to Europe would last a month, and the artist was to spend three days in London before he finally landed back on French soil. Once there he made for his parents' home in Rouen. Duchamp had been away for four years.

Always an artist whose works were marked by an almost mathematical precision, he returned from Argentina with the sense that art and chess were not so different after all. By the 1920s, chess was to have all but supplanted art in Duchamp's life. By then he had come to believe that chess was, in effect, an art form and that the game possessed a visual and imaginative beauty akin to something like poetry. By his definition, the game had really become his means of artistic expression. In an address to the New York State Chess Association in 1952, he summed it up by stating that, 'From my close contacts with artists and chess players, I have come to the personal conclusion that while all artists are not chess players, all chess players are artists.'

▶ Buenos Aires.

Albrecht Dürer Has a Whale of a Time in the Netherlands

Dubbed the first truly international artist, Albrecht Dürer's (1471–1528) achievements are comparable only, in the opinion of the art historian Norbert Wolf, to Leonardo da Vinci. Such is his significance as a national figure in his native Germany that the 1500s are often referred to as the Age of Dürer; an era in which the Middle Ages were finally thrown off and the Renaissance flourished in the Germanic world by following his example.

As Wolf notes, Dürer was the first German artist 'to write about his own life' and 'to grant autonomy to the genre of the self-portrait' and he helped carry copperplate, woodcut, watercolour and oils to artistic and technical heights. He mastered silverpoint engraving as a precocious teenage apprentice goldsmith in his father's workshop. He abandoned the apprenticeship soon after, having persuaded the family to let him pursue a career as an artist on the grounds that he was more inclined toward painting. One painting in particular, *Saint Jerome*, completed when he was at the height of his powers and during an extended tour of the Netherlands in 1520–1, was to ensure he remained a touchstone for Dutch art ever afterward – and no single picture was copied as often in the sixteenth century. Yet this tour of the Netherlands, for all of its many highlights, personal and professional, was to have grave consequences for the artist.

Born in Nuremberg, Germany, on 21 May 1471 and named Albrecht after his father, Dürer was an inveterate traveller. His wanderlust was first stoked at age nineteen when he was dispatched on a trip to Alsace and Basel via, most likely, Frankfurt and Mainz, then both major German printing centres, to further his artistic education. At Basel he obtained a position as a journeyman and produced woodcut illustrations for Sebastian Brant's hugely successful book, *The Ship of Fools*, among others. He married on his return to Nuremberg in May 1494. But he was almost immediately off on his travels again, departing just a few months later to Italy and, specifically, Venice, thereby setting the pattern for much of his married life as a husband often absent from home. However, his journey of 1520–1 would be different. For on this occasion his wife, Agnes, accompanied him.

Their union seems unlikely ever to have been a love match. Dürer's father had engineered the marriage in the first place, largely to ensure an alliance with one of Nuremberg's grandest families. There would, in the end, be no issue. It has long been suspected that Dürer was homosexual, though sex between men remained an offence punishable by death in Nuremberg at that time. The Dürers' excursion to the Low Countries can hardly be thought of as a late

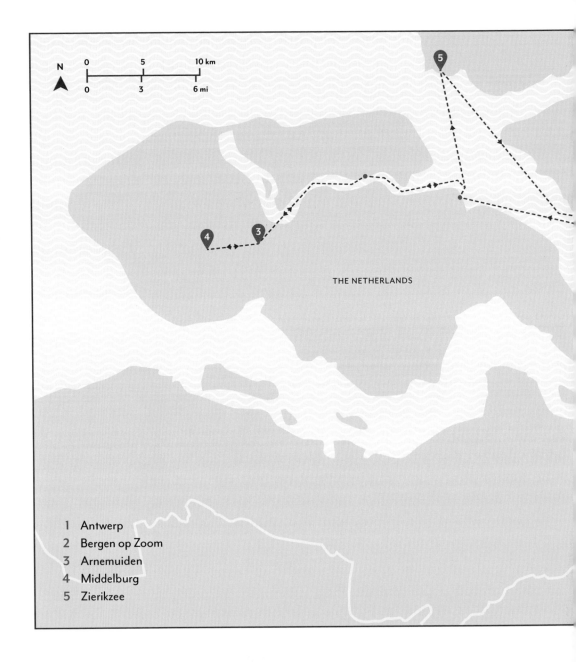

N

0	5	10 km
0	3	6 mi

THE NETHERLANDS

1 Antwerp
2 Bergen op Zoom
3 Arnemuiden
4 Middelburg
5 Zierikzee

◀ PREVIOUS PAGE Antwerp,
Belgium.

Dürer's Expedition to Zeeland

BELGIUM

second honeymoon in any case, since its chief motivation was money.

In 1515 the Holy Roman Emperor Maximilian I had granted Dürer a lifetime annuity in recognition of his work. But four years later Maximilian died, and his grandson Charles V succeeded him. Uncertain that this financial arrangement would hold under the new regime, Dürer therefore decided to attend Charles's coronation in Aachen, Germany, and contrived to attach himself to the official delegation from Nuremberg for this event. He then aimed to follow this up by pressing the case for the continuation of his annuity in person with the emperor.

Even if this scheme failed to bear fruit, Dürer's other objective was to obtain a slew of fresh commissions and wealthy clients, Flanders having become awash with money from the New World as treasures from the Americas flowed across the Atlantic and into Lisbon and Antwerp, Belgium, with the latter now tipped to supplant Venice in importance.

The Dürers were to leave Nuremberg on 12 July 1520, and were away, in the end, for almost exactly a year. Their first stopping off point was Bamberg, Germany, where Dürer presented the local bishop with two paintings of the Virgin Mary, one of the apocalypse and 'a florin's worth of engravings'. Pious as these gifts might appear, and Dürer was a deeply religious man, the artist was always a canny businessman who understood that distributing works gratis to distinguished persons often paid off handsomely. He was therefore an assiduous presser of rapidly completed sketches, paintings and prints into the hands of potential future patrons throughout this whole sojourn. From Bamberg, and after making a pilgrimage to the nearby Shrine of the Fourteen Holy Helpers, the Dürers set off for Antwerp. Their

course was mostly by boat and along the Rivers Main, Rhine and Maas, with pauses at Frankfurt, Mainz, Koblenz and Cologne on the way.

Arriving in Antwerp on 2 August 1520, the Dürers were to spend most of the next month in the city. The couple were to treat Antwerp as their main base, returning to it a further five times over the course of their year away. Dürer's initial impressions were extremely favourable and he made the rounds accepting invitations, glad-handing, drawing would-be clients and their servants and enjoying the hospitality of admirers, peers and affluent merchants. He also took in the cathedral, the Abbey of Saint Michael and the Burgomeister's new house, which he judged more noble than any 'in all German lands'. On the Sunday after the Feast of Assumption, he watched a procession through the city, and was charmed by the visual spectacle of it all, with bowmen, the cavalry and infantry soldiers and representatives from the trade guilds in full livery and decorative wagons decked out with scenes from the New Testament and even a full-scale model dragon followed by Saint George parading by for over two hours.

At the end of August, Dürer left Antwerp and after putting up for the night in Mechelen, Belgium, reached Brussels, staying a few nights there. At the Royal Palace of Brussels he was able to inspect a display of Aztec artefacts, a spellbinding array of priceless weapons, harnesses, darts, jewellery and religious objects in gold, which had been looted from the kingdom of Tenochtitlan by Hernán Cortés and then presented as gifts to Emperor Charles V by the conquistador. Dürer's interest in all things exotic led him to the ducal zoological gardens, where he sketched the lions, as well as the Count of Nassau's Cabinet of Curiosities, which included marvels such as a large meteorite. He also received a letter from the Archduchess Margaret of Austria, Maximilian's widow, promising to speak to the new emperor about his annuity. As a thank you he

subsequently, at her palace at Mechelen, presented her with an engraving of Saint Jerome and a portrait of her late husband. The latter, alas, did not meet with the archduchess's approval as she judged it a poor likeness.

Dürer was back in Antwerp to witness Charles V's grand entry into the city en route to his coronation and by the beginning of October 1520 the artist had himself also journeyed on to Aachen and joined the great and the good in watching Charles crowned in 'all manner of lordly splendour' at a ceremony in the cathedral on 23 October. Dürer then continued on to Cologne, where on 1 November (All Saints' Day) he was present at a banquet and ball for nobles in Charles's 'dancing saloon'. Less frivolously, he also went to the church of Saint Ursula to see the martyred virgin's grave and its collection of holy relics and acquired a tract by Martin Luther, the Protestant firebrand whose views on reforming the papacy Dürer had come increasingly to share. In June of the following year, once again back in Antwerp, and fearing that Luther had been killed following his abduction on the road from Worms, Germany, the artist would write a lament for the reformer, urging the Dutch scholar Erasmus, who he'd become acquainted with during his time in Flanders, to continue the campaign.

While still in Cologne, Dürer was to receive confirmation that thanks to Margaret's entreaties with Charles, his annuity was to continue as before. Buoyed by this welcome news, Dürer headed back to Antwerp, taking a rather scenic route through Düsseldorf in Germany and Nijmegen (then Nymwegen), Tiel and Herzogenbusch in the Netherlands to get there.

▶ TOP *Young and Old Woman from Bergen-op-Zoom*, 1520.

▶ BOTTOM *Schelde Gate Landing*, 1520.

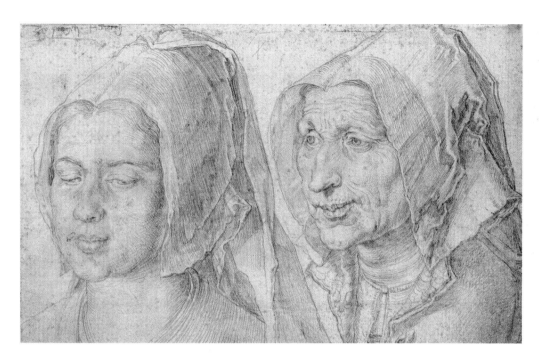

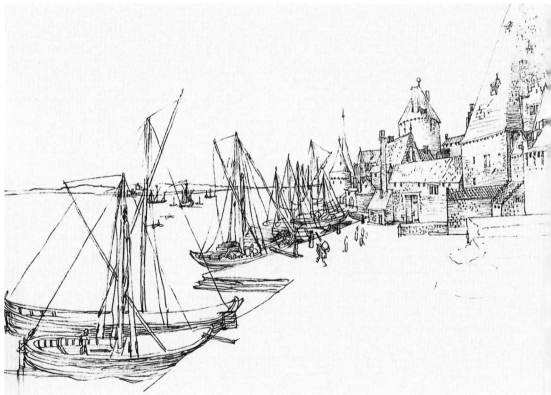

At the beginning of December, Dürer was to hear that a whale 'more than one hundred fathoms long' had 'been washed ashore by a great tide and storm' in Zeeland, the westernmost province of the Netherlands. Desperate to see and sketch a whale in the flesh, Dürer hastily arranged to go to Zeeland, leaving Antwerp on Saint Barbara's Eve, 3 December, for Bergen op Zoom, a coastal town just south of Rotterdam, where what would turn into a quest to reach the beached sea creature would begin. Sailing out of Bergen op Zoom, the intended destination was Zierikzee, where the great 'fish' had last been sighted.

But just as it was landing at Arnemuiden, with most of the crew already disembarked, the boat was knocked by another ship, breaking its mooring rope, and a storm suddenly blew in and carried the craft away from the harbour and out into the open sea. Fortunately, they managed to get a sail up and steer the craft back to the shore but the boat, its captain, Dürer and about four other passengers came within a whisker of being lost.

Dürer never did get to see the whale. By the time the boat arrived in Zierikzee a tide had already carried the creature away. Despite these misfortunes, Dürer found the liminal scenery of Zeeland, where the difference between the land and sea was often blurry and the water in places stood higher than the buildings, beautiful and he deemed Middelburg, with its abbey and town hall with a fine tower, excellent for sketching.

However, soon after getting back to Antwerp, Dürer was overcome by a strange sickness; one that was to afflict the painter for the remainder of his days and may possibly have hastened his end seven years later at the age of fifty-seven. Some have claimed the malady was malaria, which he may have contracted during his misadventures in the brackish waters of Zeeland. But all we know for sure is that he was never a well man again. Nevertheless, it was in the spring of 1521 that he executed his celebrated painting *Saint Jerome* for the Antwerp-based Portuguese merchant Rui Fernandes de Almada, who also gave Dürer's wife a green parrot, then an extremely rare and exotic bird in Europe, as a present.

Saint Jerome was the translator of the Bible into Latin, the patron saint of scholars and a figure revered by Dürer, who made several depictions of him over the years in different media. But for this particular oil painting on an oak panel Dürer modelled the saint's features on sketches he'd undertaken of a ninety-three-year-old Antwerp local. The saint is shown wearing a blue cap and draped in a red robe, labouring at his books in a monkish cell, with a skull, quill and ink pot on his desk and a crucifix on the wall. The image is a masterpiece by any standards.

More paintings were to be completed in Antwerp, including portraits of his innkeeper host, Jobst Planckfelt, and King Charles II of Denmark. And there were to be further excursions and a banquet before Dürer bid a final goodbye to Antwerp on 3 July 1521, wearier but much wealthier, with his reputation considerably enhanced but his health severely undermined.

◀ Middelburg, Netherlands.

Helen Frankenthaler Soaks Up Provincetown

Fluidity was almost everything to Helen Frankenthaler (1928–2011). The soak and stain method that she developed in the early 1950s put her at the forefront of what later became known as Colour Field Painting. It was considered an advancement on the Abstract Expressionism of Jackson Pollock and Willem de Kooning, and resulted from her diluting house paint and enamel with turpentine and pouring it directly onto untreated canvases from an empty coffee can. The fluidity of the paint, rather than the motion of the painter in Action Painting, was the essential animating force in her abstracts. Most of her major artistic breakthroughs and some of her greatest works, meanwhile, were to result from the time she spent beside the ocean (an abiding subject and inspiration for Frankenthaler) and above all her summers at Provincetown, the landing site of the *Mayflower* back in 1620 and a resort on the tip of Cape Cod in Massachusetts.

Signalling her artistic ambition, as a young girl Frankenthaler had drawn a line in chalk on the ground from her family's rather swanky apartment in Manhattan's Upper East Side (her father was a former New York State Supreme Court judge) to the Metropolitan Museum of Art. In 1950, and aged twenty-one, she was tasked with organizing a graduation show by students of her alma mater, Bennington, the liberal arts college in Vermont, where she'd been taught by Paul Feeley, an exact contemporary of the Abstract Expressionists.

Demonstrating a certain amount of chutzpah, she rang up Clement Greenberg, then the art critic of *The Nation* magazine and a great champion of Pollock, to invite him to attend. He agreed after she promised that there'd be a lot of liquor including martinis and manhattans. Though he was nearly twice her age, bald and had a complicated enough personal life, they hit it off instantly, and their love affair would continue for the next five years. He would introduce her to Pollock and took her to the openings of Abstract Expressionists' shows at the Betty Parsons Gallery. Pollock's rejection of easel painting would in turn encourage her to be bolder in her own working methods.

In 1950, Greenberg suggested Frankenthaler go to Provincetown in the summer and take classes with Hans Hofmann, the German-American painter who had help shape Greenberg's own views on art. He himself would be out of New York in any case, as he had a seasonal teaching gig at Black Mountain College in North Carolina, which, when Frankenthaler later visited him there, she found dismal, the people dingy and, worse, there was 'no water ... just a swimming hole'.

Hofmann had been running his school in Provincetown as a means to supplement the income from his New York atelier at 52 West 8th Street since the 1930s. Back then the place had been dominated by fishermen who worked from shacks on the beach and lived in clapboard houses with peeling white paint, and the town

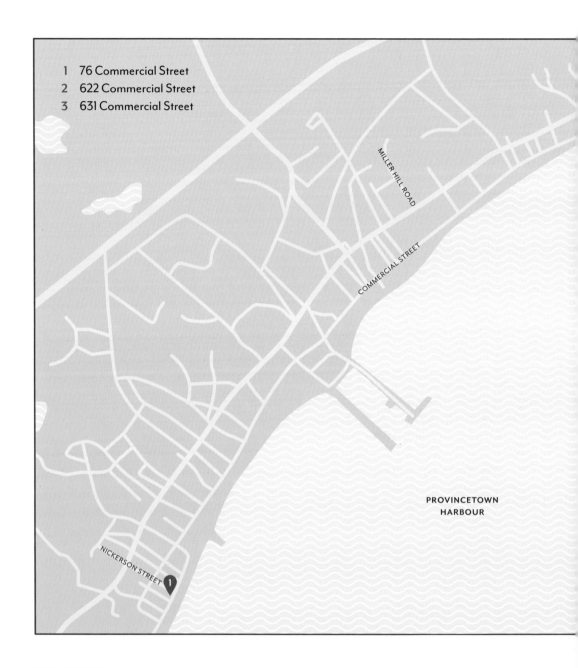

1 76 Commercial Street
2 622 Commercial Street
3 631 Commercial Street

MILLER HILL ROAD

COMMERCIAL STREET

PROVINCETOWN
HARBOUR

NICKERSON STREET

◀ PREVIOUS PAGE An empty
pathway to the beach,
Provincetown, USA.

Frankenthaler's Time in Provincetown

N

0 200 400 m

0 1000 ft

and its inhabitants kept their distance from the mainland. But its seclusion and the beauty of its setting meant it had already become something of a coastal bolthole for New York writers and artists. John Dos Passos, the author of the modernist classic *Manhattan Transfer*, came every year between 1929 and 1947 and stayed at 571 Commercial Street, a clapboard house near the old Lewis Wharf (which had been destroyed in a storm in 1928) owned by his wife Katharine 'Katie' and her brother Bill. In 1936 she co-authored a guidebook to Cape Cod, in which she described Provincetown and its transformation into a Mecca for the arty set, writing of its:

> Narrow, foreign-looking streets; crowded houses; a wildly diverse population of old-time Yankees, Portuguese fishermen, actors, artists, tourists, sailors; easels jostling gay umbrellas on the beaches; wharves made over into night clubs, fish sheds into studios; shops of all kinds; tearooms and restaurants; caravans, trucks and an endless stream of cars.

The critic Edmund Wilson was another literary lion who visited annually, as if pulled by the local tides that he once poetically evoked in the line, 'the great sea unfurrowed and bright blue, frothing whitely over the bright yellow beach, which it chews and spits out and chews again like a dog worrying a bird'. His third wife Mary McCarthy, however, would satirize Provincetown's artistic community in her caustic novel *A Charmed Life*, a thinly veiled fictional account of the breakdown of their marriage.

Lenore 'Lee' Krasner, Pollock's wife and a considerable artist in her own right, who'd studied for two years under Hofmann in New York, had first visited her mentor out in Provincetown in 1938, accompanied by her then lover the Russian emigré artist Igor Pantuhoff and their painter friends Rosalind and Byron Browne.

Initially, Hofmann had worked and taught at the Charles Hawthorne Class Studio on 9 Miller Hill Road and also did a season at Fritz Bultman's studio at 8 Miller Hill Road. In 1945, he purchased 76 Commercial Road, a property previously owned by the seascape painter Frederick Judd Waugh

and that came with a studio directly behind the main house on Nickerson Street. And by the late 1940s, a brief spell with Hofmann by the sea 'had become a rite of passage for an aspiring New York painter', as the biographer Mary Gabriel puts it.

On her arrival in Provincetown, Frankenthaler promptly enrolled to study under Hofmann, seeing it as a necessary bridge in her career. She was charmed by the painter, who she recalled 'was a tough geezer, but very human, very straight, very bright'. Her accommodation, on the other hand, a wooden beach shack she had to share with four other students that was managed by Hofmann's

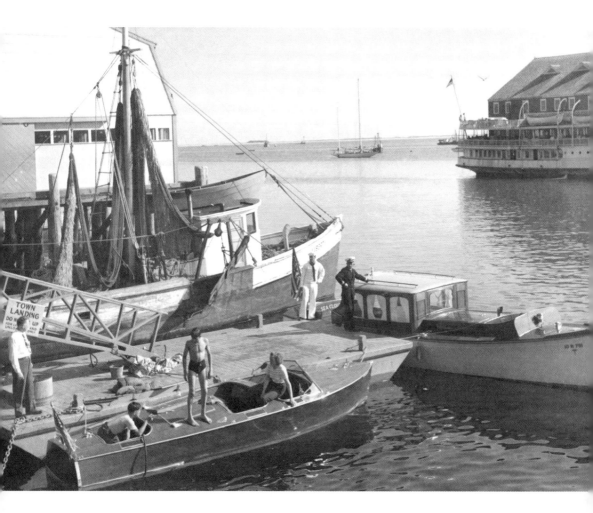

'alcoholic secretary and her alcoholic boyfriend', left a lot to be desired. She knuckled down to the classes but one day, feeling slightly bored, she slipped out of the studio and went down to the beach. Mesmerized by 'the humbling infinitude of sea and sky' before her she set up her easel in the porch of the shack and began to paint, feeling as if the picture was telling her what to do.

At the following Friday's critique, Hofmann's weekly feedback sessions a somewhat legendary feature of his summer courses, Frankenthaler brought in her painting, which she titled *Provincetown Bay*, in which she represented the seascape in flows of cobalt blue, grey, black, red, burnt umber and brown. Hofmann discussed colour and its necessity in conveying experience. Then, gesturing to Frankenthaler's picture, he offered his highest praise, saying simply, 'this works'. And it did.

Two years later she was to travel up to Nova Scotia in Canada on a painting holiday with Greenberg, the couple sitting side by side on the beach sketching in watercolour. On returning to her studio in New York, Frankenthaler had another breakthrough, when attempting to render what she'd seen and felt in Canada. She trialled her soak and stain method, nailing a canvas 2.1 metres/7 feet high and 3 metres/10 feet wide to the floor, and pouring thinned paint on its surface. The resulting picture, *Mountains and Sea*, presented a brilliant summarization of another coastal sojourn in arcs and swathes of blue, green, red, delicate pink and glowing yellow.

Her technique could continue to evolve in the 1950s and into the 1960s as she experimented with watercolours and acrylics, such as Magna, an acrylic resin paint. But throughout this time Provincetown would be a lodestar; the artist and her first husband, the Abstract Expressionist Robert Motherwell, who she married in 1958, spending their summers at 622 Commercial Street, before later moving to 631 Commercial Street, where Frankenthaler had a barn-studio in the woods.

Throughout her career, Frankenthaler, like Krasner and Elaine de Kooning, had to contend with being a woman in an art world – and a society – still presided over by men. In 1960, Frankenthaler unexpectedly found herself a full-time stepmother to Motherwell's two daughters when the custody arrangements with his ex-wife changed. The girls eventually returned to live with their mother, but would spend their summers in Provincetown. If Frankenthaler often found this arrangement a strain she nevertheless gamely helped them set up a beachside lemonade stall, prepared their lunches and created a schedule of events that allowed her to paint. And it was during this period that she produced some of her greatest Provincetown pictures, among them such masterpieces as *Summer Scene: Provincetown*, *Cool Summer*, *Low Tide*, *Indian Summer* and *Blessing of the Fleet*. The latter was a colour bomb of red, green and yellow in imitation of the Portuguese flag, and a homage to a local sea-faring ritual.

◄ Provincetown Harbour,
 c.1955.

Caspar David Friedrich Replenishes Himself on Rügen

Just six months older than his English contemporary J.M.W. Turner, Caspar David Friedrich (1774–1840) was one of the most important Romantic painters in Germany. He was a revolutionary who discovered a new way of representing landscape, imbuing it with feeling and spiritual meaning. The first oil painting he exhibited, *The Cross in the Mountains*, commissioned as an altarpiece for the chapel in Děčín (Tetschen) Castle in Bohemia (now the Czech Republic), was a profound and radical statement. Friedrich presented nature itself as sacred, with the crucifixion scene set amid green scenery; an approach that scandalized some but also earned him immediate recognition as an artist with a unique perspective.

Yet in his lifetime, Friedrich enjoyed only a fleeting period of acclaim. Though once he'd counted Tsar Nicholas I of Russia as a patron, after about 1825 his pictures, with their lone figures standing on moonlit misty mountaintops and barren trees haunting snowy hillsides, came to be dismissed by critics in Germanic circles as out of date, gloomy and a little strange. His death on 7 May 1840, after a decade-long decline in mental and physical health, largely passed without comment. Rediscovered in the opening years of the twentieth century, his works then had the misfortune to be taken up by German nationalists in the Nazi era. But since the 1950s, Friedrich's art has been recognized for its importance in the broader European Romantic tradition.

Unusually for a painter of his era, Friedrich was never to visit the Alps and his landscapes were based on detailed studies completed in pencil on location, mostly in northern Germany, around which he travelled extensively. He lived for most of his life in the city of Dresden, and often went sketching on the banks of the River Elbe nearby and in the meadows of the neighbouring countryside. But it was the shores of the Baltic Coast and perhaps most of all the island of Rügen, near his home town of Greifswald (once a significant Hanseatic port but by then a provincial backwater in Swedish Pomerania), that nourished him most as both an artist and a human being.

Raised in a staunchly Lutheran family, his early life was marked by tragedy. He lost his mother at the age of seven. In 1787, his elder brother Johann Christoffer drowned while attempting to rescue Friedrich after he fell through some ice on a pond. And four years later his sister Maria succumbed to typhus. Little wonder then that Friedrich grew up to be a rather melancholy young man given to deep introspection who sought comfort in drawing and prized solitude. Solitude would, in fact, become a central element of his creative process. Explaining how he worked in the field, he once stated, 'I must remain alone and know that I am alone, in order to see and feel nature completely; I must surrender myself to my surroundings, unite myself with my clouds and rocks, in order to be what I am.'

As a teenager, Friedrich had been tutored in art by Johann Gottfried Quistorp, the drawing

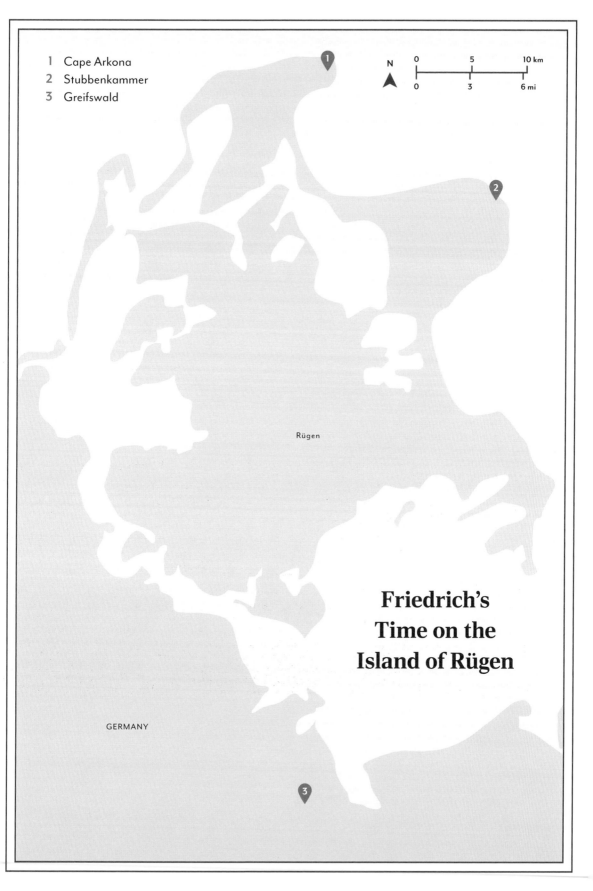

1 Cape Arkona
2 Stubbenkammer
3 Greifswald

N

0 5 10 km
0 3 6 mi

Rügen

**Friedrich's
Time on the
Island of Rügen**

GERMANY

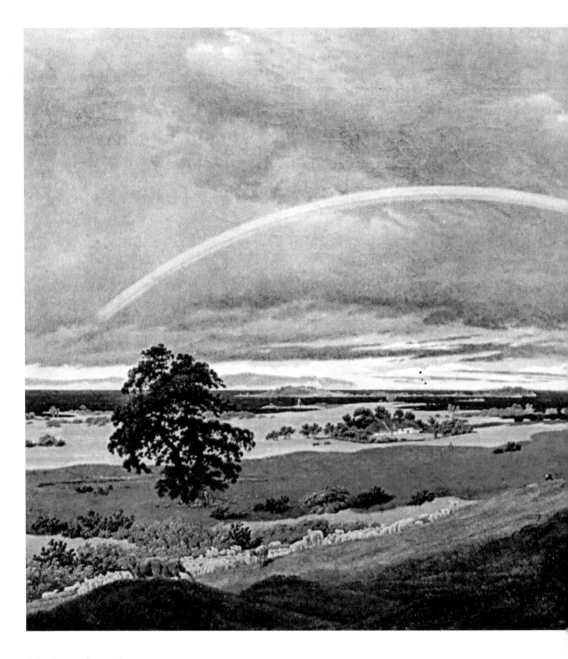

▲ *Landscape on Rügen with
Rainbow, c.1810.*

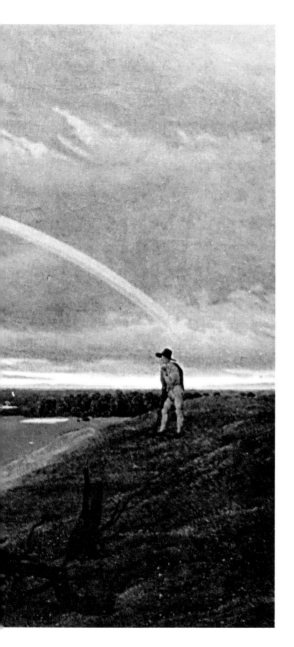

master at the University of Greifswald. He was to continue his studies at the distinguished Copenhagen Academy between 1794 and 1798, before leaving the Danish capital to settle permanently in Dresden, where he began trying to make a mark as an illustrator and printmaker.

But in the spring of 1801, travelling by way of Neubrandenburg, Germany, he came back to Greifswald and stayed on until the following summer. During this extended visit, he took the time to immerse himself in the scenery of his native landscape and made sketching excursions to Rügen.

The sight of Friedrich out and about in all weathers was clearly a memorable one. A contemporary was to recall that, 'The fishermen used to watch him, sometimes fearing for his life, as he clambered around on the jagged rocks of the hills and chalk cliffs that jutted out into the sea, as if he were voluntarily seeking a grave in the waters below.'

If the local fisherman thought him mad, and probably bad and a danger to himself too, these methods paid off and he returned to Dresden with a series of drawings that demonstrated a new eye for the natural world. He was becoming attuned to the way light glanced off the swirling sea and glinted on the cliffs and how shadows were cast from wavering trees. Over the coming months, he devoted himself to turning his impressions of Rügen into a series of sepia and wash scenes that earned rapturous reviews from critics when they were exhibited in Dresden in 1803. This year, in the opinion of many art historians, marked the turning point in his development as an artist, with Friedrich growing in confidence and starting to explore the themes of time and impermanence by charting the effects of the changing seasons and cycles of day into night on the natural landscape.

In May 1806, Friedrich again came back to Greifswald to recuperate from an illness he claimed to have brought on himself after falling into despair at Napoleon's victories over the Prussian army. He lingered there into June and once more went sketching on Rügen. It was in the following year that he began working in oils, most likely spurred on by the Děčín altarpiece commission.

His next significant homecoming was not until the autumn of 1815. But it was three years later that Friedrich came back to introduce his new bride to his relatives in Greifswald. The painter's marriage on 21 January 1818 came as a surprise to many. The saturnine artist was forty-four and had been a confirmed bachelor. His new wife, Caroline Bommer, was nineteen years his junior and the daughter of the manager of a Dresden depot. She nevertheless seems to have had a positive effect on his outlook. Certainly the picture *Chalk Cliffs on Rügen* from this time, which shows three figures peering out at the view from the clifftop, is one of Friedrich's least brooding. Although despite its cheerier tone and the lightness of palette, it should be noted that this trio do still stand on the edge of a precipice. Further studies of the local scenery, such as *Meadows near Greifswald*, completed in around 1820–22, however, show the painter in a gentler, more pastoral mode.

In 1824, Friedrich received a chair at the Dresden Academy of Fine Arts, but overwork appears to have triggered another bout of ill health; one that left him unable to paint in oils for nearly two years. Once more he withdrew to Greifswald. While there he put what little energy he had into undertaking a series of studies of Rügen in watercolour. He is known to have finished at least thirty-seven of these island pictures and aimed to publish them as a collection of engravings. But the plan was never realized and most of the original pictures were lost. The failure of this project, alas, set the tone for the remainder of Friedrich's life. He was passed over as landscape painting teacher at the Academy of Fine Arts and his disappointment at this snubbing found expression in ever more sombre pictures. Increasingly reclusive and bitter and disillusioned at his treatment by the art establishment, Friedrich began exhibiting signs of paranoia. He became convinced his wife had been unfaithful to him and was violent and moody with her and his children. On 26 June 1835, Friedrich suffered a crippling stroke from which he never recovered, and it appears he never saw his beloved Rügen again.

▶ Rügen, Germany.

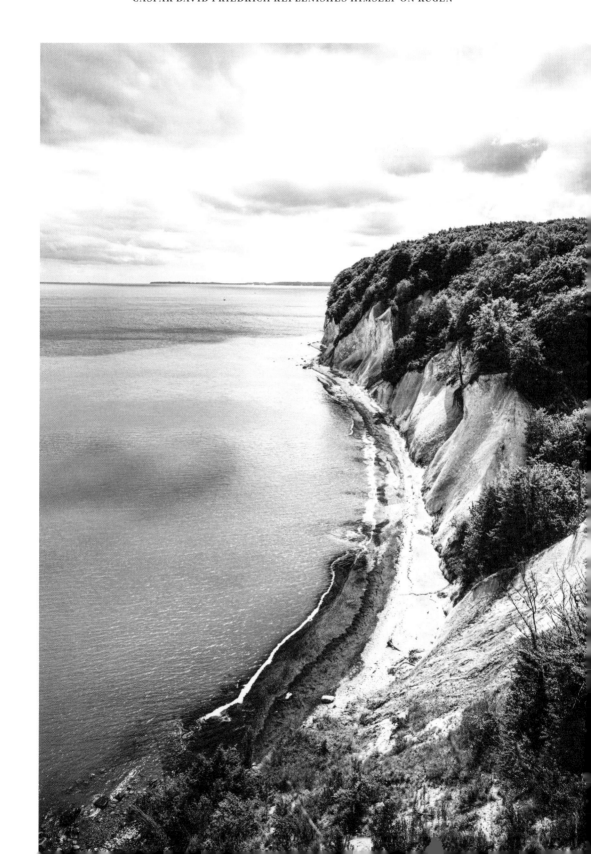

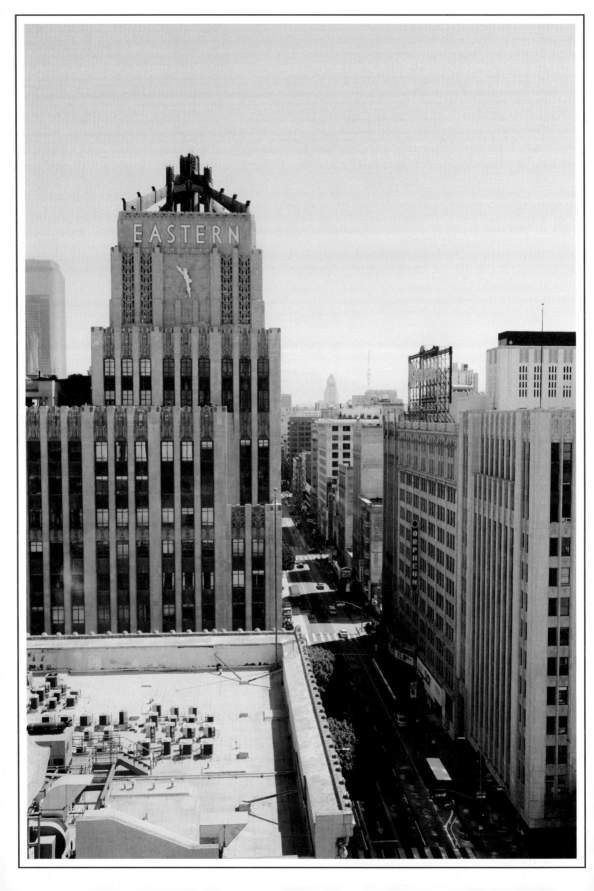

David Hockney Goes La-la over Los Angeles

America was a place that the British artist David Hockney (b. 1937) had fantasized about since boyhood, ever since watching Hollywood serials like *Superman* and *Flash Gordon* at the Saturday morning Kids' Club at Bradford's Greengates Cinema. Later, trams in Leeds bearing the destination 'New York Road' sparked adolescent thoughts of crossing the Atlantic and taking a bite out of the Big Apple. Flush with the proceeds from a commission to paint a mural for the SS *Canberra*, P&O's new flagship ocean liner, and an award from the Robert Erskine Gallery, Hockney was eventually able to visit the United States in the summer of 1961, flying to New York with a £40 return ticket on 9 July – his twenty-fourth birthday.

He had arranged to stay with Mark Berger, an openly gay American mature student who he'd met when they both were studying at the Royal College of Art (RCA) in London. Through Berger, Hockney had also been introduced to *Physique Pictorial*, an American 'beefcake' magazine whose pages were full of homoerotic photographs of semi-naked men, ranging from rough-and-ready street toughs and bodybuilders to pretty boy-next-door types. The latter were more to Hockney's taste.

The magazine was to imbue the Land of the Free with the kind of sexual possibilities that seemed absent to the artist in Britain, where at the time homosexuality remained a criminal offence and most gay men and women lived in fear of public exposure. By comparison, Hockney was to find New York unbelievably easy. The artist recalled, 'People were much more open, and I felt completely free. The city was a total twenty-four-hour city. Greenwich Village never closed, the bookshops were open all night so you could browse, the gay life was much more organised.'

The trip was to transform Hockney's life in many ways. Among the most striking, though, was his appearance. For it was in New York that Hockney bleached his hair blonde for the first time – the platinum bombshell barnet becoming almost his trademark look ever after. Hockney made a second visit to New York in April of 1963, on this occasion staying about a month and meeting Andy Warhol and the actor Dennis Hopper. He was back again that December, but this time was planning to spend nearly a year in the States and wanted to go to Los Angeles.

As his biographer Christopher Simon Sykes points out, Hockney didn't know a soul in the city and couldn't drive, and when challenged by his New York art dealer Charles Alan on how he intended to get about a sprawling metropolis comprised of hundreds of square miles of suburbs offered that he'd just get a bus. Alan attempted to persuade the artist to try San Francisco instead. But Hockney was adamant that he must go to the home of Hollywood movies and the place where *Physique Pictorial* was based, a town whose seamier sides he'd read all about in John Rechy's *City of Night*. This heavily autobiographical novel is narrated by a gay hustler who relates his sexual

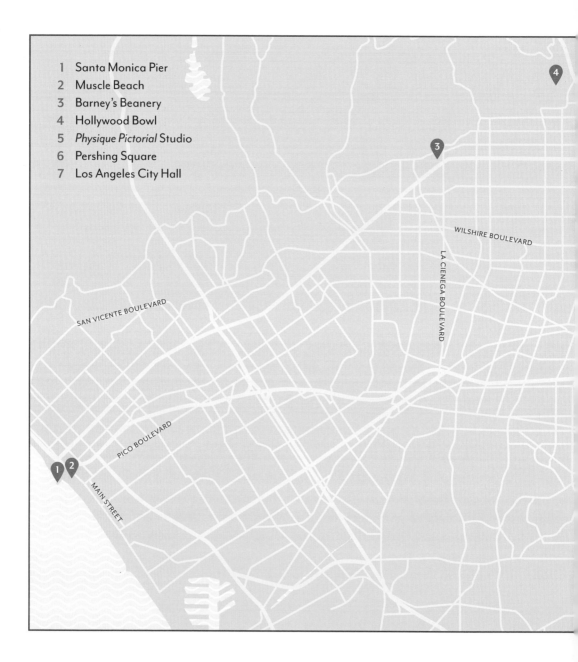

1 Santa Monica Pier
2 Muscle Beach
3 Barney's Beanery
4 Hollywood Bowl
5 *Physique Pictorial* Studio
6 Pershing Square
7 Los Angeles City Hall

SAN VICENTE BOULEVARD

WILSHIRE BOULEVARD

LA CIENEGA BOULEVARD

PICO BOULEVARD

MAIN STREET

◀ PREVIOUS PAGE
Los Angeles.

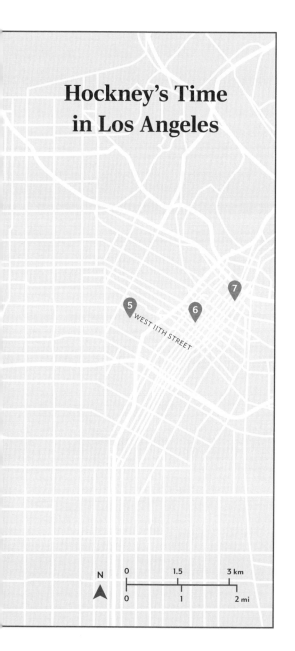

Hockney's Time in Los Angeles

WEST 11TH STREET

N

| 0 | 1.5 | 3 km |
| 0 | 1 | 2 mi |

encounters with various men in New York, Los Angeles, San Francisco and New Orleans. It contains an especially colourful portrait of LA's Pershing Square, a district Rechy characterized as the 'world of Lonely America' and the free and easy, if sleazy, refuge of 'the nervous fugitives of Times Square, Market Street SF, the French quarter', teeming with 'masculine hustlers looking for lonely fruits to score from', 'scattered junkies, small-time peddlers', queens, panhandlers and 'exiled nymphs'. Naturally, Pershing Square was top of Hockney's LA itinerary.

Unable to dissuade Hockney from his southern Californian odyssey, Alan arranged for the artist to be picked up from the airport by another of his clients, the LA-based sculptor Oliver Andrews, who agreed to help the Yorkshireman get his bearings on the west coast. Flying in over San Bernardino in January 1964, Hockney was immediately enraptured by the sight of lines of houses all with swimming pools, the water glistening in the shining sun, and later confessed that he was more thrilled than he'd ever been arriving at any other city, including New York. This common feature of Californian homes was soon to become a mainstay of Hockney's subsequent output. In painting after painting he came to delight in examining the possibilities of depicting the way light played on swimming pool surfaces. And equally, the splashes and ripples wrought by swimmers diving into their cool waters beneath hot suns and clear blue skies in California's endless, year-long summers.

Good as his word, Andrews was waiting for Hockney at the airport and safely deposited him at the Tumble Inn, a motel at the bottom of Santa Monica Canyon, and promised to return the following day. Hockney decided to do a bit of exploring and, seeing some lights in the distance, set off in their direction, believing he was heading into town. But after walking for a couple of miles he found himself at a brightly illuminated gas station with nothing else in sight. When Andrews arrived the following morning, Hockney, determined to solve his transportation needs, asked to be driven to a shop selling bicycles. Hockney consulted a map and discovered that the nearby Wilshire Boulevard, which begins near the Pacific coast at Santa Monica, ran directly to Pershing Square. And so off he peddled, failing to realize that it was some 27 kilometres/17 miles away, nor that Rechy's book, if drawn from life, was still a work of fiction. The Pershing Square the artist finally reached was virtually deserted and very far from the Sodom and Gomorrah he'd dreamed of. After a nursing beer in the forlorn hope something interesting might turn up (it didn't), all he could do was cycle straight back to the Tumble Inn.

Andrews argued, successfully, that Hockney should just buy a car and offered to give him some lessons to get him through the driving test. Despite his coaching, Hockney managed to fail on four points but was awarded a provisional licence anyway and celebrated by splashing out on a brand new white Ford Falcon. After accidentally straying onto the freeway, he promptly drove to Las Vegas, over 400 kilometres/250 miles away, where the artist succeeded in winning $80 at one of the desert resort's famed casinos. Once checked out of the Tumble Inn, Hockney rented an apartment on Pico Boulevard in Santa Monica.

▲ Venice Beach, Los Angeles.

▲ Muscle Beach summer
school, Los Angeles, 1957.

Needing somewhere to work, he leased a studio
space overlooking the ocean on Main Street in
Venice Beach and began settling in, enjoying the
pace of life in this part of Los Angeles and finding
its flora, fauna, eclectic architecture and tanned
and well-toned inhabitants extremely agreeable.

Not far from his new apartment was San
Vicente Boulevard, its grand houses fronted by
palms and cactus gardens and its tree-lined
central reserve a favourite with joggers and
keep-fit fanatics who ran down it and through

Palisades Park and along Ocean Avenue to Venice's fabled Muscle Beach, a haunt of body-builders and athletic volleyball players on the sands beside Santa Monica Pier. Another feature of the waterfront, though, were lines of showers where those exercising on the shore or in the water could hose themselves down after working up a sweat or swimming in the sea. The sight of rows of bronzed hunks doing their ablutions was another of the beach's attractions for gay men. One that inevitably caught Hockney's eye.

Photographs of men showering in pseudo-classical poses were, in any case, the bread and butter of Physique Pictorial, whose studio downtown on 11th Street (a surprisingly ordinary house with a pool that often served as a backdrop) Hockney also visited. The artist would respond to all this imagery, producing such breakthrough paintings as Boy About to Take a Shower and Man in Shower in Beverly Hills during his stay in America.

However, as the art critic Peter Webb has suggested, the actual buildings of the city arguably had as much an influence on Hockney's artistic output as its damp beautiful boys. Hockney took to cruising the city in his Ford Falcon; not to pick up men (though his time in Los Angeles was not without sexual intrigue) but to experience a city whose architecture had largely been determined by the automobile. From roadside diners and restaurants shaped like Derby hats to mansions with castle turrets and futuristic new structures like John Lautner's Garcia House on Mulholland Drive and his Chemosphere on Torreyson Drive, Hockney drank it all in. He was to claim that Los Angeles was the only city in the world where driving around it the buildings had made him smile.

The first picture he completed in Los Angeles was Plastic Tree Plus City Hall. In the painting the city's landmark skyscraper shared a canvas with a palm of dubious provenance. The picture was completed in acrylic, a medium the artist had attempted to use previously in London without success. But Hockney discovered that American acrylic paint was of a far superior quality to English varieties and its malleability made it his preferred material. He would go on to use it to immortalize further pieces of the cityscape in Wilshire Boulevard, Los Angeles and Building, Pershing Square, Los Angeles along with California Art Collector. The latter, the first of Hockney's 'swimming pool' paintings, was based on his encounters with such well-heeled collectors and curators as Betty Asher. At that time, the city's art scene was centred around Monday-night openings at the main contemporary galleries on La Cienega Boulevard, which Hockney quickly gravitated to and where he first got to know the American painter Ed Ruscha. Barney's Beanery, a bar at the top end of the street that adjoined a cheap diner, was the main hang-out for artists and artistic hangers-on, and it was frequented by the likes of Edward Kienholz, and consequently Hockney himself.

The Yorkshireman left Los Angeles for a six-week teaching stint in Iowa in the Midwest. And there were further excursions to the Grand Canyon and New Orleans in the company of his old RCA associates, the fashion designer Ossie Clark and the painter Derek Boshier, as well as a trip to see The Beatles play at the Hollywood Bowl.

This American sojourn was to end back on the east coast that September with a show at Charles Alan's gallery in New York – Hockney's first in America. The exhibition was a triumph and announced the artist's arrival to the American art world. His latest pictures, with their imagery of the west coast, pointed to themes and subjects that would preoccupy him for decades and portrayed a place that would become his home from home, off and on, for the next fifty years.

Katsushika Hokusai Scales Mount Fuji

'From the age of six', the Japanese artist Katsushika Hokusai (1760–1849) once wrote, 'I had a penchant for copying the form of things, and from about fifty, my pictures were frequently published; but until the age of seventy nothing I drew was worthy of notice.' Hokusai was being a little hard on himself and his earlier output, which was substantial. Before hitting three score years and ten, the artist had produced at least twelve volumes of manga (sketches or caricatures that were the forerunners of modern comics), thousands of woodcut illustrations for books and prints, along with countless drawings and paintings of animals, flora, fauna and religious figures, portraits of courtesans and actors in the traditional ukiyo-e (which means 'pictures of the floating world') vein, and Western-style landscapes of the native scenery inspired by Dutch engravings.

The isolationist Sakoku Edict of 1635, which prevented foreign travel and effectively banned Europeans from entering Japan, was to prevail throughout Hokusai's long life, which somewhat limited his access to outside influences. Yet few artists have been quite so curious and questing as Hokusai, whose whole life might be said to have consisted in the search for absolute perfection in his art; a search that continued right up until his final days on earth. 'If only', he is reputed to have cried on his deathbed, 'Heaven will give me just another ten years ... Just another five more years, then I could become a real painter.' Nevertheless,

it was in 1830, and at the tender age of seventy, that Hokusai embarked on a new series of pictures that ultimately fulfilled his ambition to infuse his work with three spiritual elements, *ten* (the divine), *jin* (the human) and *chi* (the earthly).

Among these pictures was to be *The Great Wave off Kanagawa*, which remains by far and away Hokusai's most famous painting in Europe and America. In recent decades, its central image of a vast foamy wave, at once menacing but oddly friendly, has been reproduced on everything from bath towels and surf boards to beer cans. However, as with all the other pictures in this series, the painting's real subject, lurking in the background, is Mount Fuji, a Japanese landmark around which Hokusai pivoted, quite obsessively, for three years from 1830 to 1833.

In some respects, Mount Fuji can be said to have always been an object of fascination for Hokusai, since scattered appearances of it can be found in his earliest book. But the compendium of these later pictures, published as *Thirty-Six Views of Mount Fuji* (although there are actually forty-six), represented both a return to landscape after a decade away from the form and a giant leap forward in terms of focus and execution.

In Japanese culture it is fair to say that Mount Fuji looms large. Not only is it the nation's tallest mountain, it occupies a unique place in the country's psyche. Since ancient times, the mountain has been considered holy and the source of immortality. In 'The Tale of the Bamboo

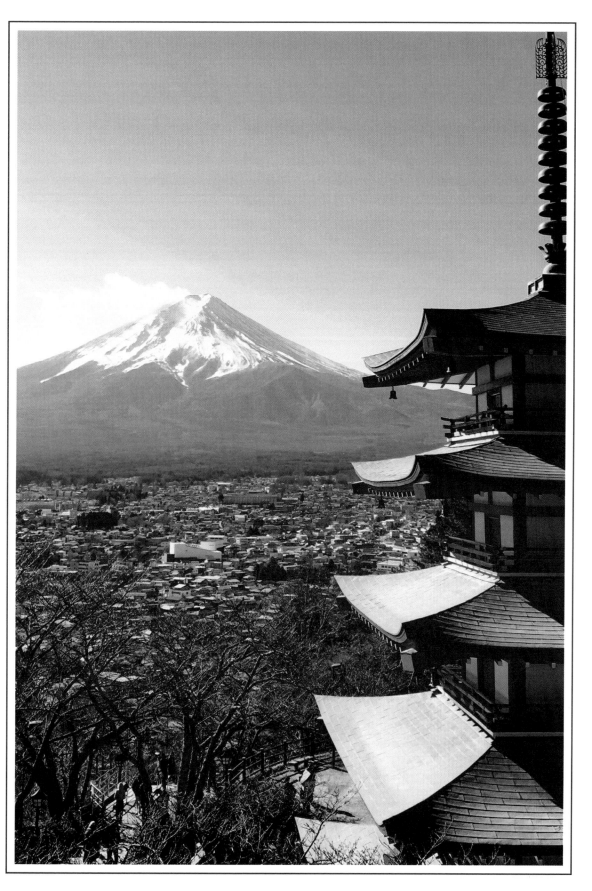

Cutter', one of the oldest-surviving Japanese *Heike monogatari* (a type of prose epic, dating from the ninth or tenth century), it is said that Fuji's peak is where a goddess stores the elixir of life. Similarly, Fuji is to be found represented on the earliest truly Japanese 'scroll' paintings of the thirteenth century.

Held as sacred by Buddhist, Taoist and Shinto traditions, the mountain, in more recent centuries, has appeared on New Year's greetings cards (*surimono*) and become virtually synonymous with Japan itself. From the distance it looks cone-like but its sides are not equal. Its very asymmetry, the art historian Jack Hillier once argued, is itself utterly Japanese and he went on to posit the idea that 'if Fuji did not exist in actual fact, Japanese artists would have created it'.

In the summer months, the summit of Mount Fuji is comparatively easy and reasonably safe to scale. A pilgrimage to its peak remains at the top of many Japanese bucket lists, and it has done so since travel and tourism within the country really began to take off among the upper classes in the early nineteenth century. It was then too that more realistic souvenir pictures of places people might actually have visited started to become popular. Prior to that artists, including Hokusai himself earlier in his career, might never leave their studios, working instead from renditions of locations by older artists, often themselves fanciful interpretations that drew on traditional representations of what certain sites were supposed to look like or based on literary sources, rather than the actual living landscapes.

Little information is available about Hokusai's working methods on this series of views of Mount Fuji. But these views of the mountain, which were designed to be sold to those who might already have visited the place, appear too numerous and simply too detailed not to have been based on personal surveys undertaken both by foot and by boat.

JAPAN

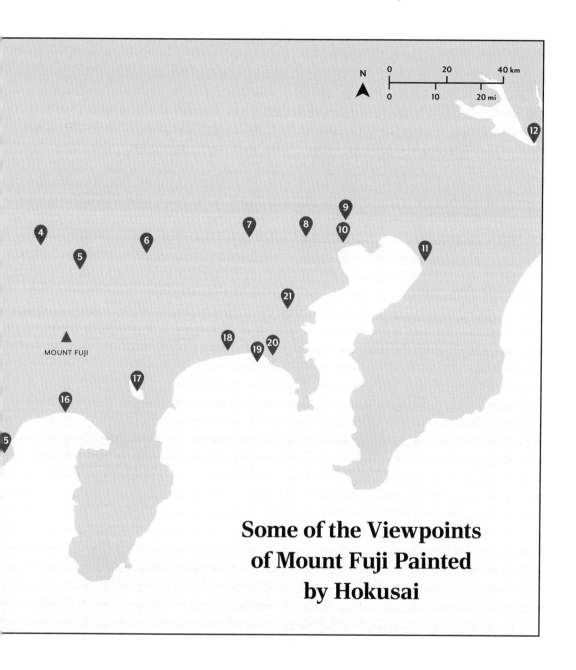

Some of the Viewpoints of Mount Fuji Painted by Hokusai

◀ PREVIOUS PAGE Chureito Pagoda on the mountainside overlooking Fujiyoshida, Japan, with Mount Fuji off in the distance.

Hokusai was a commercial artist who responded to public tastes and enjoyed periods of enormous success. It appears that it was his publisher, Eijudo, a famously canny operator, who commissioned Hokusai to undertake the series of prints of Fuji. These paintings, which satisfied the demand for authentically Japanese illustrations, saw him utilizing a new pigment called Berlin or Prussian blue that was helping artists to achieve a greater dynamism in their work. This dye was developed in Germany in about 1706 and it was imported to Japan by the middle of the eighteenth century. Unfortunately, it was far too costly for most artists to use. However, by the 1820s, the Chinese had developed a much less expensive version and by the 1830s it was finding favour with Japanese painters and, more importantly, punters.

Hokusai was born in the rustic countryside on the outskirts of Tokyo (then Edo) on the twenty-third day of the ninth month of the Hōreki period (or sometime in October or November in 1760 in the Western calendar). While Mount Fuji is almost entirely obscured by a curtain of high-rise towers in modern-day Tokyo, the artist grew up with a ringside-seat view of the mountain. Despite its distance from the city, its snowy peak would have been a constant presence on the horizon. This can clearly be seen in views such as *Surugadai in Edo*, *Nihonbashi in Edo* and *Mitsui Shop in Surugachō in Edo*.

▼ *Ushibori in Hitachi Province, c.1830–3.*

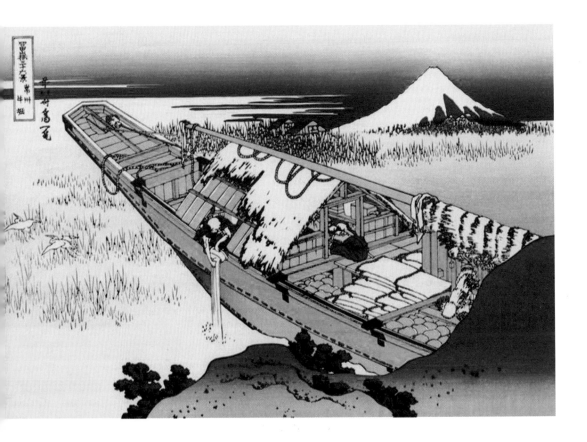

In pictures like *Red Fuji* and *Storm below Mount Fuji*, the mountain appears as a brooding elemental force, magnificent and eternal, watching the hours and weathering the seasons. But perhaps the beauty of his sequence of thirty-six views is that the mountain, if reigning supreme, is often an incidental feature, appearing as a backdrop to the lives of ordinary folk. The paintings show people living in harmony with a mountain that will, nevertheless, long outlive them.

Hokusai is recorded as having used over thirty different names, each new name adopted to signal a fresh development in his artistic practice, a custom that was quite common in Japanese art in this era. Accordingly, and tellingly, in the wake of *Thirty-Six Views of Mount Fuji*, the name Hokusai was shed like an old skin. When its

sequel, a further tribute to the mountain, *One Hundred Views of Mount Fuji* (here again the artist's maths was off, as there were 102), appeared in 1834, it carried the rejoinder 'formerly Hokusai-I-Itstu now changing his name to Gakyō Rōjin Manji' (which means 'The Old Man Crazy to Paint'). But such was the impact of *Thirty-Six Views of Mount Fuji*, especially beyond Japan's shore (Claude Monet, Auguste Rodin and Vincent van Gogh would all prove admirers of his prints in the decades to come), that the world at large continues to know him as Hokusai.

▼ View of Mount Fuji from Lake Ashi, Japan.

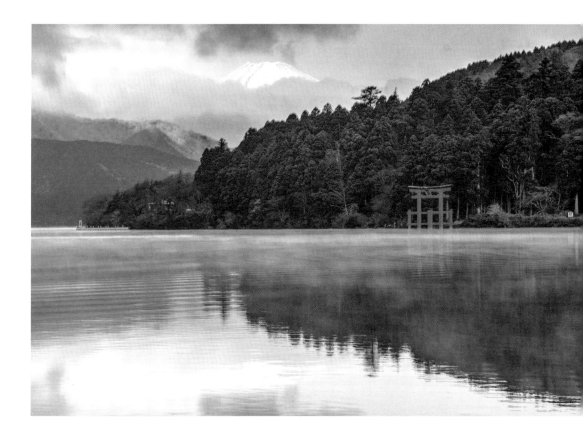

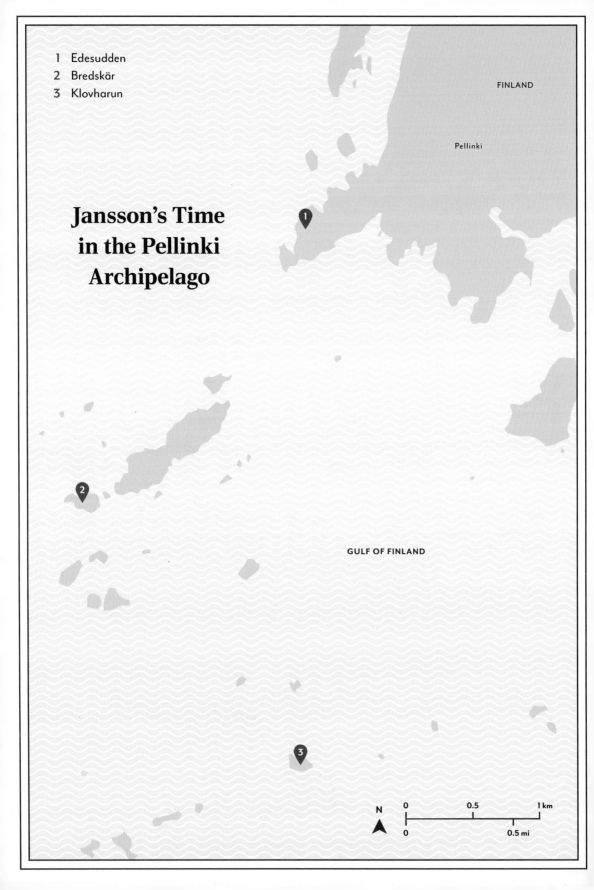

Jansson's Time
in the Pellinki
Archipelago

1 Edesudden
2 Bredskär
3 Klovharun

FINLAND

Pellinki

GULF OF FINLAND

N

0 0.5 1 km

0 0.5 mi

Tove Jansson Summers in the Pellinki Archipelago

The painter, illustrator, novelist and creator of the beloved series of children's picture books chronicling the adventures of the Moomins, Tove Jansson (1914–2001) was born in Helsinki into 'an avowedly artistic family', as Ali Smith puts it, just a few months before the outbreak of the First World War. That global conflict, and its successor, would have an enormous impact on Jansson's life and career. Her first Moomin book, *The Moomins and the Great Flood*, was composed during the Second World War, and in the opinion of her biographer Tuula Karjalainen its purpose was to 'dispel the darkness and depression of the war'.

Tove's father, Viktor, a sculptor known as 'Faffan' within the family, was transformed by the experience of fighting in the Finnish Civil War of 1918. This skirmish occurred as a direct result of the collapse of the Russian Empire, which had ruled Finland since 1809. The Romanov dynasty had been deposed by the Bolshevik-led revolution in 1917; their end and the establishment of communist rule in Russia were hastened on by the financial turmoil caused by maintaining the war against Germany and their allies in Austria-Hungary, Bulgaria and the Ottoman Empire. In Finland the following spring, Whites – rightists with Germany military support – battled for supremacy against left-leaning Reds backed by troops from the Russian Red Army, with the former ultimately proving victorious in an ugly contest that saw atrocities committed on both sides.

Faffan, the scion of prominent Finnish-Swedish merchants, sided with the Whites. His staunchly conservative values, and especially his anti-Semitism and subsequent enthusiastic support for Hitler and Germany, were often to put him at odds with Tove, who publicly denounced the Nazis and whose Bohemian circle of friends and lovers included many Jews, Socialists and liberals. But according to her Swedish mother, Signe 'Ham' Hammarsten-Jansson, the Faffan who returned from the civil war was a different man to the one she'd first met when they were both aspiring artists continuing their studies in Paris.

In Karjalainen's summation of this transformation, something snapped and the 'once sunny-tempered, playful and amusing Viktor' changed 'into an austere and embittered man, inflexible in his opinions'. A brooding, dictatorial presence at home, he preferred the company of old comrades, with whom he whiled away boozy evenings in restaurants or, after prohibition in Finland made obtaining alcohol trickier, at male-only parties hosted in the Janssons' drawing room. Tove would provide a vivid account of these smoky, testosterone-and-hooch fuelled gatherings (known as *hippor* in Finland) in her auto-biographical novel *Sculptor's Daughter* (1968).

The Finnish Civil War was to pervade many aspects of Tove's upbringing. The most prized object in the Jansson house at 4 Luotsikatu Street in the Katajanokka district of Helsinki was her father's collection of hand grenades. Only Faffan

himself was ever allowed to touch them, and he revered these spoils of the civil war as if they were holy relics.

As a sculptor Faffan's speciality was sensual female figures and tender studies of young children. Both Ham and Tove were to serve as models for Faffan's pieces. Jansson once maintained that she suspected her father only really liked women he'd carved out of stone and that were therefore impassive and silent. Faffan never achieved the level of acclaim accorded to Finnish sculptor Waino Aaltonen, at that time a leading figure in Finnish sculpture, and his bread-and-butter work, if often thinly sliced and little buttered, came from producing war memorials and statues of heroes of the White Guard. Given the somewhat limited number of such commissions available, money was often tight. So it fell to Ham, who had set her own artistic ambitions in textiles aside upon marrying Faffan, to provide for the family by working as a professional illustrator, graphic artist and caricaturist. From 1924, she had a job as a draughtswoman with the Bank of Finland, and would go on to design banknotes and watermarks, along with Finnish national stamps.

Tove was to inherit both her mother's work ethic and her talent for caricature. Her own gift for drawing manifested itself early. A sketch she made aged just two and a half is the oldest surviving piece of her juvenilia. By the age of fourteen her illustrations, verses and comic strip stories were already being accepted for publication. In this way too she began to contribute to the Janssons' straitened coffers. If the financial rewards of the Janssons' creative endeavours were often shaky, Tove remembered that she was brought up 'to feel sorry for all the people who weren't artists'.

For all its difficulties, Tove recalled her childhood as one full of games and excursions, and the family's annual summers away from the

▼ View from an island in the
Pellinki Archipelago, Finland.

city of Helsinki were especially joyful. Not unlike their Russian neighbours with their seasonal second homes (dachas), it was common for middle-class Finns to retreat to the countryside during the summer months, and the Janssons, for all their monetary travails, were no exception. Although Ham's job at the bank restricted her visits to weekends and holidays, a housekeeper was engaged to attend to the needs of Faffan, Tove and her brothers Per Olov and Lars.

Initially the Janssons spent the summers with Ham's Swedish relations on the island of Blidö in the Stockholm Archipelago. But from 1922 onwards they went almost exclusively to the Finnish islands of Pellinki (in Swedish Pellinge). Blidö, with its beaches and tall trees and vegetation, has been put forward as one potential real-life candidate for Mooninvalley. However, it was the Pellinki Archipelago that always remained dearest to Tove's heart and nourished her creatively longest of all. It was there also, following a philosophical discussion about ugliness with her younger brother, Per Olov, that she daubed the earliest version of a Moomin character on the wooden wall of an outhouse next to their holiday villa, a creature she initially called a Snork.

The Pellinki Archipelago lies in the northern side of the Gulf of Finland, about 50 kilometres/ 30 miles east of Helsinki and 22 kilometres/ 14 miles south-east of Porvoo. It is comprised of some 200 separate islands, of which the most significant are Sundö, Tullandet, Lillpellinge, Ölandet and Suur-Pellinki. The Janssons were to rent their first villa on Edesudden on Suur-Pellinki

from the local Gustafsson family. Albert (Abbe) Gustafsson, who was the same age as Tove, was to become her lifelong friend.

Later the Jansson family were to opt for Bredskär, where Tove and Lars built a cabin that shocked everyone by proving surprisingly enduring, consistently weathering the gales that frequently hit the island even in the more clement months. Bad weather, perhaps curiously, brought out the best in Faffan. Tove was to write that her father was a melancholy man but that 'when a storm threatened he became a different person, cheerful, entertaining and ready to join in with the children in dangerous adventures'. His desire to scoop up and protect his family in these situations finds parallels in the actions of Moominpapa in a variety of Tove's Moomin books. And even in the periods when Faffan and Tove were scarcely able to speak civilly to one another, she continued to join her relatives for their sojourns in Pellinki, and in summer spells that regularly lasted from late spring until well into autumn.

Perhaps most important to the Jansson clan at large, and Tove in particular, was the chance the islands gave them all to indulge their love of the sea. Per Olov was a skilled diver; Lars, an enthusiastic sailor; and Tove's greatest love was simply observing the waves from the rocky shore. This love of the sea finds numerous expressions in the Moomin oeuvre and far beyond in her various water-inflected paintings (her murals for the three hundredth anniversary of Hamina, the Finnish fortress city, were, for example, to feature sailing ships flying in the waves, mermaids and other fantastical marine creatures), drawings, film and radio scripts, novels and stories.

In 1965, she and her life partner, the American-Finnish graphic artist Tuulikki 'Tooti' Pietilä, first visited Klovharun, a tiny island at the outer reaches of the archipelago and fell in love with it. Its remoteness appealed to Tove, who as a child had dreamed of becoming the lighthouse keeper on Kummelskär, another of Pelinki's far-flung satellites. She described the island as the 'largest and prettiest pearl' in the necklace-like 'crescent of uninhabited skerries west of Glosham'.

Tove and Tooti were to build a cabin on Klovharun, designed by Tooti's architect brother Reima Pietilä and his spouse, Raili. And although they travelled widely around the world in this period, they summered on Klovharun for the next twenty-six years, spending their time writing, painting, fishing, sailing, swimming and just drinking in the local scenery and wildlife.

One of the first books to be completed in the wake of discovering Klovharun was *Moominpapa at Sea*, a hymn to the ocean in which Moominpapa fulfils Tove's long-cherished dream of acquiring a lighthouse. It was on Klovharun that Tove also began to write one of her most highly regarded adult books, *The Summer Book*, and Tove and Tooti were to celebrate the history, topography and mythology of Klovahurn itself in *Notes from an Island*, with Tove providing the text and Tooti the pictures. However, by 1992 Tove's health was failing and with access to Klovharun at the mercy of the weather, even in the summer months (the island was cut off entirely during the harsh Finnish winters), the couple reluctantly gave up their cabin, donating it to a local community association who today open it to visitors each July.

◀ Tove Jansson (left) and Tuulikki Pietilä, Bredskär, Finland, 1961.

Frida Kahlo and Diego Rivera Honeymoon in Cuernavaca

The relationship between Mexican painters Frida Kahlo (1907–1954) and Diego Rivera (1886–1957) was one of the most creatively fruitful if emotionally turbulent in art history. Inspiring and urging each other on and producing numerous portraits of each other, their partnership would encompass marriage, multiple miscarriages, divorce, remarriage and numerous affairs on both sides, with Rivera sleeping with Kahlo's sister, and the bisexual Kahlo counting the Russian revolutionary Leon Trotsky, the American-Japanese sculptor Isamu Noguchi and most probably the American painter Georgia O'Keeffe as lovers.

Kahlo had first encountered Rivera in 1922, when she was a fifteen-year-old student and he was painting a mural in the amphitheatre of her school, the prestigious National Preparatory School in Mexico City. They were reintroduced to one another six years later by a mutual friend, the Italian photographer Tina Modotti, and their courtship commenced at a pace despite Rivera being married to Lupe Marín, whose portrait Kahlo would later paint.

Before Diego, Kahlo had dressed reasonably conventionally, but under his influence she was to embrace a more emphatically Mexican style of dress, with Tehuana clothing and jewellery becoming her trademark. For the couple's wedding in a civil ceremony at the town hall in Coyoacán, a borough of Mexico City, on 21

August 1929, she wore a dress borrowed from an indigenous Mexican maid. Rivera was forty-two and Kahlo twenty years his junior.

In December of that year, Rivera accepted a commission from Dwight W. Morrow, the United States ambassador to Mexico, to paint a mural in the Palace of Cortés in Cuernavaca, about 64 kilometres/40 miles south of Mexico City. Rivera and Morrow were unlikely associates: Rivera a card-carrying member of the Communist Party and Morrow a firm believer in American capitalism. Equally unlikely were the intended site and subject of the mural. The palace had been erected by the Spanish conquistador Hernán Cortés soon after the fall of the great Aztec city of Tenochtitlan in 1521. Built on top of the remains of an Aztec pyramid, the palace was used by Cortés to store much of the Mexican gold and other treasures he looted. Now though, Rivera was free to adorn its walls with a fresco that not only portrayed the brutality of the Spanish conquest but also gloried in the success of the Mexican Revolution, featuring a heroic Emiliano Zapata astride a white horse. Although the content of his mural was to be radical, the fact that its paymaster was the American government angered many of his fellow communists, who accused the artist of hypocrisy and duly expelled him from the party.

The commission came with the added bonus of the free run of Morrow's rambling house, Casa

MEXICO

Morelos

**Kahlo and Rivera's
Time in Morelos
and Guerrero**

Guerrero

N

| 0 | | 10 | | 20 km |
| 0 | 5 | | 10 mi | |

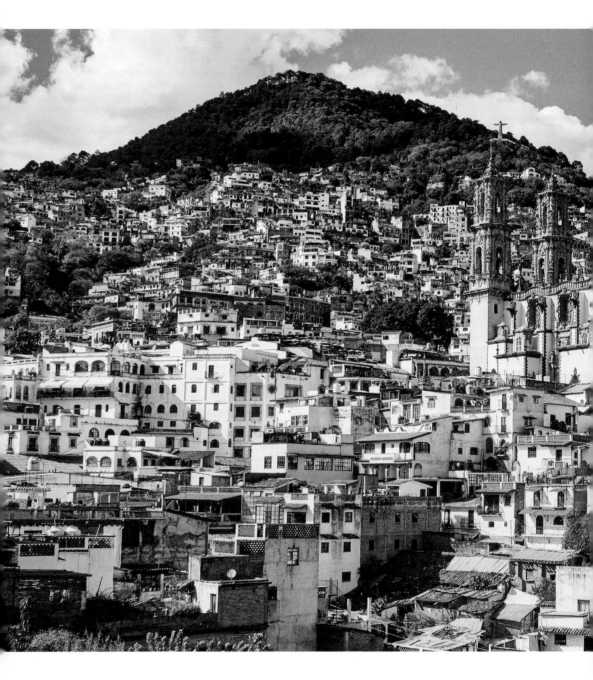

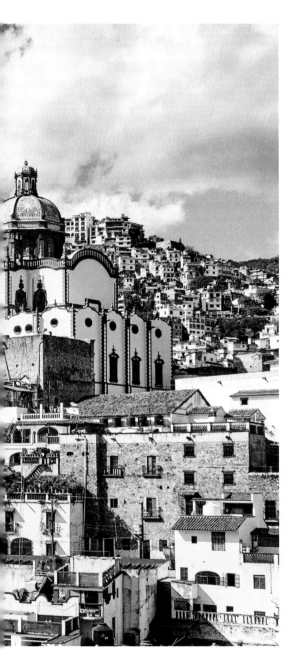

Mañana, in Cuernavaca for the best part of the year it took Rivera to complete the mural. With its gardens and fountains and its views of the snow-capped volcanoes Popocatépetl and Iztaccihuatl to the east, it formed an idyllic backdrop to the honeymoon period of their marriage.

Rivera would head off to the palace each day to paint, with Kahlo often accompanying him. She usually visited every lunch time in any case to bring a midday meal in a basket decorated with flowers. Kahlo was also to critique his efforts, making Diego redo parts that didn't match up to her standards. 'I had', he later recalled, 'to correct that white horse of Zapata according to Frida's wishes'. Kahlo had initially questioned the colour of the horse since the Mexican revolutionary was known to have ridden a black steed but she accepted Rivera's argument that he had to create something beautiful for the people. She, nevertheless, took him to task for making its legs too heavy and he repainted them at her insistence.

Progress on the mural was extremely slow. With Rivera hard at work, Kahlo, who'd devoted herself almost body and soul to him since their marriage and neglected her own art, began to paint again. She made several portraits of indigenous Mexican children, painted a since-lost picture of an indigenous Mexican woman in foliage and most likely started on the third of her self-portraits here.

Perhaps just as important to her growth as an artist were the excursions she made to the historic

◀ Taxco, Mexico.

sites in Cuernavaca and the surrounding towns of Taxco, Iguala, Tepoztlán and Cuautla. She taught herself about colonial architecture, delved into the Aztec past and explored aspects of more recent indigenous Mexican folk culture. On Sundays, Rivera would join her on these jaunts, the muralist always on the lookout for potent subjects and images that he might utilize in future works, and both artists would come to add pyramids (as well as hairless Mexican dogs) to their painterly lexicon in due course.

Their time in Cuernavaca was brief and relatively idyllic, though Frida suffered a miscarriage, the first of several – her inability to have children was to be a bitter blow to the couple. In November 1930, they left Mexico for San Francisco, where Rivera had been hired to provide the Pacific Stock Exchange Luncheon Club with a mural, the artist dismissing any further carping by Mexican communists by pointing out that Lenin himself had counselled revolutionaries to work from within the enemy camp.

▼ Cuernavaca Cathedral, Cuernavaca, Mexico.

▶ Diego Rivera at the Palace of Cortés in Cuernavaca, 1930.

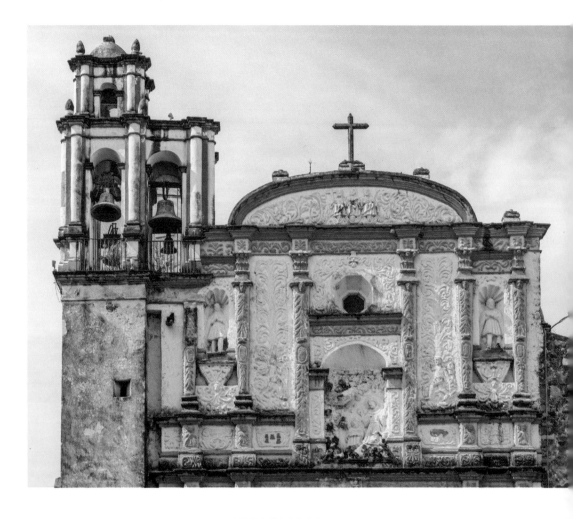

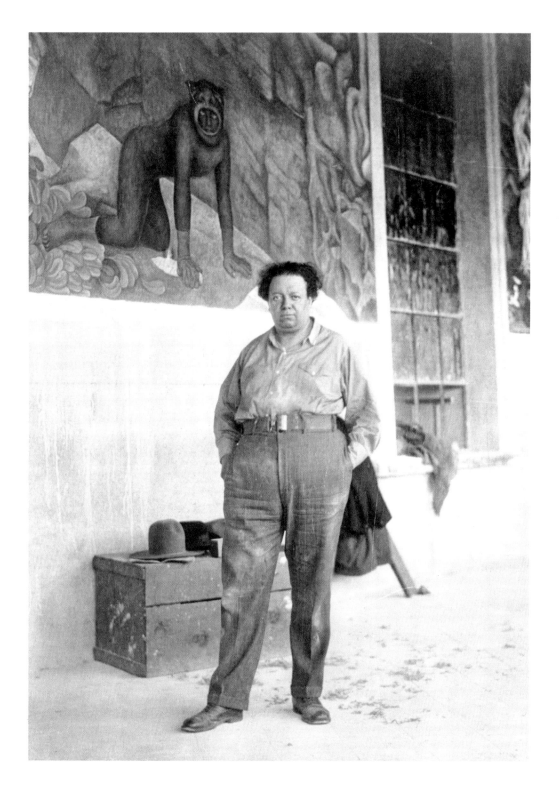

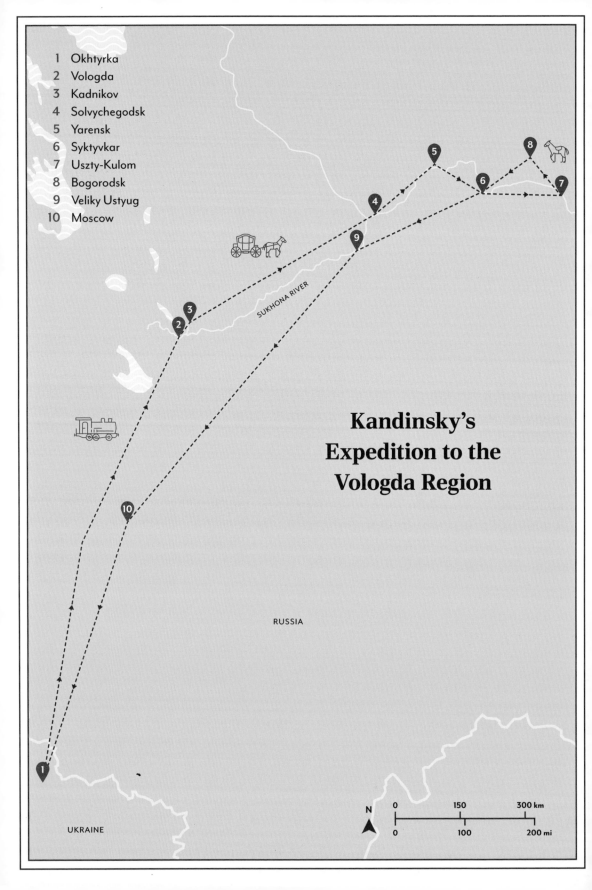

1 Okhtyrka
2 Vologda
3 Kadnikov
4 Solvychegodsk
5 Yarensk
6 Syktyvkar
7 Uszty-Kulom
8 Bogorodsk
9 Veliky Ustyug
10 Moscow

SUKHONA RIVER

Kandinsky's
Expedition to the
Vologda Region

RUSSIA

UKRAINE

N

0 150 300 km

0 100 200 mi

Wassily Kandinsky Finds His Artistic Calling in the Province of Vologda

On the 28 May 1889, a promising young legal scholar by the name of Wassily Kandinsky (1866–1944) set out from Moscow on a fact-finding expedition to the obscure Russian region of Vologda, a province bordering the Ural Mountains and the western frontier of Siberia. Kandinksy's research trip was to be sponsored by the prestigious Imperial Society of Friends of Natural Science, Anthropology and Ethnography and its aim was two-fold. The assignment, as he later recalled in his 1913 memoir, *Retrospect*, was 'to study peasant criminal law among the Russian citizenry (to discover the principles of primitive law) and to collect the remnants of pagan religion among the fishermen and hunters of the slowly disappearing Zyrians'.

Since the abolition of serfdom in Russia in 1861, emancipated peasants had been granted a degree of economic autonomy and the right to adjudicate their own legal disputes and even punish certain criminal acts under their local codes of law. This field of 'peasant law' had become Kandinsky's special area of interest while studying law at the University of Moscow, where he'd enrolled in 1885, after concluding with a heavy heart that art, his first love, 'was an unallowable extravagance for a Russian'.

As for the second tier of his mission, the art historian Peg Weiss has argued that Kandinsky had a personal interest in ethnographic studies as his own background was an eclectic mix of nationalities. Although Kandinsky himself was born in Moscow and raised in Odessa on the Black Sea coast, his mother was of German Baltic stock and his father, a successful tea merchant, originally hailed from Kyaktha, on the border between Russia and Mongolia. Kandinsky's first language was German and a Zyrian–German dictionary was to feature on the reading list he compiled for his expedition. His bible, however, would be a copy of the *Kalevala*, a poetic epic that was compiled in the nineteenth century from ancient Finnish oral folklore and mythology.

In family lore, the Kandinskys were said to have migrated to eastern Siberia after being banished from west Siberia for political reasons. This expedition to the fringes of the Vologda region, to the very frontier of western Siberia, therefore, possibly represented an attempt of sorts by the painter to connect with his own ancestry.

The Zyrians (or Komi, as Kandinsky was to learn they preferred to call themselves) were a people of Finno-Ugric origin who retained both their language and many of their ancient customs and

some pre-Christian rituals and beliefs. Scattered over a vast if sparsely populated region, much of it dense taiga forest rich in game, the Komi were accomplished hunters, fishermen and herdsmen, who traded widely via the network of rivers – chiefly the Northern Dvina, the Sukhona, the Pechora, the Vychegda and the Sysola – that served as the main transport routes across the province. These rivers, naturally, were to help facilitate Kandinsky's own excursions into Komi territory.

The starting point of his journey was to be Okhtyrka (Akhtyrka) in Ukraine, where the family of Anna Chemiakina, his cousin and future first wife, had a rural retreat. This house and the neighbouring countryside would come to feature in numerous Kandinsky paintings, including *Akhtyrka*, *A Dacha Close to the Pond* and *Akhtyrka, Autumn*. Anna was to accompany Kandinsky on the first stage of his expedition, the couple travelling by train to Vologda, a city on the river of the same name in the basin of the Northern Dvina. There they put up in the Golden Anchor Inn, which Kandinsky concluded was cheap but clean. He also sketched a *vasa* (water spirit), a mythic creature with a man's bearded head and a fish's tail, whose likeness was carved above the inn's main door. It was an intimation of what was to come. For while Vologda was known for its many churches, including the Saint Sophia Cathedral, modelled after the Dormition Cathedral in the Moscow Kremlin and famed for its frescos by Dmitry Plekhanov, it typified the ways in which Kandinsky was to find that the pagan and the Christian cohabited out here.

After seeing Anna off, he continued on to the almost 'completely wooden' town of Kadnikov (even down to its planked pavements), where he'd arranged to meet Nikolai Ivanitskii, an

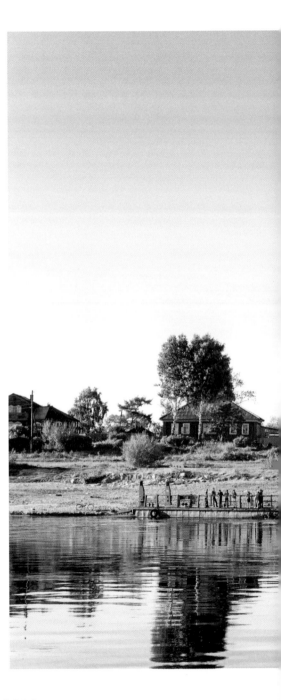

▼ Cathedral of the
Annunciation,
Solvychegodsk, Russia.

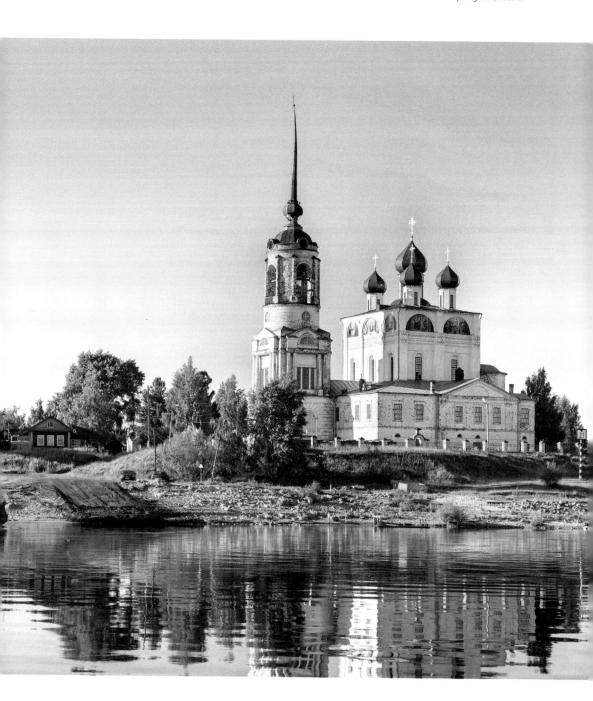

enthnographer and member of the Imperial Society, who'd carried out his own studies of the Komi. Together they would visit the local municipal library and Ivanitskii would take Kandinsky shopping for warmer clothes, the painter having failed to realize that even in June and July temperatures in the region barely rose about 10°C/50°F and regularly dipped below freezing at night.

These new garments would prove especially welcome on the next leg of his trip, which was by spring-less coach along rough country roads to a section of the Sukhona River where he was able to board a steamer whose passengers were mostly labourers. After Solvychegodsk, where he sketched a cross dedicated to prayers for cattle, he arrived in Yarensk, a village whose buildings were again solely made of wood. But since there was no inn, he was immediately forced to continue

on to Syktyvkar (Ust-Sysolsk). This was the administrative centre of Komi territory and Kandinsky busied himself interviewing the local people, collating stories and songs and learning about Poludnita, a goddess believed to reside in rye, and hearing about a fearsome forest monster that had supposedly once made off with one of village children. From here he ventured to Uszty-Kulom, less that 322 kilometres/200 miles from the Ural Mountains, and then further still on horseback to Bogorodsk, before eventually wending his way by boat and two-wheeled gig back to Syktyvkar. From there he headed homeward, reaching Veliky Ustyug on 28 June and then, travelling via Moscow, he arrived back in Okhtyrka by 3 July.

His expedition had lasted barely six weeks but he'd covered some 2,575 kilometres/1,600 miles and filled out over five hundred pages of notes.

Alongside the diligent accumulation of the hard data of field research though were countless drawings of everything from traditional costumes and loaves of pie-shaped Komi bread to icons and farming implements.

He subsequently likened the trip to discovering another world. 'I would', he later wrote, 'arrive in villages where suddenly the entire population was clad in grey from head to toe, with yellowish-green faces and hair, or suddenly displayed variegated costumes that ran about like brightly coloured, living pictures on two legs. I shall never forget the great wooden houses covered with carvings.'

He described the houses themselves similarly as real-life pictures, each interior a kaleidoscopic profusion of vivid, often clashing colours with interior walls and furniture, such as table and trunks, all brightly decorated and a corner given over to icons and other holy objects, rye leaves and the like. Such folk art and decoration, with its mixture of the everyday, the sacred and the heathen, was to make a deep impression on the painter. A decade or so on its influence is plain in his colourful Russian fairy tale-infused works like *Sunday (Old Russia)*, *Song of the Volga* and *Motley Life*. Equally obvious is that the expedition was a formative event for Kandinsky, an experience that cemented his decision eventually to become a painter. In 1896, he moved to Munich with his wife, enrolled in painting classes with Anton Ažbe and dedicated himself to art from then on.

◀ Saint John Orthodox Church, Veliky Ustyug, Russia.

▲ *Song of the Volga*, 1906.

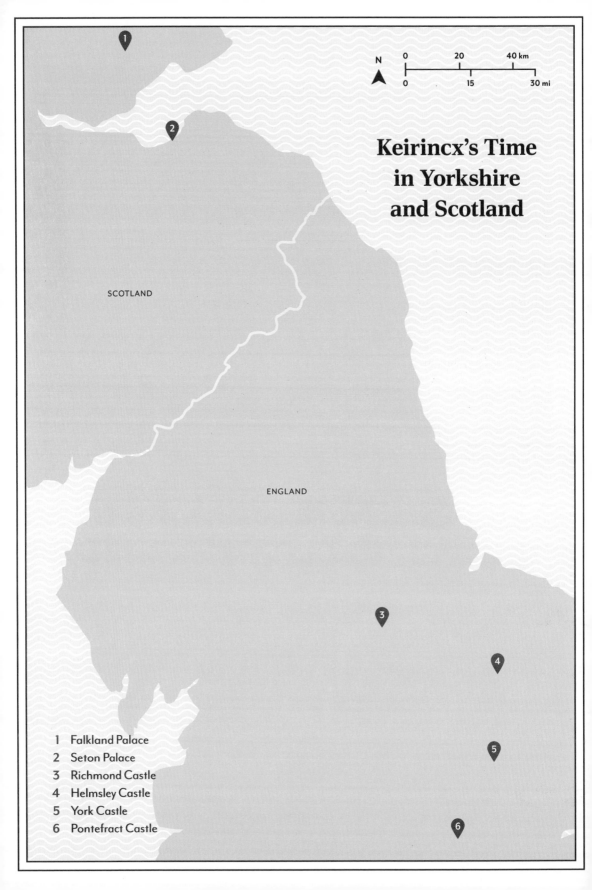

**Keirincx's Time
in Yorkshire
and Scotland**

SCOTLAND

ENGLAND

N

| 0 | 20 | 40 km |
| 0 | 15 | 30 mi |

1 Falkland Palace
2 Seton Palace
3 Richmond Castle
4 Helmsley Castle
5 York Castle
6 Pontefract Castle

Alexander Keirincx Paints All the King's Castles in Yorkshire and Scotland

O n the bitterly cold morning of 30 January 1649, King Charles I was escorted through the banquet hall at Whitehall Palace in Westminster, London, and out to the scaffold in the palace yard to face his execution by beheading. The sickly and weak second son of King James I, Charles had never expected to become king. But the sudden death of his elder brother, the much-admired Prince Henry, who died aged eighteen, led to his accession in 1625. Among the last things he saw were nine paintings that the art-loving monarch had previously commissioned from the Dutch master Peter Paul Rubens.

Charles's chief advisor in the opening years of his reign was the courtier George Villiers, 1st Duke of Buckingham, a trusted favourite, and possibly the lover of his late father. Widely despised by the public and parliament for the extravagance and ineptitude of his naval ventures while serving as Lord Admiral, Villiers was murdered in Portsmouth in 1628. But as a self-aggrandizing patron of the arts himself, who commissioned portraits by Rubens and the Flemish artist Anthony van Dyck, Villiers encouraged the king in his ambition to amass an art collection to rival those of the Spanish Habsburg court. Although initially enamoured of the work of Italians like the Venetian Titian, Charles, following Villiers' lead, soon began to acquire more examples of Northern European art. In 1632, he invited Van Dyck to become his court painter, and upon arriving in England, the artist embarked on a monumental series of portraits of the king and his family.

Van Dyck 's migration, and the promise of regal stipends and subsidized accommodation, tempted other painters from the Low Countries to take the king's patronage (in most instances a generous annuity of up to £100, plus additional per-picture fees) and come to England. By 1633, the Dutch painters Jan Lievens, Hendrik Pot and Cornelis van Poelenburgh, along with the Dutch silversmith Christian van Vianen, were all recorded as boarding in grace and favour properties in Orchard Street, Westminster.

It has been suggested that the Antwerp-born landscape artist Alexander Keirincx (1600–1652) was also in London at that time, which is plausible; Van Poelenburgh was a friend and the pair collaborated on several pictures. But he is known to have been living in Amsterdam with his wife in 1636, and his first appearance in the regal account books dates from 25 April 1638, when Charles I granted him a pension of £60 per year. Evidence of his more permanent status in London is supplied from crown lease agreements on Orchard Street, with both Keirincx and Van Poelenburgh listed among the overseas artistic residents in September 1838.

His timing was propitious for in the next year he was to be entrusted with a commission that, in the opinion of the art historian Richard Townsend, marked 'a watershed moment in the painter's career ... and for a certain aspect of British painting'. Keirincx was charged with completing ten views of the king's properties in Yorkshire and

Scotland. The finished pictures were to represent one of the earliest, if not the first, examples of house portraiture in English art and set a precedent for an entire genre that came into its own in the eighteenth century.

But to an extent the pictures are also harbingers of the English Civil War since the king's unnecessary battles with Scotland were to play a decisive role in the conflict to come. Charles was a native Scot, having been born in Dunfermline Palace. Soon after his coronation as King of Scotland in 1633, he had determined to reform the Presbyterian Scottish Church by imposing the *Book of Common Prayer* and bringing its services into line with those south of the border. On 23 July 1637, at the first reading of the prayer book in Saint Giles' Cathedral in Edinburgh, the congregation rioted, drowning out the minister with screams of 'the Mass is entered among us'.

Diplomatic attempts to calm the situation floundered and in February 1639 the Scots drew

▼ *Pontefract Castle, c.1620–40* ▶ Helmsley Castle, England.

up the National Covenant, reaffirming the supremacy of the Church of Scotland and the right to self-rule. Charles assembled an army of 28,000 men and, with Thomas Howard, Earl of Arundel at his side, marched north with the aim of quelling the rebellion by a show of force and expecting a fairly easy victory. Accompanying Arundel to document the army's supposedly triumphal progress was Wenceslaus Hollar, a Bohemian artist in service to the earl, who produced several studies of his master on horseback. It's probable that Keirincx travelled in the same retinue, or followed shortly afterward, and that his paintings were similarly intended to serve as the visual equivalent of victory laps.

As events turned out, the king's army was to meet the Scots at Berwick, on the borders of Northumberland, in May and it soon became

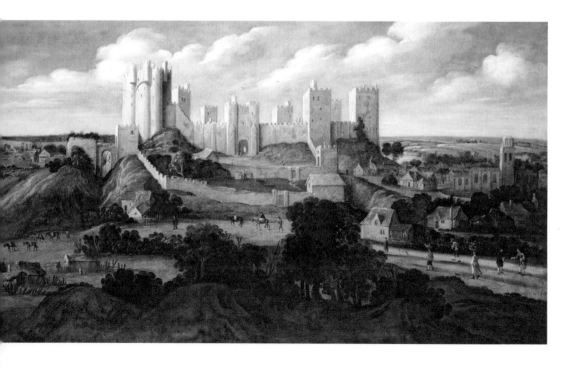

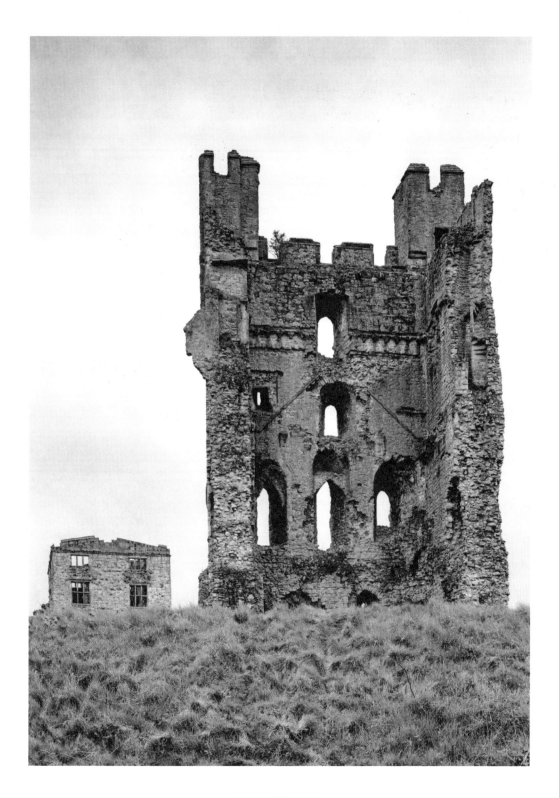

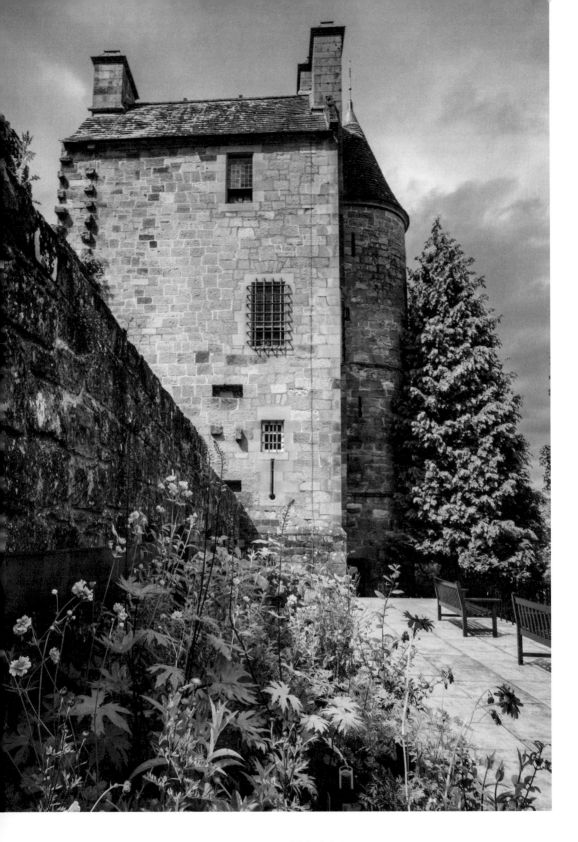

painfully obvious that they were vastly outmanned. In June, a treaty was negotiated without blood being spilled, and both armies were disbanded. Happily for Keirincx's commission, Charles was granted the restitution of his castles in Scotland.

By the end of 1639, Keirincx had completed the first four of his views, all sites in Yorkshire, one unknown but the three others readily identified as York, Richmond and Helmsley. York Castle, pointedly, was where Charles had rallied his troops that March to begin their assault on the Scots. Richmond was an august royal fortification in Yorkshire and Helmsley, if not strictly one of the king's castles, had belonged to the late Villiers. Of the other six views finished by mid-1640, and all presumed to be of Scottish fortresses, only two pictures have survived, and they are of *Falkland Palace and the Howe of Fife* and *Seton Palace and the Forth Estuary*.

At the outset of this career, Keirincx had often worked from existing studies or based pictures on mythological or biblical schemas. But his pictures for Charles, shaped by the turn toward greater

veracity in Dutch landscape painting, set new standards in realism. In the case of his Seton Palace picture, scholars have been able to pinpoint the precise location near Riggonhead from which the painter must have made his preliminary sketches. As such these pictures, with their then still novel combination of aesthetic grace and topographical accuracy, stand as invaluable and unsurpassed records of these places at that time.

All ten views were first hung at the 24-metre/ 80-foot long gallery at Oatlands Palace, the Royal residence near Weybridge in Surrey, which had been granted to Charles's Catholic wife, Henrietta Maria, as a country retreat upon their marriage. Keirincx was to return to Amsterdam in 1641, just a year before the outbreak of the English Civil War. Following Charles I execution, the king's vast art collection was sold off to settle royal debts and its contents scattered across Europe. While many royal pictures were reacquired by his son Charles II following the restoration of the English monarch in 1660, the fate of those four lost views by Keirincx remains unknown.

◀ Falkland Palace, Scotland.

Paul Klee Is Transformed by Tunisia

At the beginning of April 1914, shortly before the outbreak of the First World War, thirty-five-year-old Paul Klee (1879–1940) paid a visit to Tunisia. If his time in the country was to be comparatively brief – just twelve days – the experience was, in the opinion of the art historian Sabine Rewald, the turning point in the artist's life and career.

His journey is a perfect example of what in the German tradition is termed a *Bildungsreise*, essentially a voyage of personal growth and discovery. The Klee who came back from Tunisia was a different man from the one who first arrived, an artist so enriched by what he'd encountered there that he'd never be quite the same again.

Born in Münchenbuchsee, near Berne in Switzerland, Klee was the second child of a German music teacher and a Swiss singer. After studying at the Academy of Fine Arts in Munich, he had followed the path of many artists seeking to continue their education and undertaken a lengthy tour of Italy, where he was stirred by the light and colours of Rome, Naples and the Amalfi coast. A stint in Paris in the opening decade of the new century, at a time when the city was the crucible of Cubism and full of fresh theories about the possibilities of art, was no less educational. Not long after that, back in Munich, he came to know Wassily Kandinsky, the Russian co-founder of Der Blaue Reiter (The Blue Rider), a loose association of like-minded avant garde artists, including the German painter August Macke, at

the forefront of what became known as Expressionism. Kandinsky would become Klee's great mentor. That the older artist had visited Tunisia for two months in 1904 was something of a spur to his own trip a decade later.

Macke was to join Klee on the Tunisian adventure, which came about after a mutual friend, the aristocratic Swiss painter Louis Moilliet received an invitation from Dr Ernst Jaggi, a severely asthmatic physician from Berne who'd moved to Tunis with his family for health reasons, to come and visit him there. All three were fired by the artistic possibilities of the place.

After depositing his son, Felix, with his parents in Berne on 5 April 1914, Klee embarked on the first stage of the journey, taking a train to Marseilles via Geneva and Lyon, where the train stopped long enough for the artist to venture out into the city and eat lunch in a restaurant specializing in fish dishes from the Rhône. The following morning he was in Marseilles and at noon, reunited with Macke and Moilliet, he boarded the *Carthage*, 'a fine, big vessel' operated by the Compagnie Générale Transatlantique. Klee was satisfied with its 'pleasant, clean cabins', which he noted were also helpfully equipped with 'little receptacles for vomiting'.

Klee and co. were to awake on the morning of 7 April 1914 with Sardinia in sight and a few hours later they caught their first glimpse of the African continent. In his diary, Klee provides a rapturous account of their arrival, writing that:

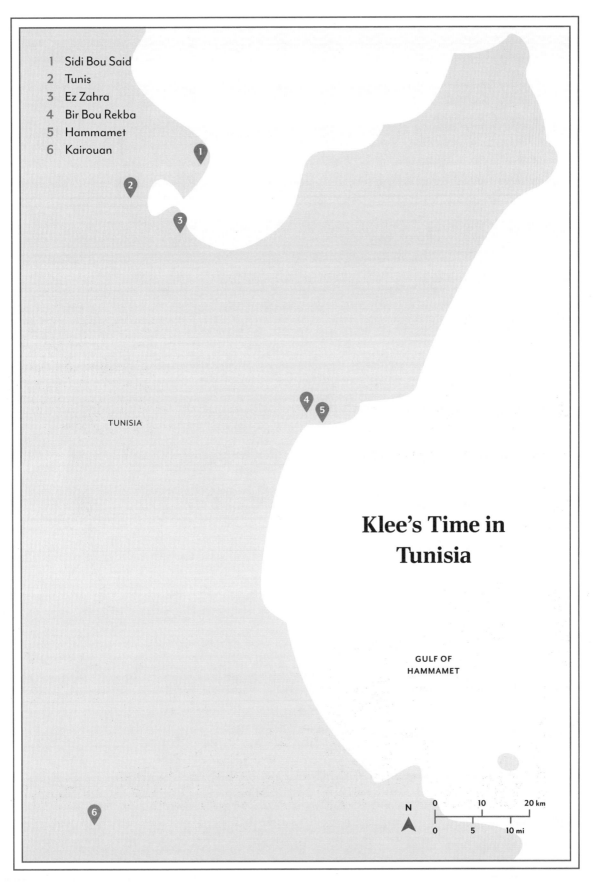

1 Sidi Bou Said
2 Tunis
3 Ez Zahra
4 Bir Bou Rekba
5 Hammamet
6 Kairouan

TUNISIA

Klee's Time in
Tunisia

GULF OF
HAMMAMET

N

0 10 20 km

0 5 10 mi

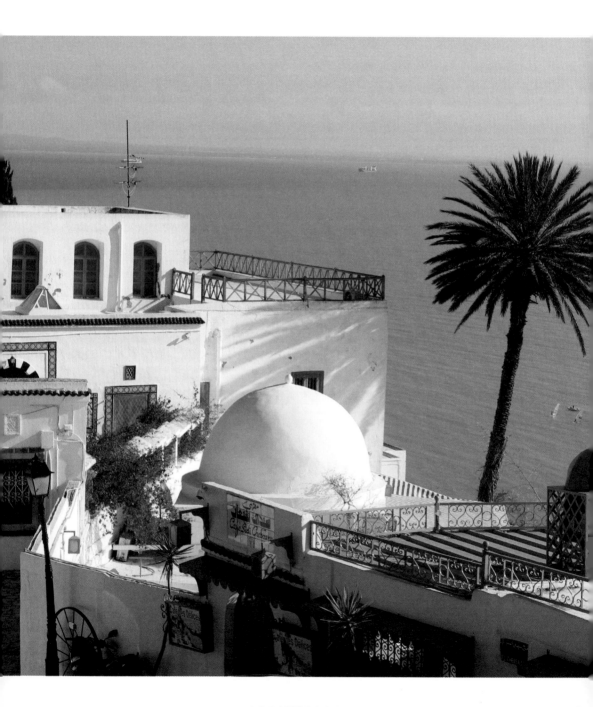

In the afternoon the coast of Africa appeared. Later on, the first Arab town was clearly discernible, Sidi-Bou-Said, a mountain ridge with the shapes of houses growing out of it in strictly rhythmical forms. A fairy tale turned real ... Our proud steamer left the open sea. The harbour and city of Tunis were behind us, slightly hidden. First, we passed down a long canal. On shore, very close, our first Arabs. The sun had a dark power. The colourful clarity on shore full of promise. Macke too feels it. We both know we shall work well here. The docking in the modest, sombre harbour very impressive ... though the ship was still moving, incredible characters climbed aboard up rope ladders. Below, our host Dr Jaggi, his wife and his little daughter. And his automobile.

Klee and Moilliet were to spend the first night in Tunisia as guests of the Jaggis in their Paris-style apartment at 7 rue de Sparte in the European section of the city. Macke, meanwhile, had a room at the Grand Hôtel de France. But all three were to be fed and watered by Dr Jaggi, who was to play the role of generous host (the abundance of his meals commented on by Klee), tour guide and taxi driver throughout much of their time in Tunisia. That evening he treated them to a nocturnal tour of the Arab quarter.

◀ Sidi Bou Said, Tunisia.

The following morning, his head overflowing with impressions of the previous night's ramble, Klee wasted no time and immediately went off into the city with his watercolours to begin painting, and there would be little by way of let up from now on. Remarkably, he would, nevertheless, be outgunned almost two to one in the numbers of pictures he produced here by Macke. The German artist, by his own estimation, had completed seventy-five sketches within three days of arriving and wrote to his wife to tell her he was experiencing a joy in his work not known before.

If Macke was more prolific and also created such masterpieces of modernism as *Tunisian Landscape*, Klee was to evolve much more as an artist. Tunisia was to set Klee on the path toward full-blown abstraction as he wrestled with ways to find something objective to cling on to amid the sensory overload of its street life and the vibrancy of its buildings and scenery. *Street Café in Tunis* presents an exuberant tangle of chairs, tables and stick figures; *In Front of a Mosque in Tunis*, which depicts the Saheb Ettabaâ Mosque, was painted in Halfaouine Square; and *Red and Yellow Houses*

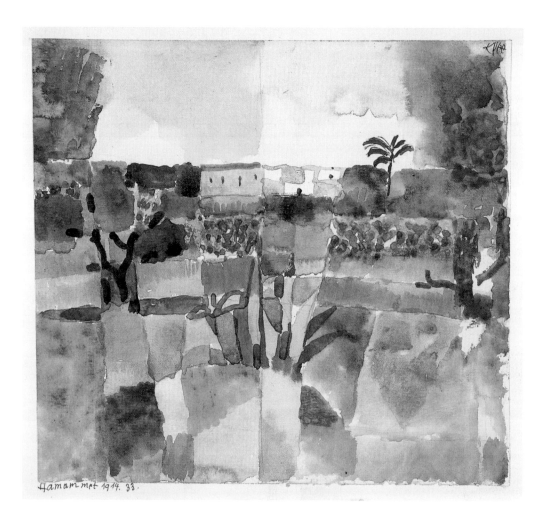

Hamamet 1914. 33.

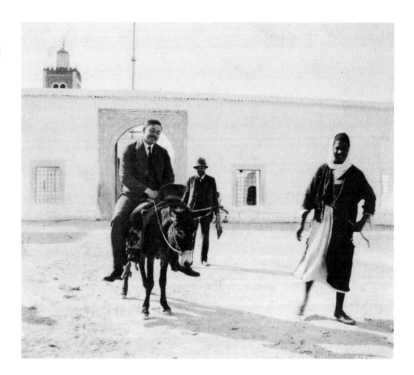

▶ August Macke (left) and
Paul Klee (centre) in front of
a mosque in Tunisia, 1914.

◀ *Hammamet*, 1914.

in Tunis was executed in the Medina in one of the many similar small, dusty squares leavened by a few trees. With these he successfully conveyed the city's cosmopolitanism in minimal brush strokes rather than resorting to tired tropes of Eastern exoticism.

On 10 April 1914, Good Friday that year, the doctor drove the artists through the countryside, in intense heat, to his estate in what was then known as Saint-Germain and today is Ez Zahra. From the balcony of Jaggi's coastal retreat Klee was to complete at least ten watercolours, among them *Bathing Beach of St Germain near Tunis*. He enjoyed going swimming and decorated Easter eggs for the children and painted two figures on the plaster wall of the house's dining room. The curious planting of Jaggi's garden, with its mix of green, yellow and terracotta colouring, caught Klee's eye and duly resulted in the pictures *Dune Flora* and *Garden in St Germain, the European Quarters near Tunis*.

A few days later, and after returning to Tunis, they drove to Sidi Bou Said, the town they'd first spied from the ship and where Klee paused to make a watercolour sketch of the view of the sea from the garden gate, before moving on from there to explore the Roman ruins of Carthage, whose mountainous location Klee deemed more beautiful than Tunis.

Hammamet, which they reached by train, was the destination of their next excursion, with Klee observing a dromedary working the cistern in a field as they approached the station. The city, 'right by the sea, full of bends and sharp corners', its superb gardens lined by walls of cacti, and its streets enlivened by the performances of snake charmers and tambourine players, was magnificent, the artist concluded.

After Hammamet, Klee and his companions walked to the railroad station at Bir Bou Rekba and took another train to Kairouan. It was here that Klee was to paint one of his most renowned

Tunisian pictures, *Red and White Domes*, one of several he made to feature views of the five cupolas of the Sidi Amor Abbada, known as the Mosque of the Sabres.

There were to be further visits to the Jaggi's Saint-Germain garden and a dutiful trip to the museum in Tunis, which, perhaps slightly to Klee's annoyance, seemed to be overloaded with Roman art from Carthage. But on 19 April, the artist clambered on to a 'mediocre ship', the *Capitaine Pereire*, with a third-class ticket for Palermo. His companions were to linger in Tunis for some days. But Klee confessed to feeling restless and overloaded. The 'big hunt', as he wrote in his diary, 'was over'. Now he had to 'unravel'.

Once back in Munich on 25 April, and after making his way by steamer to Naples and then by train from Rome to Berne, he worked intensely on pieces produced in Tunisia. On 15 May, Klee was ready to debut two of his Tunisian-themed watercolours at the first Black and White Exhibition at the 'New Art' gallery of Hans Goltz. And just two weeks later, eight of his Tunisian watercolours were to appear in the first exhibition at the New Munich Secession.

Klee would continue to draw explicitly on his Tunisian trip until 1923, but its influence would last a lifetime. For Macke their journey was probably no less profound. But, sadly, having been called up to serve in the German infantry, and being awarded the Iron Cross for valour six days after, he was killed in battle near Perthes-lès-Hurlus in France on 26 September 1914.

▶ Tunis.

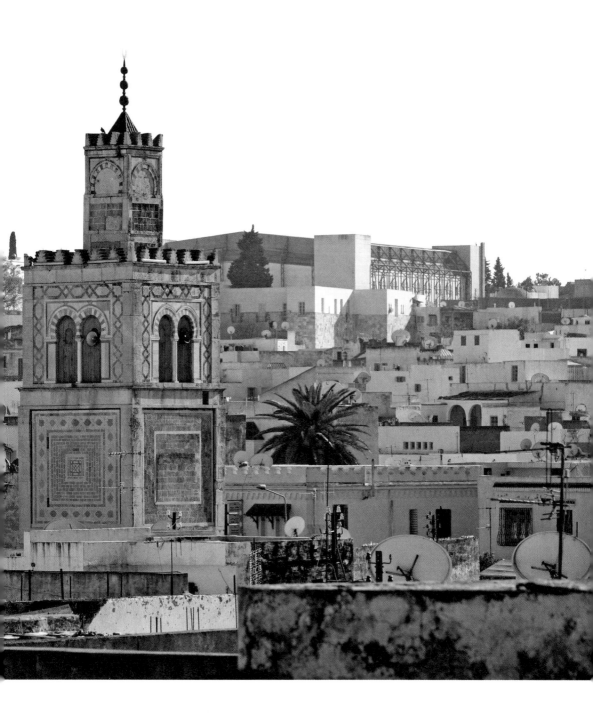

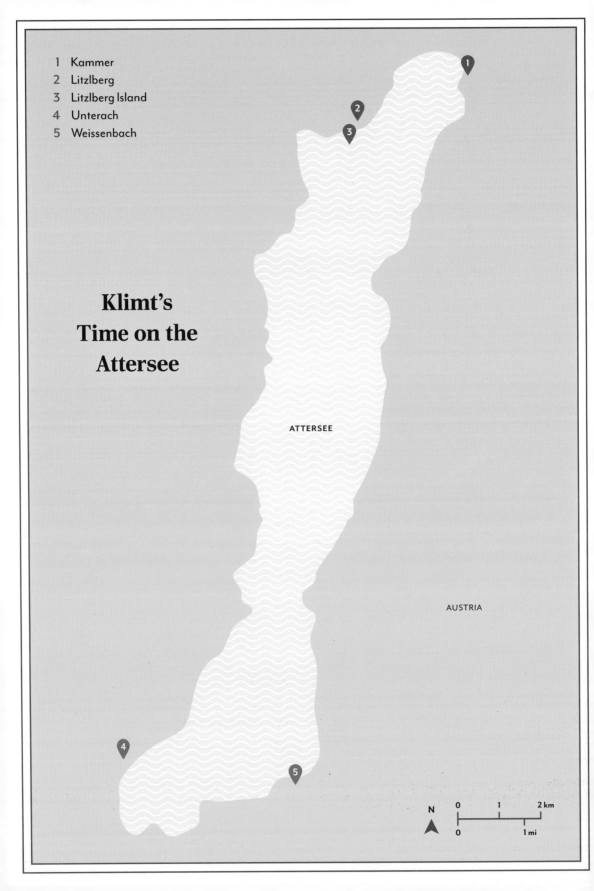

1 Kammer
2 Litzlberg
3 Litzlberg Island
4 Unterach
5 Weissenbach

Klimt's
Time on the
Attersee

ATTERSEE

AUSTRIA

N

0 1 2 km

0 1 mi

Gustav Klimt Gets Scenic on the Attersee

T he Viennese painter Gustav Klimt (1862–1918) wasn't much of a traveller. Never especially comfortable venturing much beyond the Germanic world, outside Austria he limited himself mostly to Berlin and Munich. He was thirty-five before he made his first trip to Italy. But that excursion to Florence in 1897 was not a success, and six years would pass before he could be persuaded to visit again. On his next trip to Italy he travelled to Ravenna, taking in Venice, Padua and Florence again, and somewhat more happily. He ventured back once more in 1913, this time staying in Malcesine on Lake Garda, where he painted some views of the lake – among the only landscape paintings he produced that were not of his homeland.

Belgium was also graced by Klimt's presence, on multiple occasions, but only because he needed to be in Brussels to oversee work on the ornate interior decorations he had devised for the Palais Stoclet, the luxurious mansion built in the Vienna Secession style (Austria's answer to Art Nouveau) by Josef Hoffmann and the craftsmen of the Wiener Werkstätte (Vienna Workshop) for the Belgian industrialist and coal magnate Adolphe Stoclet. Klimt made his sole visit to London directly from Brussels in 1906, primarily to see the Imperial Royal Austrian Exhibition in Earl's Court. Though he judged the quality of London's air unhealthy, at least that city fared better in his estimation than Paris, which he reached three years later and loathed. In one postcard home from the French capital he complained that there was 'a terrible lot of painting going on'.

Ultimately, Klimt was happiest at home. The only place he ever yearned to travel to was the Salzkammergut, the upper Austrian region of alpine mountains and lakes that since the arrival of the railways in the 1860s and 1870s had become a popular summering resort (*Sommerfrische* in German) for the Viennese gentry and bourgeois. Just like Baden-Baden in Germany and Bath in England, the area's rich mineral deposits and its saline-laced waters were held to have medicinal qualities. This had led to the development of various health spas, which from the opening decades of the nineteenth century began to be frequented by the Austro-Hungarian nobility. It was from his imperial summer palace in Bad Ischl, the idyllic lake resort at the centre of Salzkammergut, that in July 1914 the Austro-Hungarian Emperor Franz Joseph I was to issue both the ultimatum to Serbia and the subsequent declaration that fired the starting pistol on the First World War.

Before his death in 1916, the emperor clocked up over sixty summers at Bad Ischl; Franz's loyalty to it perhaps enhanced by the belief that his mother, Archduchess Sophie, had only become capable of producing an heir after taking its waters as a cure for her infertility in the 1830s. Although of no less regular habits, Klimt, who paid his final visit to the region in the last year of the emperor's life, was never to match quite such a tally. Both men, however, were to note the

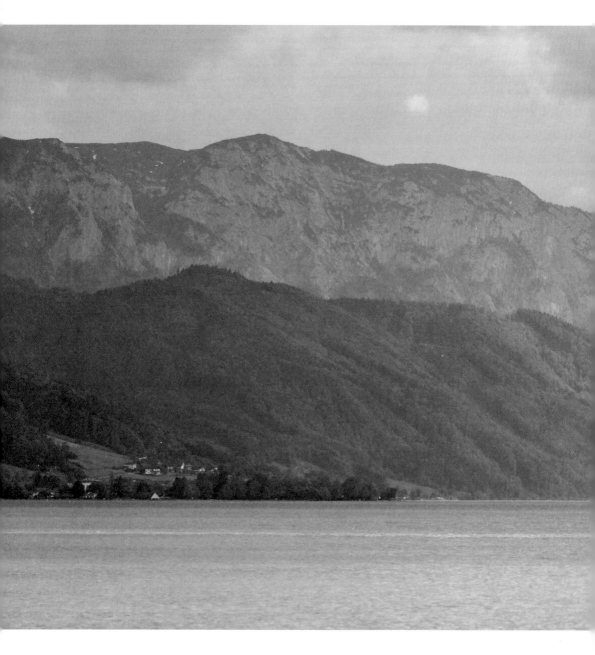

▲ Attersee, Austria.

unpredictability of the Salzkammergut's weather, which the emperor tracked daily with the barometers he'd had installed in nearly all of the state rooms at the imperial villa in Bad Ischl.

Klimt was once memorably described by Hélène Nostitz as an artist who, despite looking like a robust peasant, possessed an ability to depict 'women like costly orchids lost in dreams of ecstatic rapture'. Women were to be the subject of the majority of Kilmt's portraits and richly allegorical paintings, and it was these pictures that made him one of the most celebrated and controversial artists in *fin-de-siècle* Vienna, their explicit sexuality and the frankness of some of his female nudes being deemed scandalously obscene by some. When it came to landscapes, though, Klimt was a late starter. His earliest dates from 1897 and he only began to paint them in earnest after spending his first extended vacation in the Salzkammergut. From then on he used summer holidays to take a break from his regular style of painting and devoted himself entirely to landscapes during those precious weeks away.

This annual pattern was set in motion when Klimt decided to join the Flöge family on their *Sommerfrische* in Fieberbrunn in Austria's Tyrol in 1897. Klimt's elder brother Ernst had been married to Helene Flöge. After Ernst's premature death, Klimt formally became the guardian to his niece, also called Helene, and Ernst's sister-in-law Emilie was to become Klimt's muse and soul mate. Although it's possible their relationship was never consummated, the couple often were assumed to be man and wife. Some continue to believe that the couple embracing in Klimt's most famous painting, *The Kiss* (or *The Lovers*) are Klimt and Emilie. Klimt, in any case, continued to have numerous affairs with his models and he fathered several illegitimate children, among them a son named after him with his on-off mistress Maria 'Mizzi' Zimmerman.

It was in August 1898 that Klimt paid his first summer visit to the Salzkammergut, when he again joined the Flöges who this time had taken lodging in Saint Agatha on Lake Hallstatt near Bad Goisern. While there he painted *After the Rain* in the orchard of the Agathawirt (Agatha Inn). The next year, the family opted for Golling an der Salzach, south of Salzburg, a Salzkammergut watering place acclaimed for its picturesque waterfall and a spa that specialized in treating the sufferers of gout. Klimt evidently found the surroundings conducive to art as at least three more landscapes, principally *A Morning by the Pond*, *Orchard in the Evening* and *Cows in Stall*, resulted from this sojourn.

It was in 1900, though, that the Flöges and Klimt became near-permanent visitors to

Attersee, the largest of Salzkammergut's lakes. For the next seven summers their home from home was a guest house that was part of a brewery-cum-hostelry in Litzlberg near Seewalchen. Between 1908 and 1912, they resided in the Villa Oleander in Kammerl near Kammer and between 1914 and 1916 the Flöges lived in Villa Brauner in Weissenbach, while Klimt opted for the seclusion of a forester's cottage at the entrance to the valley, which he also painted.

In 1903, in response to a letter from Mizzi (who as ever had been left in Vienna for the summer)

▼ Unterach, Austria.

▶ Gustav Klimt with Therese Flöge and her daughter Gertrude, Seewalchen am Attersee, Austria, 1912.

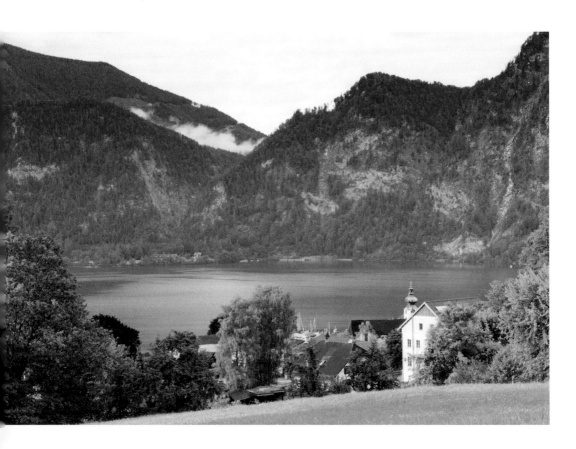

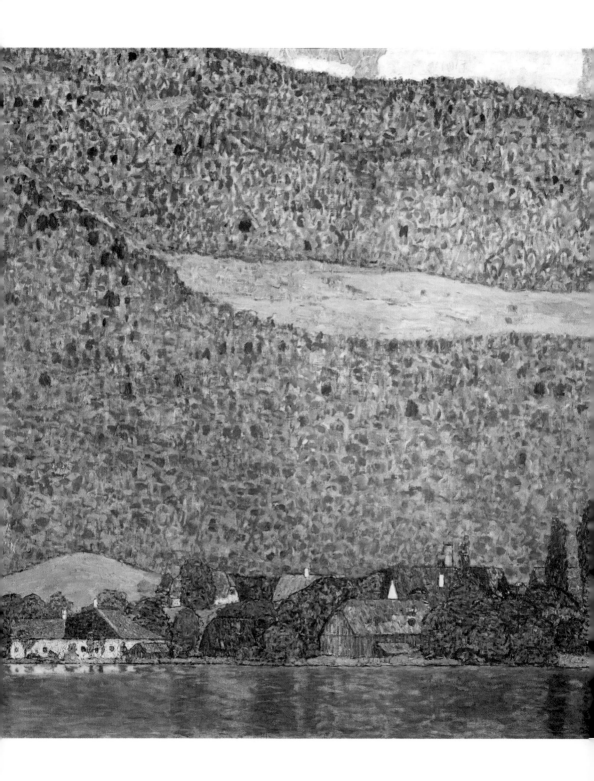

demanding to know what on earth he did all day in Attersee, Klimt supplied an almost hour by hour account of his activities, which appear to have run like clockwork. He got up, the artist was to write:

... mostly about six o'clock, sometimes a little earlier ... If the weather is good I go into the forest nearby – I'm painting a little beechwood there (in sunlight) with a few conifers among the beeches, and that lasts until eight o'clock. Then it's time for breakfast, after that swimming in the sea, undertaken with due care – after that a little painting again, if the sun is shining, a view of the lake, if the weather's overcast, a landscape from the window of my room – sometimes I don't paint at all in the morning, instead I look at my Japanese books – in the open air. So midday arrives, after the meal comes a nap or some reading until coffee time – before or afterwards some more swimming in the lake, not always but most often. After coffee it's painting again – a large poplar at dusk as a storm is coming on. Now and again instead of this evening painting I take part in a game of skittles in a village nearby – but that's seldom – dusk falls, dinner, then early to bed and next morning I get up early again. Now and again a little rowing intervenes this regular timetable in order to tone up the muscles a little ... The weather is very irregular here – not hot at all and often interrupted by rain – with my work I'm prepared for every eventuality and that's very nice.

Klimt's habit of wandering alone about the forest with his painting materials earned him the nickname *Waldschrat* (Forest Demon) from the locals. Wet canvases might be stowed in the bushes to dry overnight and fished out the following morning. For his landscapes he liked to paint *en plein air* and sometimes rowed out onto the lake with his easel and oils. Emilie occasionally accompanied him on these boating excursions. Klimt often used a cardboard viewfinder to seek out motifs in the scenery to paint. Litzlberg Island, one of the small uninhabited islands in the lake that they rowed to for al fresco picnics, would supply the motif for the paintings *Attersee I* and *The Island in the Attersee*, having been scanned from offshore in this manner.

If many pictures were finished in the field, some were completed back in his studio in Vienna. In sharp contrast to his Viennese output, people are entirely absent from his landscapes and animals are only rarely included. However, he painted local landmarks several times, including Schloss Kammer, a castle that dominated the view from the Villa Oleander. The village of Unterrach with its white church, which he surveyed from the opposite shore at Weissenbach, was another subject he returned to. Tranquil ponds, meadows, orchards, birch trees and forests were other recurring tropes that he showed bathed in summer light.

The symbolic association of water with the feminine, it has been suggested, is a connecting point between Klimt's almost entirely lakeland and largely Arcadian landscapes (almost all of which of are of Attersee and its environs) and his Viennese output. During his lifetime, Klimt continued to exhibit his landscape pictures but they were never to attract the same critical attention as his portraits and gold-leaf-adorned tableaux. Yet they remain some of the most beautiful and stimulating of his works, and for nearly twenty years they – and his summers by the lakes – were of equal importance to Klimt himself, without which he might not have painted some of his better-known pieces.

◀ *Unterach on Lake Attersee,*
 1915.

Oskar Kokoschka Takes Refuge in Polperro

An historic fishing port shaped over the centuries by the violent storms that have done their best to wipe it from the map, Polperro in south-east Cornwall, with its narrow hilly streets of old fishermen's cottages, picturesque harbour, dramatic cliffs and rocky shoreline, is one of Cornwall's most delightful coastal villages. A tourist hot spot since the 1960s, when holiday-makers started to supplant fishing as its major industry when the shoals of pilchards that once sustained its fleets went into sharp decline, one of its most endearing and enduring attractions is a museum dedicated to the history of smuggling, which flourished in its coves in the eighteenth century. Before mass tourism in the latter half of the twentieth century, however, among the chief visitors to Polperro were artists inspired to paint and draw the local scenery and its hardy inhabitants, rather romanticized portraits and caricatures of salty maritime folk at their nets being something of a popular subject in the Victorian era and beyond.

While still less synonymous with painters and sculptors than Newlyn or St Ives (the historian David Tovey entitled his boosterish survey of its artistic heritage *Cornwall's Forgotten Art Centre*), Polperro can, nevertheless, claim one of the giants of European Expressionism as a one-time resident. The Austrian artist, poet, playwright and political activist Oskar Kokoschka (1886–1980) and his partner and soon-to-be wife Oldřiška 'Olda' Palkovská came to Polperro in August 1939, just weeks before the outbreak of the Second World War.

Born in Pöchlarn in what was then Austro-Hungary, Kokoschka, who counted Alma Mahler, the widow of the composer Gustav Mahler, as a former lover, had moved to Prague from Vienna in 1934 after his art was denounced as degenerate by the Nazis. Crucially for what was to follow, he obtained Czech citizenship in the next year. On 30 September 1938, Adolf Hitler signed the Munich Pact, which effectively gave him free rein to annex the Sudetenland, the part of Czechoslovakia where three million ethnic Germans lived. With little disincentive for Hitler not to go whole-hog and seize the rest of the country, Oskar and Olda fled Prague, flying to London via Rotterdam on 18 October. Kokoschka carried the unfinished painting *Zrání* on the plane with him.

To start with they were put up at 11a Belsize Avenue, a boarding house in Belsize Park, before a flat at 45a King Henry's Road in Hampstead was found for them by sympathetic supporters in London. Kenneth Clark and John Rothenstein, the directors, respectively, of the National Gallery and the Tate, were among those who eased Kokoschka's anxieties by offering to help with commissions, exhibitions and teaching work.

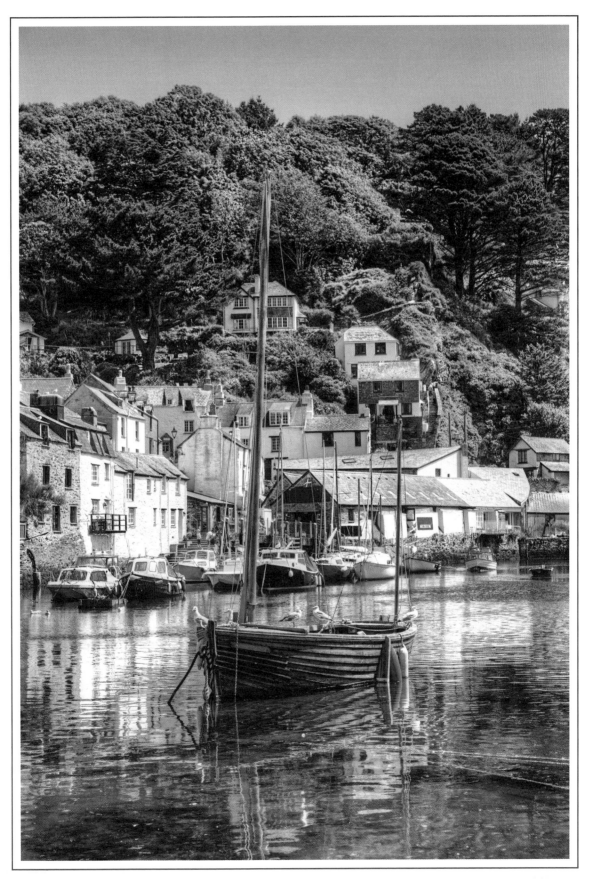

Kokoschka also made contact with the Artists' Refugee Committee, who were based at 47 Downshire Hill in Hampstead, and threw himself into campaigning with other anti-Nazi, refugee and left-leaning political organizations. During this time in London, he painted, from memory, *Prague, Nostalgia*, a melancholy picture evoking his final impressions of the Czech capital.

By the summer, he and Olda were tiring of the expense of London. Seeking to change gear after such a frenetic few months, they retreated to Polperro, where their friends the German sculptor Uli Nimptsch and his Jewish wife, Ruth, had recently settled. Moving into Cliff End Cottage, whose terrace presented the painter with a magnificent view of the village below, on 28 August 1939, Kokoschka was to describe his new home as a 'beautiful, healthy place ... much lovelier than a cosy Italian port because so much more real'.

In the nine months he was to remain in Polperro, the artist completed three major paintings registering the tensions of the war: the landscapes *Polperro I* and *Polperro II*, unsettling views of boats in the harbour menaced by reptilian seagulls, and the powerful political allegorical study *The Crab*. During that time he also produced *Private Property*, an impassioned critique of capitalism, since lost, as well as numerous watercolours. Although watercolour was a medium he had not used since the 1920s, he embraced it again out of expediency once wartime restrictions rendered painting freely out of doors impossible without official permits.

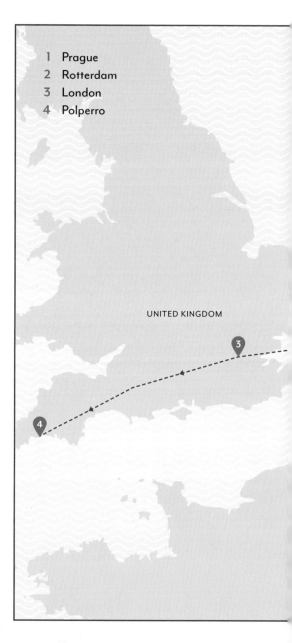

1 Prague
2 Rotterdam
3 London
4 Polperro

UNITED KINGDOM

Kokoschka's Flight into Exile

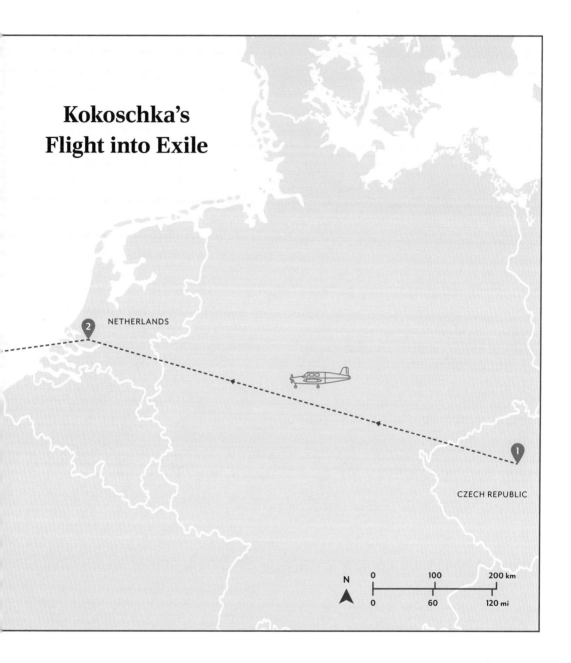

NETHERLANDS

CZECH REPUBLIC

N

0 100 200 km

0 60 120 mi

◀ PREVIOUS PAGE Polperro, England.

In June 1940, after the debacle of the evacuation of Dunkirk and with German forces having occupied Paris, foreigners were banned from living in strategically important southern regions of England. Polperro was just 24 kilometres/15 miles west of the naval base at Plymouth and so Kokoschka had no option but to return to London. By that time, both he and Olda had begun to feel less welcome in the village in any case. Their neighbours, it seems, viewed them with increasingly paranoid suspicion as the war progressed and had come to believe that they were Nazi spies and that all Oskar's sketching expeditions were cover for covert mapping of coastal defences. Nevertheless, as Czech citizens they were fortunate to be classified as 'friendly aliens' and thereby avoided internment. Nimptsch, as a German, was less fortunate; he was deemed an 'enemy alien' and despatched to an internment camp, albeit briefly.

On 15 May 1941, Oskar and Olda were married in an air-raid shelter that then served as the temporary registry office in Hampstead, with Nimptsch and Ruth acting as witnesses. Kokoschka was to take British citizenship in 1947 and in the 1950s he and Olga emigrated to Switzerland, where the painter remained until his death in 1980.

◀ *Polperro I*, 1939–40.

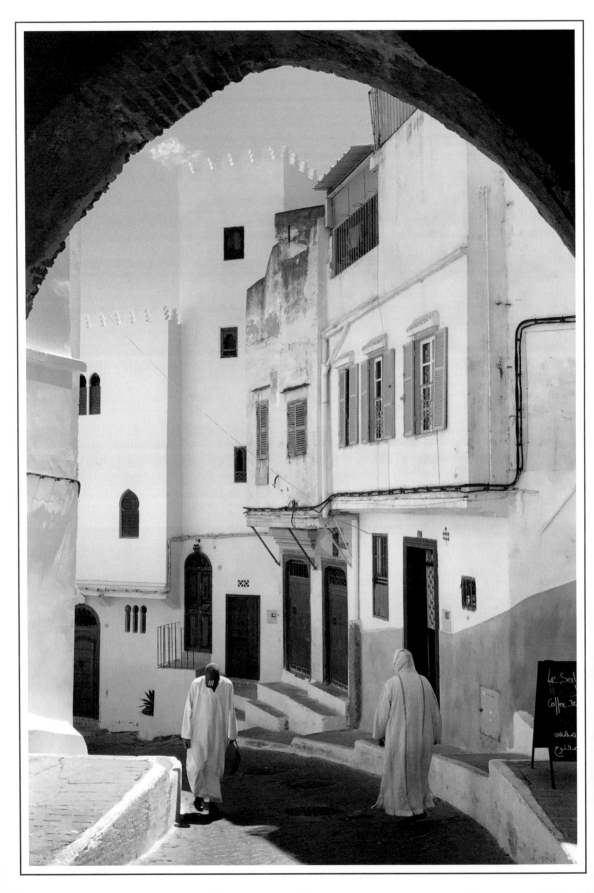

Henri Matisse Fends Off the Rain in Morocco

'Shall we ever see the sun in Morocco?', Henri Matisse (1869–1954) wrote, in dismay, to the American novelist Gertrude Stein, about a week after arriving in Tangier on 29 January 1912. The leading light of Fauvism (the French avant garde art movement that embraced intensive colour palettes and spontaneous bold brushwork in a break with the naturalism of the Impressionists), Matisse had sailed with his wife, Amélie, from Marseilles aboard the SS *Ridjani*. The couple had been lulled into a false sense of security having encountered only good weather on their sixty-hour passage down the Balearic Sea coast and through the Strait of Gibraltar to the mouth of the Atlantic. Matisse recorded that they'd eaten and slept well and that the ship had glided along without rocking or pitching and that the sea, if rough on occasion, was the purest blue and only harmless-looking clouds bruised an otherwise clear sky. But no sooner had they docked in Tangier than they met torrents of rain, and the downpour was not to let up for days.

For an artist whose primary purpose in coming to Morocco had been to sketch and paint outdoors in what he assumed would be days illuminated by brilliant African sunlight, this was a big problem. Matisse instead found himself virtually confined to his hotel bedroom. On the upside, the Matisses were booked into the Hôtel Villa de France, then the best hotel in town, and their suite, Room 35, came with an expansive view of Tangier, with the Grand Socco (the great market), the Anglican church of Saint Andrew, the Casbah, the Medina (the oldest quarter of the city) and the Bay of Tangier with its beaches all laid out before them. That view and the vases of flowers in their room proved about the only consolation as the days slipped into weeks with little improvement in the weather. Unable to venture abroad and in the spirit of necessity being the mother of invention, on 6 February, Matisse began work on *Vase of Irises*, a cheery still life of a bouquet of blue irises on the hotel dressing table, and the first picture to be completed in Morocco.

On 12 February, the skies appeared to have brightened and Matisse was able to report 'the first relatively beautiful and pleasant day'. Nevertheless on 28 February he was still complaining about the variability of conditions and clouds and fogs hindering his progress out of doors and that many sessions were required on the same picture. But the rain was to leave Tangier as lush as Normandy in Matisse's view. While the light he judged was 'mellow ... not at all like the Côte d'Azur'. Both qualities were to shape the painter's responses to Morocco and the art he produced following what would turn into two sojourns in the country in 1912–13, or 'one voyage

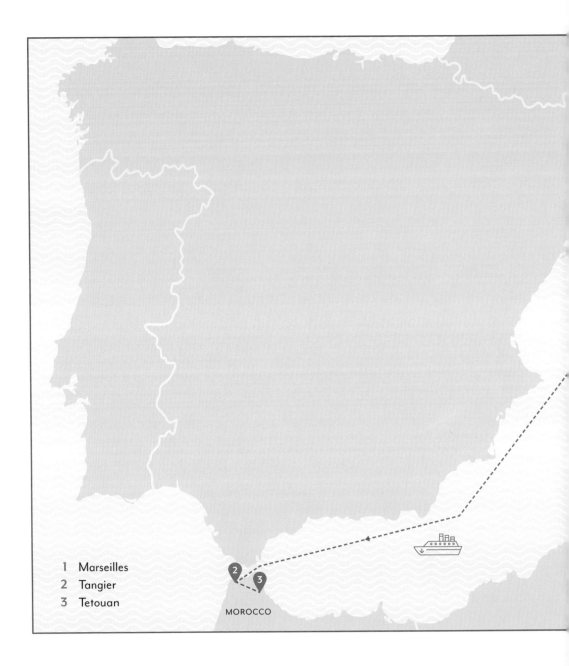

1 Marseilles
2 Tangier
3 Tetouan

MOROCCO

◀ PREVIOUS PAGE Tangier,
Morocco.

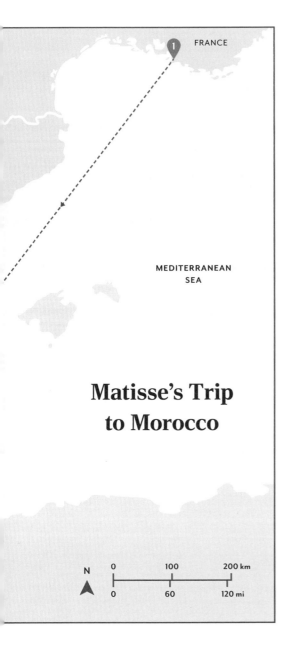

FRANCE

MEDITERRANEAN
SEA

Matisse's Trip to Morocco

N

0 100 200 km

0 60 120 mi

interrupted by a parenthesis of five months in France', as the art historian Pierre Schneider believes is a more accurate description of these two trips. His first impressions of Morocco continued to bleed into the paintings he produced during his second spell in Tangier, when far from a surfeit of rain, the city was in the midst of a drought that threatened disaster for the sowing season. Though Matisse confessed, if slightly guiltily, to being 'at heart glad' because the weather was ideal for his work.

Matisse once described himself as a sedentary traveller and also claimed that he was 'too hostile to the picturesque to have gotten much out of travelling'. Yet despite such protestations he travelled widely and in the previous year alone had visited Madrid, Córdoba and Seville in Spain and Saint Petersburg and Moscow, encountering examples of Moorish art, architecture and decoration in the former and the omnipresent influence of the Byzantine Empire and the Eastern Orthodox Church in the latter. The Morocco trip was not Matisse's first time in Africa either. He'd first stepped on the continent in 1906, when he'd visited Algeria, a French colony since 1830. Morocco was a far newer addition to Gallic imperial interests; it had only recently been turned into a French Protectorate with the signing of the Treaty of Fez in March 1912. Fez itself proved something of a flashpoint for dissent against French control and Matisse appears to have abandoned a planned excursion to Morocco's historic second city in April 1913, amid rumours of violent unrest and was to avoid it when he came back in the autumn too.

It was most likely the artist Albert Marquet, a friend of Matisse's, who first suggested he go to Morocco. Marquet had spent a fruitful couple of months in Tangier in the August and September of 1911 and had returned to France with a set of views he'd painted of the Casbah that evidently piqued Matisse's interest. The Fauvist, if genuinely interested in indigenous Islamic art, and especially its expression in decorative ceramics and the patterns of tiles, woven rugs and carpets, had a loathing of the orientalist exoticism peddled by Western painters in the nineteenth century. He therefore set out quite self-consciously not to succumb to it himself; an ambition that for the most part he achieved, while still responding with great enthusiasm to the local flora, the flamboyance of its inhabitants' traditional dress and the colour and character of the buildings with their blue tiles and minaret domes.

During his first stay in the city, and once the rain had finally abated, Matisse was able to explore its narrow streets, souks and mosques in the company of the Canadian artist James Morrice, an old friend from his student days in Paris, who by chance happened to be visiting Tangier at the same time. Amélie was to depart for home at the end of March 1912, shortly after the painter undertook an overnight jaunt, most probably by mule, to Tetouan, a famous Rif village to the south-east of Tangier. Matisse was to linger on until 14 April, spending time in the days before his own departure in the garden of the Villa Bronx, whose wisteria he deemed wonderful.

After rejoining Amélie at their home in the Parisian suburb of Issy-les-Moulineaux, the couple were to summer on the French Mediterranean. But Morocco continued to play on Matisse's mind and he was back in Tangier on 8 October 1912, having again sailed from Marseilles on another packet ship, the SS *Ophir*. This visit was originally intended to be fleeting and so he'd journeyed alone. But after a month in Morocco, he decided to extend his stay and sent for Amélie and invited another friend, the painter Charles Camoin, to travel with her and join him on painting excursions in the city. The pair arrived on 24 November 1912 and the Matisses were not to leave now until the following spring. Holed up again in the Hôtel Villa de France, Matisse dedicated himself to working daily, as well as riding or reading most mornings and bathing in the sea in the evenings.

By the end of this second, and in the end final, trip to Morocco, Matisse had amassed some twenty-three paintings and filled over eighteen sketchbooks with his impressions of the place. Tangier seemed to spur the painter toward triptychs, almost as if its landscape and flora and fauna were too much to take in with a single picture. Of the most well known are his topographical views *Window at Tangier, Zorah on the Terrace* and *Entrance to the Casbah*, usually referred to simply as the Moroccan Triptych. But portraits such as *Amido, Zorah Standing* and *Fatma, the Mulatto Woman* and the nature pictures *Acanthus, Periwinkles (Moroccan Garden)* and *The Palm* complement one another equally well.

Morocco would mark a fresh chapter in Matisse's creative thinking. In years to come he would credit these trips with renewing a closer contact with nature, and admitted that his time here helped him accomplish a necessary transition in his approach to painting. While he never went back, he also never forgot what he'd learned from its light and landscape and verdure.

▶ *Entrance to the Casbah*, 1912.

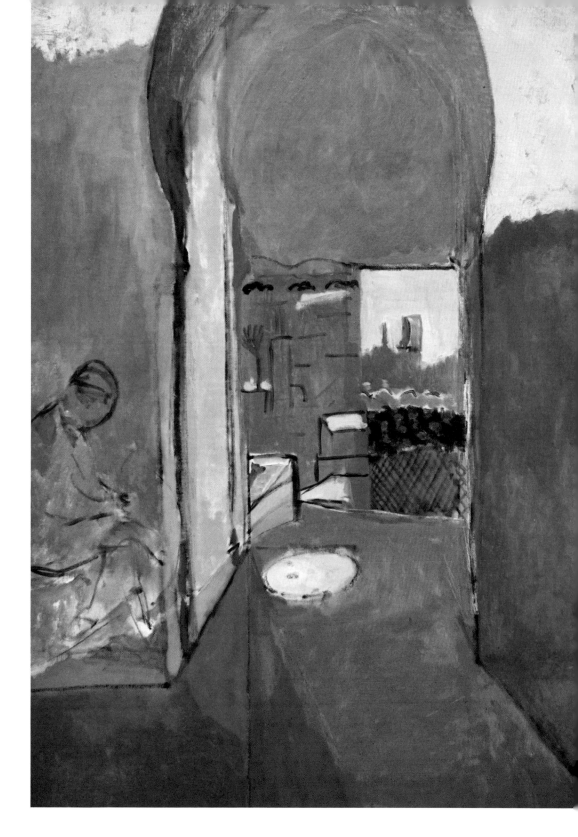

London Makes a Big Impression on Claude Monet

Of his first encounter with Claude Monet (1840–1926) in London in 1870, Paul Durand-Ruel, the art dealer who became the fiercest champion of the artist's work and also that of his friend and contemporary Camille Pissarro, recalled that Monet 'was a tough, strongly built man who looked to me as if he would go on painting for much longer than I myself expected to live'. All three men, along with many other French artists, not least the landscape painter Charles-François Daubigny, had been forced into reluctant exile in the English capital by the outbreak of the Franco-Prussian War in July 1870.

Monet had been honeymooning with his wife Camille and their two-year-old son Jean in Trouville, a seaside resort in Normandy, when war had been declared and seems not to have made any immediate plans to flee France. But by early September he was in Le Havre where he observed the unseemly scramble for boats intensifying and perhaps vowed to join the exodus, though he wasn't to reach London until late September or early October and possibly not even until November. The painter was, by all accounts, anxious to avoid being conscripted into the army. Though as the art historian John House has pointed out, Monet would have been exempt from the initial *levée en masse* (a French policy of conscription) as only unmarried men were required to enlist. Still, with the Prussian army reaching Paris on 19 September 1870, there were reasons enough for getting out of the country. News of the siege of

Paris was to spur his peer Pissarro's own departure from France that October and his subsequent exile to the south London suburb of Upper Norwood.

Rather more centrally located, Monet first London address was at 11 Arundel Street (now Coventry Street, off Shaftesbury Avenue) in the West End. But he eventually moved to Kensington, the family lodging in the house of a Mrs Theobald at 1 Bath Place, roughly where 183 Kensington High Street currently stands, the building itself long since torn down.

Monet was drawn to London's riverfront and its docks and bridges, and during this stay in the city he haunted the banks of the Thames painting *en plein air* and finished three studies, *Boats in the Pool of London*, *The Pool of London* and *The Thames below Westminster*. The latter presented a view of Westminster Bridge and the Houses of Parliament veiled in fog and was painted from the then-brand-new Victoria Embankment, Joseph Bazalgette's riverside road and walkway having only been completed in July 1870. In subject, style and execution it is an obvious forerunner to a number of pictures evoking the city's hazy shore and skyline he was to make when he returned to London in 1900, and again in 1901 and 1904. In the intervening thirty years, Monet had become one of the most fêted artists of the age and his wealth allowed him to stay, first class, in the Savoy Hotel on the Strand rather than in dingy digs. The London fog, nevertheless, remained the same and as enchanting to Monet as before.

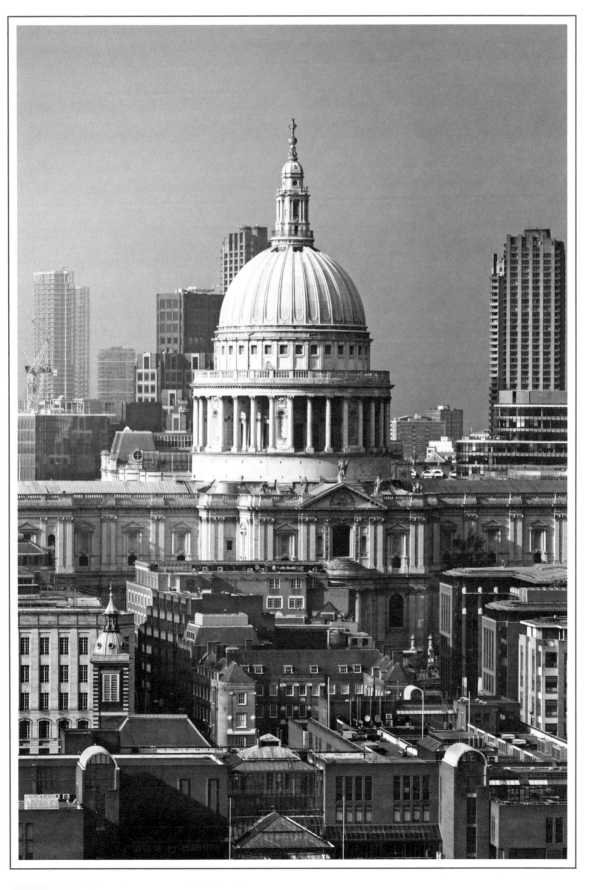

Asked in 1900 about his earlier visit, the artist recalled that it had been a miserable time, and yet for Monet and Pissarro this sojourn, if hard going for the artists and their families, sowed the seeds of their later successes. Both men visited the city's great museums and galleries almost daily, studying and sketching the watercolours and paintings of J.M.W. Turner and John Constable, as well as landscapes and portraits by Thomas Gainsborough and Joshua Reynolds, and increasing the breadth of their knowledge. There were also to be several important encounters with fellow French exiles, a couple of whom would go on to play vital roles in both men's future careers. It was, for instance, while heading down by the Thames one day that by sheer chance Monet happened to bump into Daubigny. A distinguished French landscape artist famed for his scenes of the Rivers Seine and Oise, which he painted while bobbing about on the water in a specially adapted boat, Daubigny had ventured to the Embankment for the same purpose as Monet: both artists met armed with their easels and paints.

Over twenty years older and a well-established figure in the art world at large, Daubigny had visited London twice before, making the acquaintance of the likes of James Abbott McNeill Whistler and Frederic Leighton. Leighton would consequently be among the artists, French and British, who contributed to an exhibition Daubigny organized that was mounted in Pall Mall in December 1870 for the benefit of 'the Distressed Peasantry of France ... ruined by the Prussian invasion of their country'. Monet was also invited by Daubigny to show a canvas completed on his honeymoon that he had brought over with him from France, *Breakwater at Trouville, Low Tide*.

After a stint at the Hôtel de L'Étoile at 16 Great Windmill Street (today part of the Lyric Theatre building), Daubigny lived on Lisle Street near Leicester Square. And it was in and around Soho,

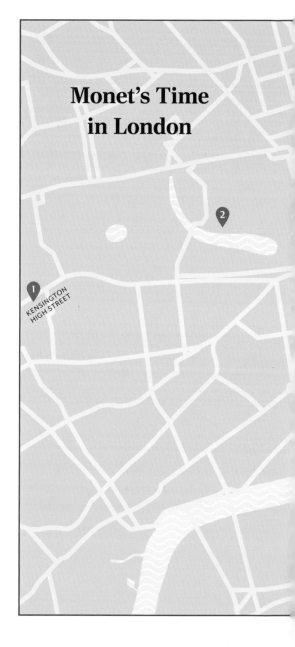

Monet's Time in London

N

| 0 | | 0.5 | | 1 km |
| 0 | | 1500 | | 3000 ft |

OXFORD STREET

REGENT STREET

SHAFTESBURY AVENUE

STRAND

THAMES

1 1 Bath Place
2 Hyde Park
3 Green Park
4 Café Royal
5 11 Arundel Street
6 Maison Bertaux
7 Savoy Hotel
8 Palace of Westminster
9 Westminster Bridge
10 Pool of London

◀ PREVIOUS PAGE The
dome of Saint Paul's
Cathedral rises above the
City of London.

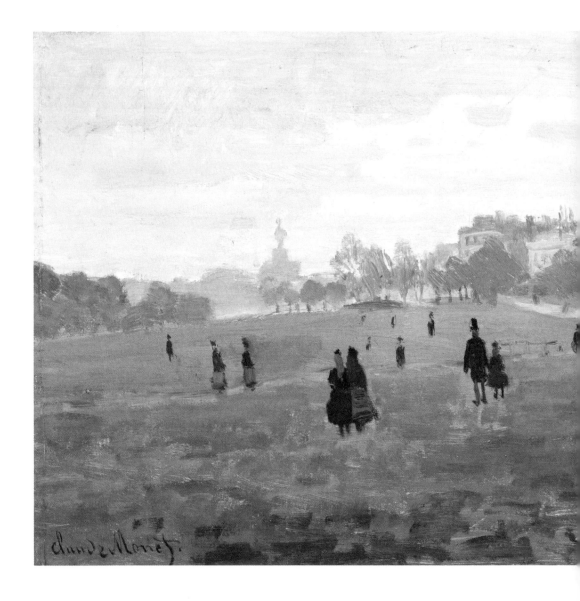

from Covent Garden to Oxford Street, that the majority of the French community was clustered. That district's cafés and restaurants were to prove especially conducive places for exiled painters to congregate with their compatriots and exchange news and information. Maison Bertaux, a café on Greek Street established in 1871 by Monsieur Bertaux, a communard who'd fled the massacres in Paris, was one such artistic hang-out. Another was the Café Royal at the bottom of Regent Street, which had been founded about five years earlier by a French wine merchant.

It was in the Café Royal that Monet had another fateful encounter with Daubigny. 'Several Frenchmen had gathered in the Café Royal', he remembered three decades after the event, 'and we didn't know how to earn any money. One day Daubigny asks me what I am doing. I tell him some

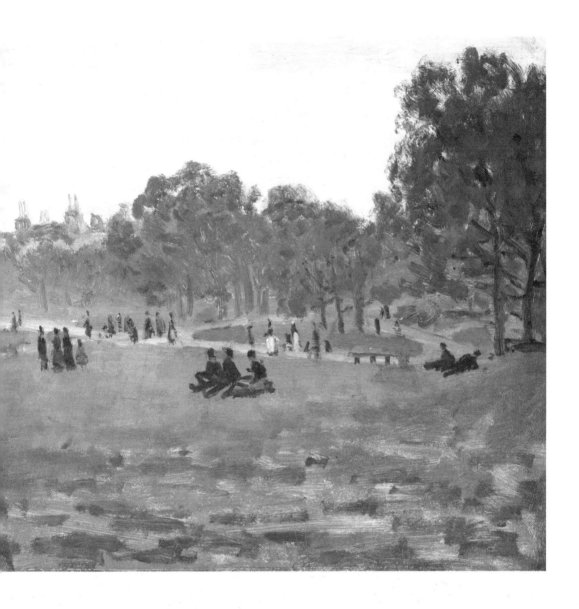

▲ *Green Park, London,* 1870–71.

landscapes in the park. He tells me, "But how wonderful ... I am going to introduce you to a dealer."' The paintings in question were *Hyde Park, London* and *Green Park, London,* two spell-bindingly misty views of London's civic greenery, and the dealer was Paul Durand-Ruel, who was to become, in the words of his biographer Pierre Assouline, 'the single most important source of income for most of' Monet's life.

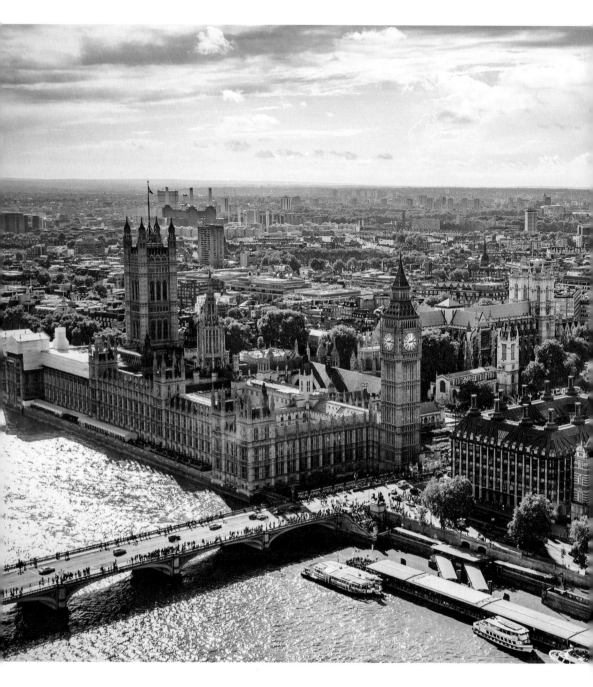

▲ Westminster, London.

Durand-Ruel had come to England in September 1870 with his wife, five children and thirty-five crates full of paintings, decanted from his gallery in Paris, with the aim of opening up shop in London for the duration of the hostilities. Upon arrival he almost immediately staged his first exhibition at Thomas McLean's gallery on Haymarket. Soon after, the Frenchman acquired premises of his own, after taking out a lease on the inopportunely named German Gallery at 168 New Bond Street, and launched a series of shows under the patriotic banner of The Society of French Artists. While no such organization existed, thanks to Daubigny's introduction paintings by Monet and Pissarro were to feature in these exhibitions. Not only did Durand-Ruel save both artists from penury in London but his patronage also ensured that their work was to be included in the French section of the International Exhibition in South Kensington when it opened in May 1871, since he was on the organizing committee.

Neither Monet nor Pissarro, however, were successful in their attempts to woo the English art establishment. Both men's submissions to the Royal Academy that spring were turned down and native punters for their paintings proved thin on the ground. Monet left England in May 1871. Within three years a French critic would coin the term 'impressionist' in response to a painting by Monet of Le Havre, the harbour blurry in greyish blue and orange and shrouded in fog, that he'd entitled *Impression, Sunrise*. Finally, an artistic movement formed by several like-minded painters, whose ties and commitment to painting *en plein air* had been consolidated by their enforced exile in London, had a name to be reckoned with.

Berthe Morisot Accepts a Proposal in Normandy

Berthe Morisot (1841–1895) is a household name in her native France, and a painter justly regarded as an artist of the same rank as her male peers. However, she was ridiculed as the 'arch-Impressionist' by critics in her day, who felt Impressionism itself was an effete deviation from the manly, and its leading female practitioner was, thereby, somehow doubly offensive.

Morisot is usually classed as one of the *trois grandes dames* (three great ladies) of Impressionism, along with her compatriot Marie Bracquemond and the American Mary Cassatt. Morisot, however, was in on it at the start. She contributed four oils (including *The Cradle*, one of her most famous paintings), two pastels and three watercolours to the debut show by the Anonymous Society of Painters, Sculptors and Printmakers. This landmark exhibition, staged independently and in opposition to the Paris Salon (the official art exhibition of the Académie des Beaux-Arts), opened on 15 April 1874 in the former studio of the photographer Gaspard-Felix Tournachon (better known by the pseudonym Nadar) at 35 boulevard des Capucines. In retrospect, it has come to be seen as the first exhibition of the Impressionists. Morisot's paintings appeared alongside the likes of Claude Monet, Edgar Degas, Pierre-Auguste Renoir and Camille Pissarro. She would participate in all but one of the next eight Impressionist exhibitions held between then and 1886, and only missed the 1878 show due to the birth of her son.

Morisot was born into a well-to-do family. Her father, Edmé Tiburce Morisot, was a senior and highly respected government official. His death from heart disease on 21 January 1874 not only relieved her of certain duties – as the last unmarried daughter she would have been expected to care for her parents in their dotage – but also removed some of the anxiety she might have felt about bringing the family name into disrepute by her involvement with the Impressionist group. For the previous decade she'd regularly exhibited at the Salon itself, to which her father could hardly object since it came with the seal of approval of the French state and its academicians. But aligning herself with an exhibition that one reviewer would claim contained works by 'five or six lunatics' was probably another matter. The same reviewer was to praise Morisot as the sole woman for maintaining 'her feminine grace' amid the outpourings of such delirious minds, which was perhaps a double-edged compliment at best.

Art for women of her class at that time was seen as a genteel enough amateur pastime but not really a thing to pursue professionally – and certainly not in public and out of doors. (Unchaperoned women were forbidden from sketching in the Louvre.) As young girls, Berthe and her sisters Yves and Edma all received lessons in drawing. Berthe and Edma, who both showed real aptitude, were suitably escorted to the Louvre by their art tutor Joseph Guichard and their mother, Marie-Joséphine-Cornélie, to copy

pictures in the museum. Their mother, who was the granddaughter of *ancien regime* Rococo painter Jean-Honoré Fragonard, believed in encouraging their efforts.

Edma, if equally as gifted, was to give up painting entirely upon her marriage to Adolphe Pontillon, a naval officer stationed in Lorient on the Atlantic coast of Brittany. Known as the town of five ports, and for a time virtually the fiefdom of the French East India Company, which was founded at nearby Port-Louis in 1664, Lorient had by the 1860s begun to attract affluent sojourners seeking health-giving briny sea air. Morisot was to pay a summer visit there shortly after her sister's marriage in 1869, where she painted *The Harbour at Lorient*. Morisot's picture showed Edma wearing a fashionable white dress and holding a parasol while sitting on the harbour wall and delighting in the marine scene. It was the poet Charles Baudelaire who'd called for painting that depicted modern life in all its facets, and Morisot adhered to that edict brilliantly here, as elsewhere, by depicting a coastal landscape in its contemporary reality as a destination for tourists.

The Morisots were among the class who could afford go on such holidays. Even before Edma's marriage, the family had begun taking summer vacations by the sea, mostly visiting the resorts burgeoning on the shores of Normandy; the railways in the 1850s and 1860s helping to put the coast within easier reach of their home in Passy, then as now one of the wealthier suburbs of Paris. Morisot's submission for the 1865 Salon, *Thatched Cottage in Normandy*, a picture dominated by the image of ten birch trees, was undertaken somewhere near Houlgate, during her stay in the area in 1864, and it is one of the few early paintings she didn't later destroy.

In the aftermath of the Franco-Prussian War and the siege of Paris, an event Morisot had sat out with her mother in the suburb of Saint-

Morisot's Time in Normandy

1 Lorient
2 Cherbourg
3 Houlgate
4 Fécamp
5 Les Petites-Dalles

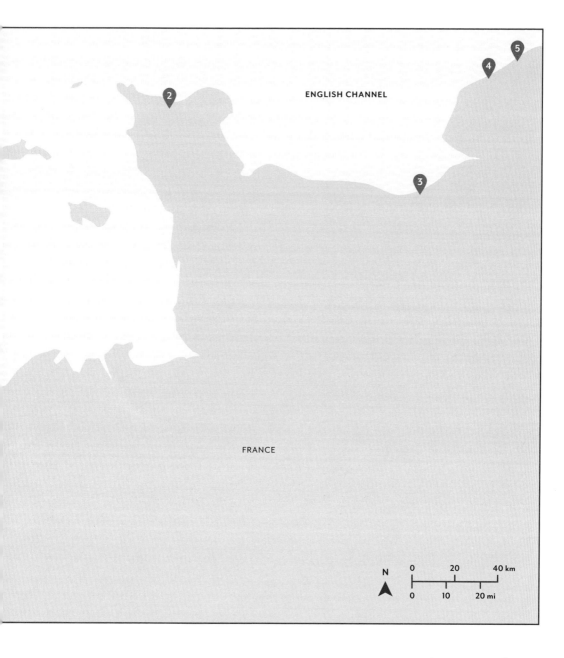

ENGLISH CHANNEL

FRANCE

N

| 0 | 20 | 40 km |
| 0 | 10 | 20 mi |

◀ PREVIOUS PAGE Fécamp,
France.

Germain-en-Laye, the artist would seek to restore her health and shattered nerves by the sea in Normandy. In the summer of 1871 she joined her sister in Cherbourg. The swirling waters of La Manche (the English Channel) seemingly worked their restorative magic, Morisot committing its harbour to canvas in a painting where a lone white-clad female figure (possibly with a child in tow) appears to drift along its front. Another painting that emerged from this holiday, and one of the pictures that demonstrates her revolutionary focus on the domestic reality of middle-class women's lives, was *Woman and Child Seated in a Meadow*, a study of her sister and her young son, with Cherbourg and its waterfront in the distance.

Two years later, the sisters reconvened in Normandy on the Côte d'Albâtre (the Alabaster Coast), famed for, and named after, its cliffs, lodging in the modest fishing village of Les Petites-Dalles, whose sandy beach Morisot would paint. Not long after the closure of the first Impressionist show on 15 May 1874, she was to

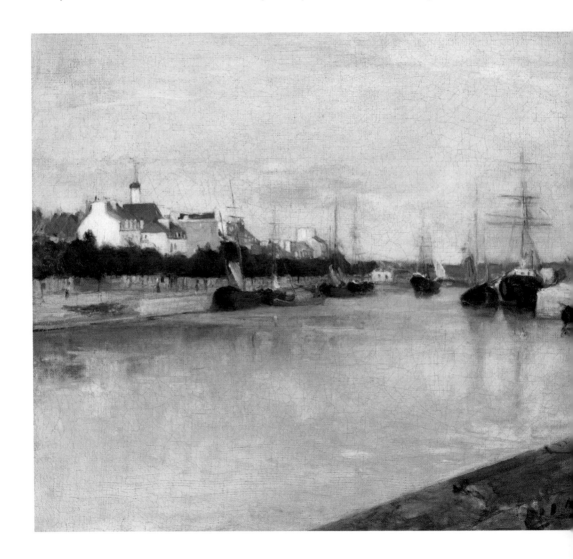

head once again to Normandy, this time to Fécamp, Les Petites-Dalles's neighbour, where extended members of both the Morisot and Manet clans had gathered for a holiday.

Berthe and Edma had first been introduced to Édouard Manet in the Louvre by their art tutor Guichard in 1868. From the same sphere of bourgeois society, the Manet and Morisot families were socially evenly matched. Manet and his two younger brothers Eugène and Gustave had been left independently wealthy on the death of their father. (The family owned substantial holdings in the Parisian suburb of Gennevilliers on a loop of the Seine, which later would become something of a hub of Impressionist artistic activity, not least for Morisot herself.) All three were free to indulge their cultural interests but Édouard was perhaps less of a dilettante than his siblings. As fellow artists of ambition, he and Morisot developed a solid working relationship; she often modelled for him and she was to nudge him in the direction of Impressionism and en plein air painting, though ideas flowed each way between them.

Romance would blossom between Morisot and Eugène, and it was one day on this holiday in Fécamp, while they were both out companionably painting a naval construction site, side by side, that they agreed to marry. Their union, however, was not sanctioned by Morisot's widowed mother, who disapproved of Eugène's joblessness. On the church register of the religious ceremony at the Church of Notre Dame de Grace in Passy, which followed their civic union on 22 December 1874, Eugène was listed as a man of property but of no profession.

The couple were to honeymoon in Ryde on the Isle of Wight in England, during the week of the Cowes Regatta, and Morisot was to paint a magnificent portrait of Eugène in boating duds as a reluctant sitter wishing to be out in the action – a rare picture for the time depicting male containment. The restrictions imposed on even fairly moneyed women by domestic duties shine through the pictures of Fécamp composed on the brink of Morisot's own engagement. But unlike her sister, here by the choppy waters of the English Channel she'd found a mate who appreciated and respected her gifts as a painter and as a person of courage, integrity and elegance, and who, most importantly of all, was endlessly supportive of her painting.

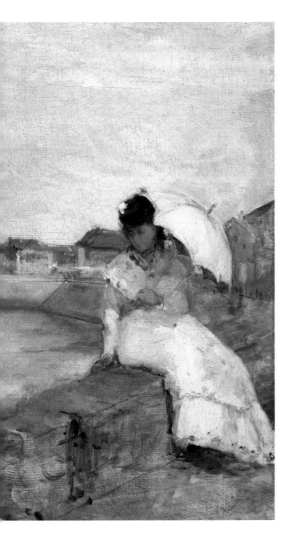

◀ The Harbour at Lorient, 1869.

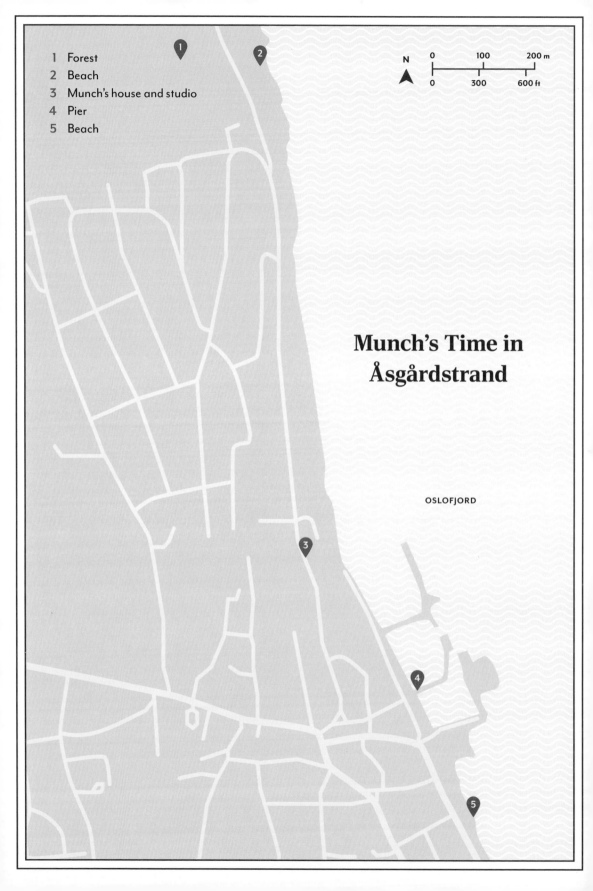

1 Forest
2 Beach
3 Munch's house and studio
4 Pier
5 Beach

N

0 100 200 m

0 300 600 ft

Munch's Time in Åsgårdstrand

OSLOFJORD

Edvard Munch Summers by the Sea at Åsgårdstrand

Some 80 kilometres/50 miles south-west of Oslo, Åsgårdstrand is a quaint Norwegian port, an ancient fishing town turned bathing resort with white clapboard houses. In summer its narrow streets are lined with visitors, its picturesque harbour is full of pleasure boats and yachts and its beaches are packed with bathers. Situated in a sheltered spot on a wide bay facing the Oslofjord, it boasts a microclimate closer to the Mediterranean during the sunnier months and is largely protected by its position from heavy storms and the worst of the weather all year round. With pine trees that nudge down to the shore whose scent mingles with the briny sea air it is almost anyone's idea of an unspoiled Scandinavian idyll.

Angst and existential despair seem very far removed from Åsgårdstrand on a sunny day in June, or indeed on almost any day really, yet this town was both a regular summering spot and a frequent subject for Edvard Munch (1863–1944), an artist whose most famous painting, *The Scream*, is seen as a quintessential depiction of human agony. The artist's work is mostly characterized by its preoccupation with the morbid themes of loneliness, isolation, sickness, madness and mortality. But then he had good reason to be preoccupied by those themes.

Born in Løten in Norway on 15 December 1863, Munch's childhood was to be indelibly marked by illness and death. His father, Christian, was a military doctor and something of a martinet, so matters medical were an unavoidable facet of his upbringing in Oslo (then Christiania), where the Munchs moved shortly after his birth. But ill health stalked the family. His mother, Laura Catherine, died of tuberculous when he was just five years old, and the same disease was to carry off his fifteen-year-old sister Sophie nine years later. His older brother Andreas would be dead at thirty and another of his sisters, Laura, was committed to an asylum for the insane.

Growing up convinced that tuberculosis or lunacy (or both) would also claim him, Munch once described illness, insanity and death as the 'black angels' that kept watch over his cradle and stated they had accompanied him ever afterward. One of his first major paintings was *The Sick Child*, a study from 1886 inspired by the travails of his family but equally by a young patient seeking treatment at his father's practice. Although dogged by periods of mental and physical instability and suffering a complete breakdown in his forties exacerbated by alcoholism, Munch was actually to die quite peacefully at the grand old age of eighty, having continued to paint into his seventies, until an eye condition forced him to stop for good in 1936.

Just three years before that, he'd spent a final summer in Åsgårdstrand, the resort he'd first visited in 1888, the location of a great leap forward in Munch's art during its early stages and a place that had nourished him creatively for decades.

After abandoning studies in engineering for painting, Munch was to attend Léon Bonnat's art

school in Paris. There he became acquainted with the works of Vincent van Gogh, Henri de Toulouse-Lautrec, Claude Monet, Camille Pissarro, Édouard Manet and James Abbott McNeill Whistler through exhibitions in the French capital. His art was to find its first champions and some of its harshest critics (outside of Norway, which was slow to appreciate this native son's talent) in Berlin. But even in the periods when he was living in France and Germany he returned to his homeland and to Åsgårdstrand for the summer months.

The summer of 1889 has come to be seen as the most decisive in Munch's career. It was then that the painter rented a little fisherman's cottage, which had been lying empty, and from then on it became his perennial coastal bolthole, the painter eventually buying the property outright in 1897. It was here, over the course of his second summer at Åsgårdstrand, that Munch competed *Inger on the Beach*. That painting was a portrait of his sister, raven haired and pale skinned but radiant in a full-skirted white dress and holding a large straw hat in her hands, sitting, gazing out to sea, on a mossy green granite boulder, on a beach shown as a shimmering bluey-reddish haze. As the art historian Ulrich Bischoff has maintained, this early work contains the whole essence of Munch's art compositionally, with its reliance on horizontal and vertical axes, and thematically, with the sense of loneliness its abiding note. Stylistically too it saw him break free of the conventions of nineteenth-century painting and start to shake off the constraints of realism. This is arguably the first work in which Munch fulfilled his later, much-repeated adage, not to paint what he *saw* but what he *had seen*. The picture is a poignant recreation of a fleeting moment recalled rather than a dutiful document of what had passed. Though on Åsgårdstrand Munch would often paint *in situ* on the shore itself.

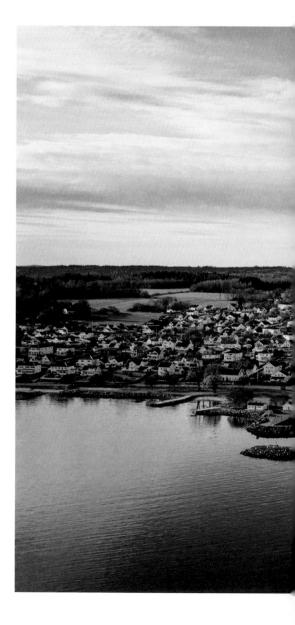

▲ Åsgårdstrand, Norway.

Exhibited in Oslo later that year, *Inger on the Beach* fared ill with critics. Munch was held to be a wild dauber making a mockery of the public for offering a picture showing a 'stone absently tossed down from some soft amorphous mass'. Yet it pointed the way forward for the painter and set a pattern for a number of pictures, among them *Summer Night's Dream (The Voice)* from 1893 and *House in the Moonlight* from 1895, where the scenery of Åsgårdstrand (the Kosterud building in the latter painting) served as the recognizable basis for something arrestingly eerie and uncanny.

Other striking examples are *The Three Stages of Woman (Sphinx)* and *The Dance of Life*, both of which were to utilize a shoreline space under the trees in Åsgårdstrand where communal dances were (and continue to be) staged. But in Munch's hands the jollity of such events is infused with something infinitely more melancholy, *The Three Stages of Woman (Sphinx)*, in particular, presenting a slightly grim parade of women ageing toward the grave.

Yet the joyful freedoms of the beach were also celebrated by Munch in pictures such as the vividly coloured late effort *Bathing Scene from Åsgårdstrand* from 1936. The free-and-easy atmosphere of the resort had earlier been noted by Munch's friend Christian Gierløff, who observed that, 'No one is bothered about swimming costumes here, the gentle gusts of warm July wind are the only fabric between us and the sun.'

Åsgårdstrand was popular with families, with young mothers with children making up the majority of summer visitors, their husbands pitching in at weekends from Oslo by a regular steamer service that made the town almost a seasonal commuter suburb. Women, accordingly, were to feature prominently in many of the paintings Munch undertook at Åsgårdstrand. *The Storm*, painted in 1893, the same year as *The Scream*, is one of his most important pictures. It features a group of women cowering from an encroaching coastal maelstrom, one clasps her hands over her ears so as not to hear the thunder in a manner that recalls the figure from Munch's best-known painting. While *Girls on the Bridge* (more accurately titled *Girls on the Pier*) from 1901, shows three adolescent females leaning on the railing of a breakwater in the local marina, lost in dreamy contemplation at the water below them, poised on the brink of land and sea and on the cusp of adulthood.

◀ *Girls on the Bridge*, 1901.

Isamu Noguchi Takes a Monumental World Tour

In the opinion of his friend the American architect Richard Buckminster Fuller, the sculptor and landscape artist Isamu Noguchi (1904–1988) 'travelled on and on ... as the intuitive artist precursor of the evoluting, kinetic one-town world man'. Born in Los Angeles in 1904 to an Irish-American editor-writer mother and a Japanese poet father, Noguchi straddled the world both literally and figuratively. He lived in Japan between the ages of two and thirteen but always proudly identified himself as 'a Hoosier' after attending high school in Indiana. As an individual and an artist, he defied almost all other labels and categorizations.

Noguchi, who travelled extensively throughout his entire life, found inspiration in Greece and India during a transformative visit to those two countries in 1949. That trip came after a couple of years in which he'd experienced the highs of critical praise and the extreme lows of a doomed love affair with a young Indian woman, Nayantara 'Tara' Pandit, and the death by suicide of his close friend and contemporary the Armenian-American painter Arshile Gorky.

Tara, then an eighteen-year-old student at Wellesley College in Massachusetts, had accompanied Noguchi to the opening of the Fourteen Americans exhibition at the Museum of Modern Art (MoMA) in New York on 10 September 1946. (The title was a misnomer as fifteen artists eventually featured.) This exhibition was to be the first significant showcase of new trends in modern American art since the war. It included pieces from the painters Mark Tobey, Robert Motherwell and Arshile Gorky, as well the sculptors Theodore Roszak, David Hare and Noguchi. Noguchi's contribution, a marble creation entitled *Kouros*, another name for Apollo, was singled out for praise by many critics. Since judged to be one of his masterpieces, *Kouros* opened up a whole new frontier in the sculptor's output. Noguchi completed the sculpture over the winter of 1945–6, with the aid of a postcard depicting an ancient statue of the Greek god from the Louvre in Paris pinned to his studio wall.

Around the same time, Noguchi had been charged by the dancer and choreographer Martha Graham, with whom he'd been collaborating for over a decade, to provide a stage set for her production of *Night Journey*, a dance based on the tragedy of Oedipus Rex that was to premiere in May 1947. This job was followed by a further immersion in the classics when he was asked to devise the sets for her subsequent show, an adaptation of *Orpheus* with music by Igor Stravinksy and choreography by George Balanchine. It was while working on *Orpheus* that Noguchi learned that Tara, who he'd asked to marry him, was to return to India and had accepted a family-sanctioned wedding match with a man from a distinguished Punjabi business dynasty. Devastated, Noguchi became obsessed with following her to India. Tara herself, if disabusing the artist of any idea that their former romance

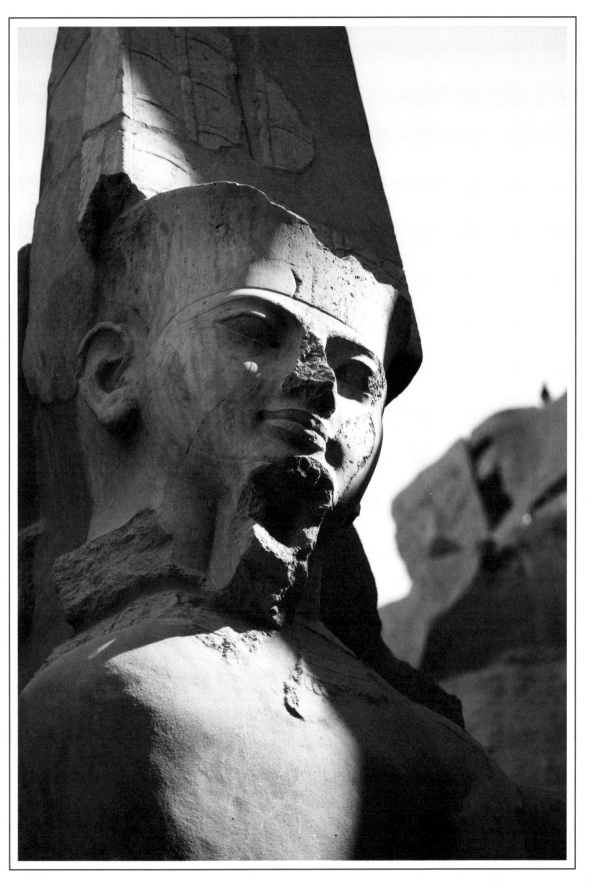

◀ PREVIOUS PAGE Luxor
 Temple, Egypt.

▼ Rome.

would be rekindled, nevertheless demonstrated an innate understanding of his needs by wisely suggesting he undertake a trip to her country for the sake of his work and soul but telling him they should not meet. She went to her grave claiming they didn't, although others have maintained one brief encounter did take place in India.

Noguchi applied to the Bollingen Foundation for a travelling fellowship to complete research for a proposed book on 'leisure'. As he later admitted, this was hardly an appropriate term for his field of interests and the book would never be written. The basis for the trip was the chance for him to study ancient cultural monuments and sculpture around the world. In the immediate aftermath of the horrors of the Second World War, he was seeking to look deep into the past in the hope of finding a public function for sculpture that might encourage healing, communality and a sense of universal belonging.

In May 1949, Noguchi was to leave New York for Paris, home to his former mentor Constantin Brancusi. From there he voyaged on to Brittany to see dolmens and menhirs and visited the prehistoric caves at Lascaux in south-western France, armed throughout with his trusty Leica camera. From France he went to Italy, photographing both the ancient ruins of Rome and its more contemporary piazzas and gardens.

Next up was Greece, where he visited Olympia and Epidaurus, and Crete. His literary guide for this particular stretch of his journey was Henry Miller's 1941 travelogue *The Colossus of Maroussi*, a book that he believed to be conducive to his understanding of the territory. And then came Egypt, where not even the intense heat of the midday sun could dissuade the restless artist from photographing the ancient monuments at Luxor, along the banks of the Nile, and the great mosques of Cairo.

Noguchi was to fly from Cairo to Mumbai (then Bombay) in September. His hosts in India were the

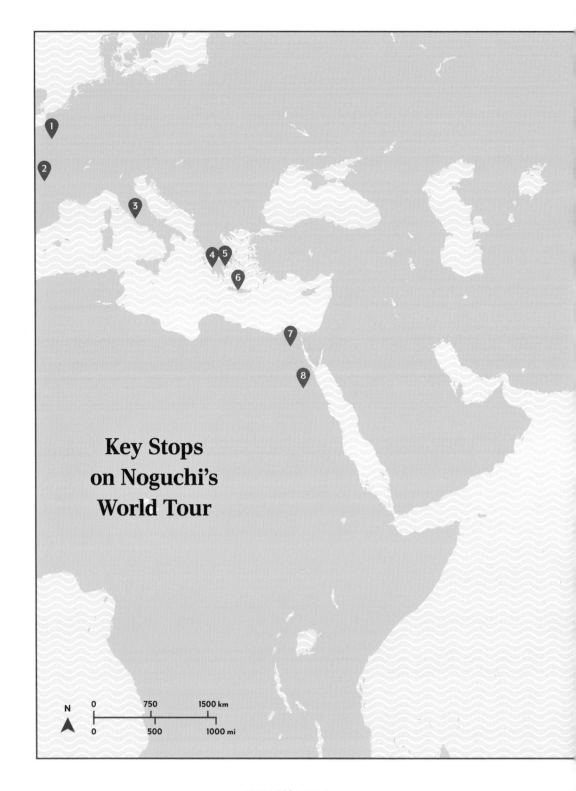

Key Stops
on Noguchi's
World Tour

1	Paris	11	Ajanta caves
2	Lascaux	12	Ellora caves
3	Rome	13	Shore Temple
4	Olympia	14	Sri Aurobindo Ashram
5	Epidaurus	15	Jantar Mantar, New Delhi
6	Crete	16	Jantar Mantar, Jaipur
7	Cairo	17	Borobudur
8	Luxor	18	Angkor Wat
9	Mumbai	19	Kyoto
10	Ahmedabad		

Sarabhai family and his main base was their palatial walled compound in Ahmedabad, where peacocks roamed its ornamental gardens and armed guards kept beggars and other undesirables at bay. The Sarabhais were wealthy cotton traders. Noguchi had come to know the clan's eldest son and heir, Gautaum, when he was sent to New York to oversee the family's stateside operation. When Gautaum's sisters Gira and Geeta visited New York, Nogochi served as their guide to the city. Since Geeta played percussion, he introduced her to his friend, the composer John Cage. Now that Noguchi was in India, Geeta was to return the favour by taking him on sightseeing trips. She later recalled that the artist had been disgusted by the dirt and poverty but became like a man possessed whenever he was presented with an ancient temple or religious shrine, his camera never still in his hands. Nogochi was mesmerized, in particular, by the lingham: carved stone phallic pieces related to the worship of the goddess Shiva.

From September 1949 to January 1950, he spent seven months touring the length and breadth of India, mostly by languid train journeys, travelling throughout like a mendicant with his bedroll, notebook, camera and not much else. His greatest delight, he reported, was 'to ride the train at night in India. On the hard shelf of a third-class coach, listening to the cliciti-clak of the wheels with the wonderful night air blowing through.'

In an itinerary heavy on monuments and historic mounds, he explored the caves at Ajanta and Ellora in Maharashtra in western India; visited the Temple of Mahabalipuram (also known as the Shore Temple) and Sri Aurobindo Ashram, both in Tamil Nadu in southern India; and undertook a ten-day excursion to Sri Lanka (then Ceylon) in the Indian Ocean. But perhaps the sites that were to have the most impact on the sculptor were the Jantar Mantar, or observatories, at New Delhi and Jaipur. These vast stone structures were built by Sawai Jai Singh II, the eighteenth-century maharaja of Jaipur. The maharaja's interest in astronomy and mathematics also led him to commission a translation of Euclid's geometry into Sanskrit.

Eventually, Noguchi was to leave India for Bali, where he made a pilgrimage to Borobudur, a ninth-century Buddhist temple in Central Java. Then in Cambodia he sought out Angkor Wat, a twelfth-century temple complex. The finale to Nogochi's journey was to be a spell in Japan, which he hadn't visited since 1935. While there he reconnected with previously estranged relatives and visited his former childhood home near the beach of Chigasaki in Kyoto. He also gave a lecture in Tokyo based on what he had gleaned from his travels and urged his audience to think anew – and much more holistically – about art. 'Architecture and gardens', he told them, 'gardens and sculpture, sculpture and human beings, human beings and social groups – each must be tightly linked to the other. Isn't this where we can find a new ethic for the artist?' He concluded that all the 'evidence of the past' attested 'to the place of sculpture in life and in ritual of communion with spirit and tranquility'. And then finally, Noguchi returned to the United States, taking a Pan Am flight to Los Angeles from Haneda Airport.

The effect of this world tour on his work was to be profound, providing Noguchi with a whole new conception of environmental art, one that would see him add gardens to an already diverse portfolio. India and Greece would receive many repeat visits from the artist and continued to inspire him for the remainder of his life.

▶ TOP Jantar Mantar, New Delhi, c.1955.

▶ BOTTOM Borobudur temple, Java, Indonesia.

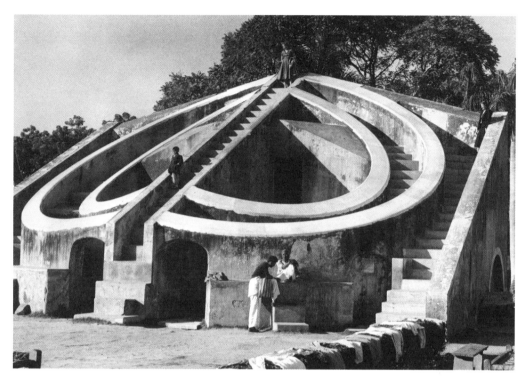

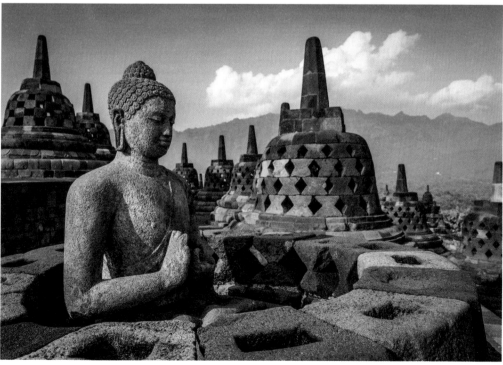

Marianne North Goes South to Paint Indian Flora

Marianne North (1830–1890) was to entitle her autobiography *Recollections of a Happy Life*. The book largely consisted of fond reminiscence of her many travels as a globe-trotting painterly plant hunter. As an artist and an unmarried woman in the Victorian era, albeit one blessed with not inconsiderable financial means, she consistently defied the limitations imposed on her sex and the conventions of her chosen genre.

It was the Royal Botanic Gardens at Kew, London, that had first made North long to travel to what was then termed 'the tropics'. Aged twenty-six, she'd been presented with a branch of what she deemed to be 'one of the grandest flowers in existence' – the orchid tree (*Amherstia nobilis*) from Myanmar (then Burma) – by its director Sir William Hooker while touring the gardens. Later in life, she bequeathed the fruits of her singular endeavours, some 832 botanical paintings, to the Royal Botanic Gardens, along with a gallery to house them. The Marianne North Gallery, designed in the Greek temple style, opened in 1882, and it can still be visited today.

Following her mother's death in 1855, North took charge of her beloved father's affairs, devoting herself to him. She also began to paint seriously, having earlier been given some lessons in what she derided as 'flower painting' by Miss van Fowinkel, who had taught her the rudiments of arrangement and groupings. Now North forged her own path, depicting plants in their natural settings rather than as isolated specimens and using oils rather than the more genteel watercolours for many of her finished works.

Although North had travelled widely across Europe and to Egypt with her father, after his death in 1869 her wanderlust knew no bounds. Over the next fifteen years, armed with pencils and brushes, she was to visit some fourteen countries, including the United States, Canada, Borneo, Brazil, Japan, Jamaica, Australia and India. Her solo expeditions were covered in the national press and her pictures were commended for their scientific accuracy by the naturalist and sage of evolution Charles Darwin.

One of her lengthiest excursions was to India. She was to spend over a year between 1877 and 1879 journeying around the country, from Kolkata (then Calcutta) to Delhi, to Jaipur and beyond. Her extended sojourn was eased by letters of introduction and invitations to stay with distinguished figures in the ruling British establishment and no botanical garden gate was ever closed to her.

Sailing from Southampton aboard the *Tagus* on 10 September 1877, North's passage to India involved stops in Lisbon, Gibraltar and Malta before landing at Galle in Sri Lanka (then Ceylon), where a steamer carried her on to Thoothukudi (then Tuticorin), the 'pearl city' of Tamil Nadu in southern India.

As she was to recall, 'The first part of my Indian journey was over white sand covered with Palmyra- and Fan-palms, and cacti; then came

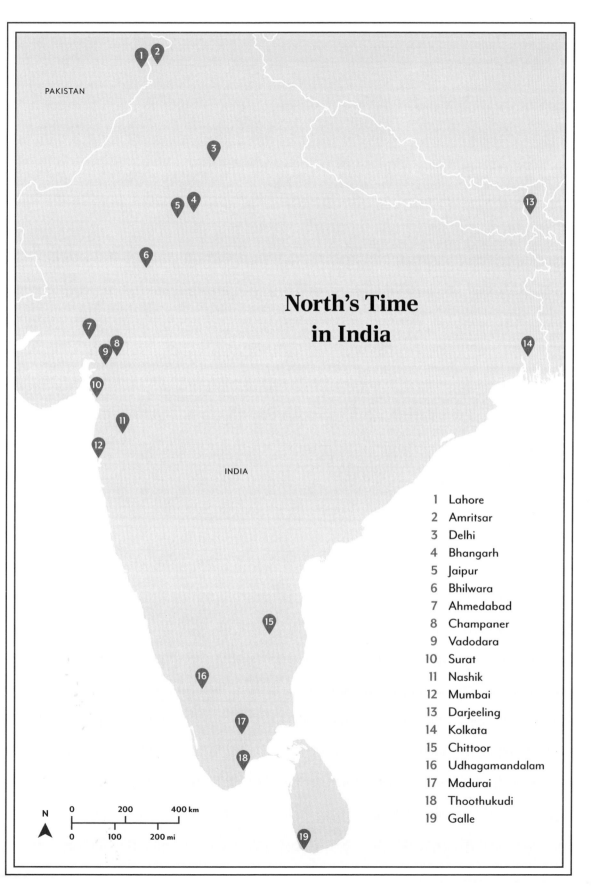

PAKISTAN

North's Time
in India

INDIA

1 Lahore
2 Amritsar
3 Delhi
4 Bhangarh
5 Jaipur
6 Bhilwara
7 Ahmedabad
8 Champaner
9 Vadodara
10 Surat
11 Nashik
12 Mumbai
13 Darjeeling
14 Kolkata
15 Chittoor
16 Udhagamandalam
17 Madurai
18 Thoothukudi
19 Galle

N

0 200 400 km

0 100 200 mi

cotton, quantities of millet, Indian corn, gram, and other grains.' To begin with she was dumbfounded by the Hindu Meenakshi Temple at Madurai, with its monkeys, elephants, bulls and parrots and 'every kind of strange person inside it', but she was soon won over by the dignity of its ceremonies. The Golden Temple at Amritsar, the spiritual centre of Sikhism, was another of the religious sites to form part of her extensive itinerary. There she was to admire the finery of its attendees' clothing. In Bhilwara, meanwhile, she came across the less exotic scene of the wives of English soldiers cooking a Christmas dinner for their husbands and was invited to spend the day with the unit's genial colonel and his friends.

The main aim of her trip was to build up a collection of paintings of plants that were sacred to the varied indigenous religious traditions. Travelling alone, through rural villages and quite remote locations in pursuit of this goal, her journey would be far from stress free – ants overran her and attempted to devour her oil paints while she was sketching the ancient buildings outside of Nashik and she had to deal with warring porters about 50 kilometres/30 miles from Udhagamandalam (also known as Ootacamund).

◀ Darjeeling, India.

Plants were her overriding obsession, from the almatas, or Indian laburnum, in Lahore and the white spirea and delphiniums in Simla to the deodara in Darjeeling and the bamboo and arrowroots of Bengal. The tour was to produce a startling series of pictures, including images of the weed-infested ruined mosque at Champaner, near Vadodara (Baroda); the valley of ferns near Rungaroon; the Great Neeva Bridge at Chittoor; Rajputana with its tomb and Tree of Heaven; close studies of the Indian coral trees that Krishna was said to have stolen from the Celestial Garden for his wives; fruit of the mango tree, whose wood was used in Hindu funeral pyres; and the frangipani planted in cemeteries so that their white petals would litter the graves in a fragrant floral carpet.

Although planning to head home from Mumbai, North delayed her departure by undertaking a final 500-kilometre/300-mile rail journey to Ahmedabad, with parting visits to Vadodara, Surat and Bhangarh just to round things off. She eventually boarded the P&O ship *Pekin* from Mumbai to Aden in Yemen on 24 February, voyaging on to Southampton, where the chill of the air coming off the Solent came as a shock after so long in the subcontinent. She arrived back in London on 21 March 1879. That summer she was to stage an exhibition of her Indian pictures in a room rented on Conduit Street in London. The shilling entrance fee, North claimed, soon recouped two-thirds of her initial costs; the remaining third she thought 'well spent in saving in the fatigue and boredom' at constantly repeating her Indian stories and showing her Indian sketches to friends who incessantly pestered her at home.

▼ Man Sagar Lake, Jaipur, India. ▶ *State Elephant, Baroda*, 1879.

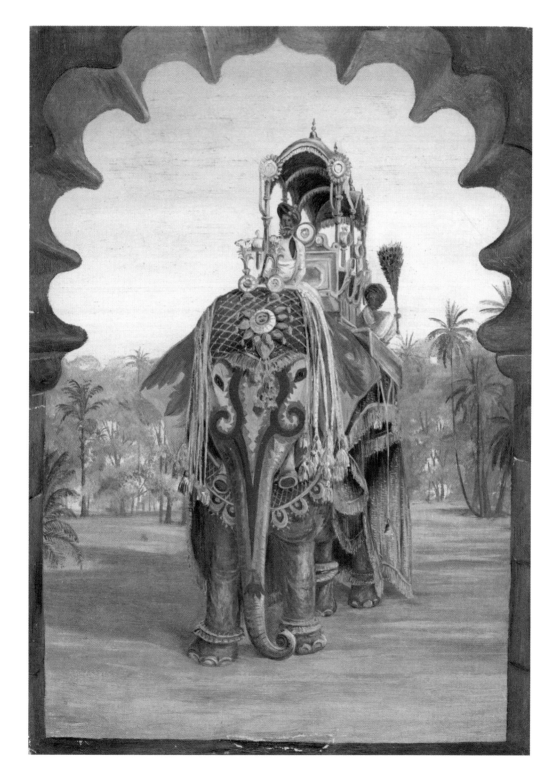

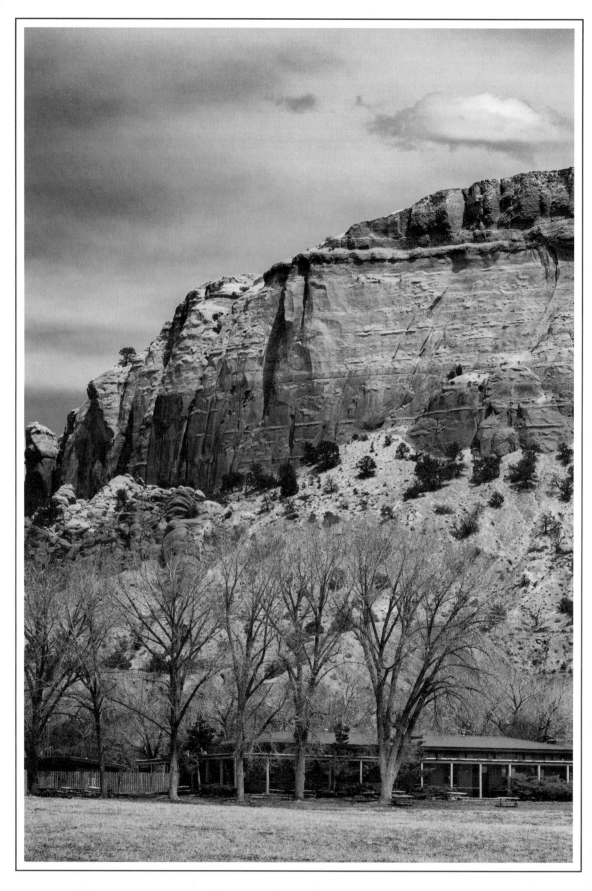

Georgia O'Keeffe Goes West

Writing to her husband, the photographer and art promoter Alfred Stieglitz, from New Mexico, the artist Georgia O'Keeffe (1887–1986) confessed, 'I'd rather come here than any place I know. It is a way for me to live very comfortably at the tail end of the earth so far away that hardly anyone will ever come to see me and I like it.'

The art historian Wanda M. Corn has argued that O'Keeffe made two momentous decisions in her life. The first, in 1918, was to accept an invitation to move to New York and concentrate on her painting from Stieglitz, who'd staged her first solo show in the city in the previous year. The second, in April 1929, was to leave New York for a summer of painting in the remote high-desert country of New Mexico. For the latter, O'Keeffe and her friend Rebecca 'Beck' Strand (wife of the photographer Paul Strand) journeyed by train to Santa Fe, bound for an art colony in Taos run by the wealthy art patron and writer Mabel Dodge Luhan.

Having hobnobbed with the American novelist Gertrude Stein and the French writer André Gide in Florence, Luhan hosted legendary salons of anarchists, suffragettes and radicals of all stripes in her palatial Fifth Avenue apartment in New York. In 1913 she supported the staging of the Armory Show, the first major exhibition of European modern art in America. In 1917 she moved to New Mexico, after a prophetic session with a medium and became a fervent campaigner for Native American land rights. Luhan's Taos

guestbook was filled with the names of some of the greatest artists and writers of the day, from the novelist Willa Cather and the playwright Thornton Wilder to the reclusive Hollywood star Greta Garbo and writer D.H. Lawrence, who was to mine his experiences in Taos for his novel *The Plumed Serpent* and the short story 'The Woman Who Rode Away', both of which are set in New Mexico and contain characters based on (or, more accurately, are grim caricatures of) Luhan.

Luhan's extensive desert compound, which ran to 5 hectares/12 acres, boasted the grand hacienda Los Gallos (named after Luhan's collection of Mexican ceramic roosters), five guest houses and various barns and stables. O'Keeffe and Strand were to be allocated a guest house to themselves at Taos, and the artist was also given an additional hut to use as a studio. From the moment she arrived, and invigorated by high-altitude mountain air, O'Keeffe was transported by the place. The wide-open spaces took her back to her childhood on a dairy farm near Sun Prairie, Wisconsin, in the Midwest and the barren beauty of the desert landscape recalled the period she'd spent as an art teacher in Texas. In Corn's view, it was here that O'Keeffe realized 'she was a natural daughter of the American west'. On this first trip to New Mexico, she and Strand feasted on all that was on offer, giving themselves over to the typical tourist itinerary of seeing tribal dances on the nearby Native American reservations, visiting the local Catholic churches, which were fashioned in adobe

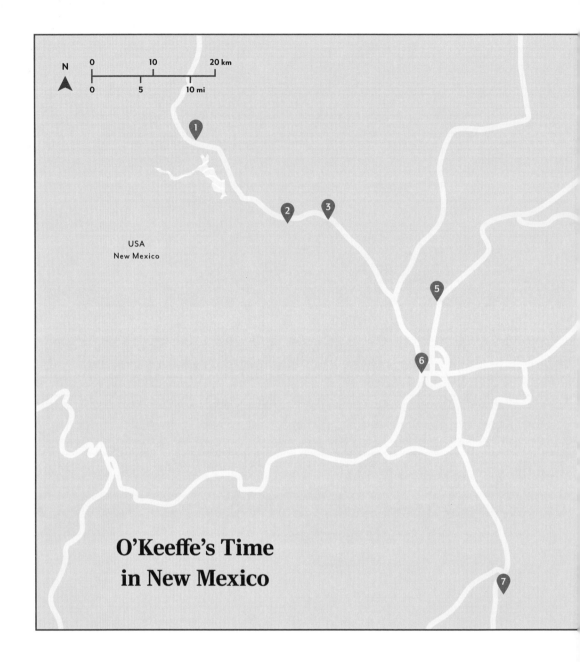

N

| 0 | 10 | 20 km |
| 0 | 5 | 10 mi |

1

2 3

USA
New Mexico

5

6

O'Keeffe's Time
in New Mexico

7

◀ PREVIOUS PAGE Georgia
O'Keeffe's Ghost Ranch,
New Mexico, USA.

with hand-carved mud interiors and dazzling Hispanic altar art, and making excursions by car to Taos Pueblo and Mesa Verde in California.

Up until this point, O'Keeffe had little experience of cars and Stieglitz regarded them as one of the evils of the modern world. However, after this initial foray west she would go on to buy a Ford Model A and learn to drive solely to be able to explore New Mexico, to which she would return, almost without fail, for the next twenty summers, before moving out for good shortly after Stieglitz's death. The photographer himself never once made the journey west.

In 1930, O'Keeffe returned to Luhan's retreat. There, among the other pilgrims, she met the photographer Ansel Adams, who was to become one of her closest friends in the west. But as someone who prized peace and solitude, Los Gallos and its surroundings, with its constant stream of high-rolling artistic visitors, proved too hectic for O'Keeffe's tastes. She then looked into what were termed 'dude ranches', which had become a popular holidaying option for urbanites on both the west and east coasts, their rise mocked in *New Yorker* cartoons and championed in the pages of fashion bible *Vogue*. Such places allowed city slickers to play at being cowboys (or cowgirls) for a few weeks, camping or living in small *casitas* (guest houses), eating communally, going riding and generally roughing it in the spirit of the Old West. O'Keeffe was not much interested in horses or the Old West but on her third visit to New Mexico in 1931 she booked herself into the H&M Ranch in the tiny village of Alcalde, north of Española. Just 23 kilometres/14 miles to the north of Alcalde is Tierra Azul, whose three bluff-coloured sand hills fascinated O'Keeffe and were to feature in her paintings.

On a tip from David McAlpin, the Rockefeller heir and art enthusiast, O'Keeffe was to learn about the even more obscure Ghost Ranch, an outpost in the shadow of the Cerro Pedernal mountain, owned by the affluent Philadelphians Arthur and Phoebe Pack. With its vistas of pink and yellow cliffs, the Ghost Ranch seduced O'Keeffe from the outset. And in due course she became the owner of a newly built adobe cottage called the Rancho de los Burros, a property some 5 kilometres/3 miles from the main ranch, which came with 3 hectares/7 acres of land to preserve her privacy. The cottage had no running water,

its central patio was constantly menaced by rattlesnakes and it took almost a day-long excursion along miles of rough road to acquire groceries but O'Keeffe loved it and the 360-degree views of the desert its location afforded.

Describing the property's importance to her as an artist, in 1939, she would write:

Badlands roll away from my door, hill after hill – red hills of apparently the same sort of earth that you mix with oil to make paint ... All the earth's colours of the painter's palette are out there in many miles of badlands. The light

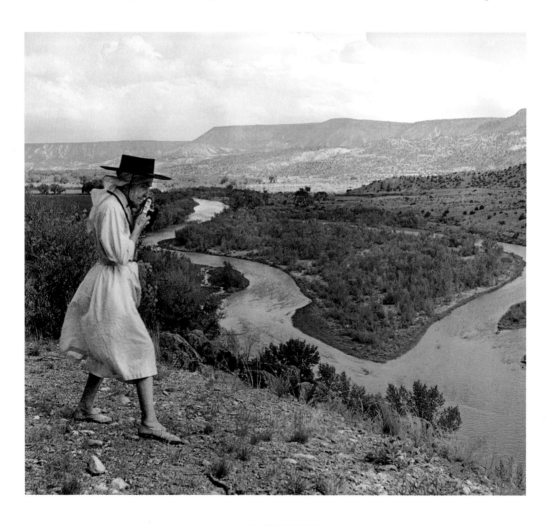

Naples yellow through the ochres – orange and red purple earth – even the soft earth greens.

The desertscape around Ghost Ranch was to lead to the execution of such major works as *Cedar Tree with Lavender Hills*, *Purple Hills Ghost Ranch 2* and *Chama River, Ghost Ranch*.

With Stieglitz in increasingly frail health, O'Keeffe would plot her ultimate departure from New York. After settling their affairs following his death in 1946, and finding homes for his archive, she moved permanently to New Mexico three years later, taking possession of a house and 1.6 hectares/ 4 acres of land in Abiquiú, some 80 kilometres/ 50 miles to the south of Santa Fe. Shortly before leaving New York for good, she painted a picture of the Brooklyn Bridge as a portal out of the city, its steely suspension cables crossing emblematically, leading to a distant but pure blue sky.

◀ Georgia O'Keeffe photographing the Chama River, New Mexico, 1951.

▼ *New Mexico—Near Taos*, 1929.

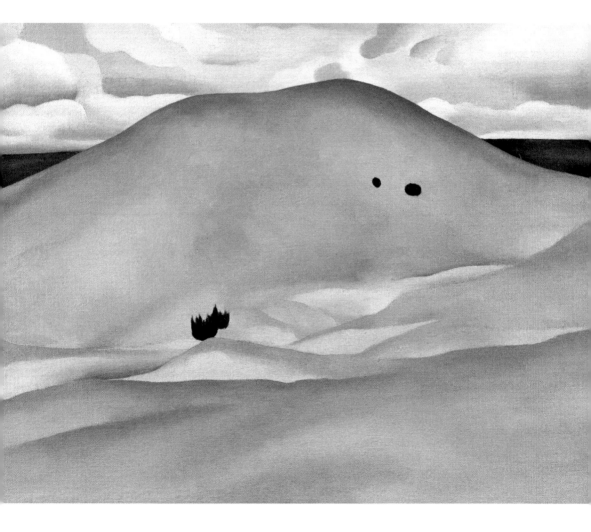

Pablo Picasso Falls for the South of France

In 1918, the Spanish artist Pablo Picasso (1881–1973) married the ballerina Olga Khokhlova in the Russian Orthodox cathedral in Paris. He had fallen madly in love with her after seeing her dance in *Parade*, a ballet by Sergei Diaghilev, Erik Satie and Jean Cocteau for which he had designed the set and costumes. Another Diaghilev ballet, *The Three-Cornered Hat*, was to take the couple to London for three months at the beginning of 1919; Picasso was again tasked with providing the costumes and sets for the show.

That August, Pablo and Olga visited the already fashionable Saint-Raphaël on the Côte d'Azur. Olga, the daughter of a colonel in the Russian Imperial Army, was perhaps more enamoured of the coastal resort than Pablo, having been raised in rather more elevated circles. However, this trip would mark the beginning of Picasso's relationship with the South of France, a relationship that would prove a good deal more enduring than any of those he had with the various women in his life.

Picasso was to become enraptured with the French Riviera the next summer when – somewhat to his wife's dismay – the painter alighted on the small fishing port of Juan-les-Pins, a quaint backwater that was all but devoid of visitors after Easter; the upper crust only ever wintered in nearby Cannes and Monte Carlo.

Juan-les-Pins and neighbouring Antibes nevertheless immediately spoke to him. 'I realized that that landscape was mine,' he later recalled.

He adored its deserted sandy beaches, its shoreline dotted with pine trees, the fishermen's shacks and the town's narrow streets and pastel-coloured stucco houses. Its easy pace and scenery reminded him of Cadaqués in his native Catalonia and he hankered to return the following summer. However, after the birth of their son, Paulo, in February 1921, the new family, largely on Olga's insistence, summered in Dinard, a favoured watering place of the English aristocracy and well-to-do Americans on the coast of Brittany.

Nevertheless, Picasso was soon encouraged to return to Cap d'Antibes by Gerald and Sara Murphy. This American couple were representative of a whole new generation of affluent, Bohemian expats who slummed it on the Continent in the aftermath of the First World War. Sara was the eldest daughter of a millionaire Cincinnati ink manufacturer, and partially raised in Europe, where she mingled in German and British aristocratic circles. Gerald was the Yale-educated second son of the well-read owner of a prosperous New York luxury goods store. Subjected to family opprobrium about their marriage (Sara's father was particularly unhappy about her choice of husband) and repelled by the stuffiness of materialist, elite American society, the Murphys had moved to Paris in 1921. Once there Gerald had been inspired to take up painting and the couple had struck up friendships with all the leading figures of the city's robustly modernist artistic milieu. Their circle of friends included

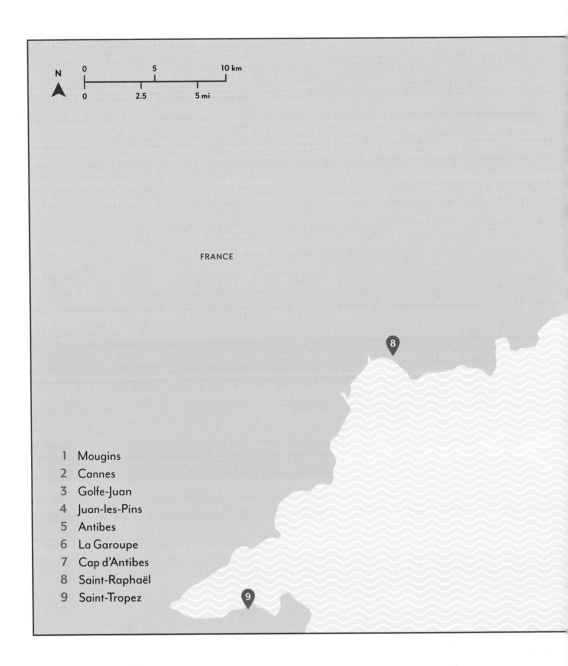

N

| 0 | 5 | 10 km |

| 0 | 2.5 | 5 mi |

FRANCE

8

1 Mougins
2 Cannes
3 Golfe-Juan
4 Juan-les-Pins
5 Antibes
6 La Garoupe
7 Cap d'Antibes
8 Saint-Raphaël
9 Saint-Tropez

9

◀ PREVIOUS PAGE Cannes,
France.

MEDITERRANEAN SEA

Picasso's Time on the French Riviera

Russian emigrés like Diaghilev and Igor Stravinsky, fellow Americans such as the writers John Dos Passos and Ernest Hemingway and also, of course, Picasso himself.

The Murphys were to do more than anyone else to make the French Riviera a summer destination for an elite set of sun- and sea-worshippers, having first visited it in 1922 at the behest of the composer and songwriter Cole Porter (a friend of Gerald's), who'd rented a villa in off-season Antibes. Porter never returned to the Riviera but the Murphys were smitten. They swiftly hatched a plan to come back the following year, persuading the manager of the Hôtel du Cap at Antibes to keep his establishment (which usually closed on 1 May) open especially for them and encouraging all their Paris friends to join them.

Picasso needed little persuasion and so it was that he, Olga, Paulo and the painter's mother, Dona María, booked themselves into the Hôtel du Cap in July 1923. They later moved into a separate villa at Juan-les-Pins. For Picasso, this was a golden time. The weeks flew past with the painter swimming, boating, sketching and socializing almost daily with the Murphys and their extended entourage at La Garoupe. Vivacious and charming, Sara was immensely attractive to Picasso – something of a welcome antidote to Olga, who could be stiff and stuffily formal in demeanour and never entered into the full swing of things in Cap d'Antibes. His biographer John Richardson is not alone in being convinced that Picasso and Sara had an affair. In any event, he executed numerous drawings of both Sara and his wife over the course the holidays. He also produced a series of neoclassical studies inspired by the iconography of Greek vase painting and local beach-life, which would result in such pictures as *Women Bathing* and *The Pipes of Pan*.

A year later the Picassos were back; this time ensconced in the Villa La Vigie, a cod-medieval belle époque hotel complete with a tower. The painter, evidently serious about getting some work done, set up a studio in a warehouse a street away. The hotel's tower is easily identifiable in *Juan-les-Pins*, an arresting painting with a panoramic view of the town from the hotel to the pine-shaded shore.

By 1925 the French Riviera was in fashion, its beach culture deemed chic enough to appear in the pages of *Vogue* magazine. However, the Côte d'Azur had not yet lost its cutting edge entirely. That summer Picasso met the surrealist André Breton for the first time on the French Riviera.

On 8 January 1927, the painter spotted seventeen-year-old Marie-Thérèse Walter through a shop window in Paris and seduced her by telling her she had an interesting face and that he wanted to paint her portrait. Marie-Thérèse was to become Picasso's mistress and the mother of his daughter Maya, born in 1935. Their relationship was conducted in secret and Picasso often took enormous risks by installing his lover in *pensions* just up the road from his family's own summering spot in Juan-les-Pins. Although the Picassos' marriage was all but over by 1934, Olga was not to learn the truth until after the end of the Second World War.

Marie-Thérèse was eventually to find herself competing for Picasso's affections with the photographer Dora Maar. In the summer of 1936, with Marie-Thérèse and Maya away in Normandy, Picasso headed down to Mougins to join the poet Paul Éluard and his artist wife Nusch. During his visit the Éluards arranged an excursion to Saint-Tropez to visit some mutual friends who were lodged at the Villa des Salins. Among the guests at the villa was Dora. A passionate affair blossomed between them on the Riviera. Picasso was doubly impressed by her commitment to leftist politics and that she appeared completely

▲ Antibes, France.

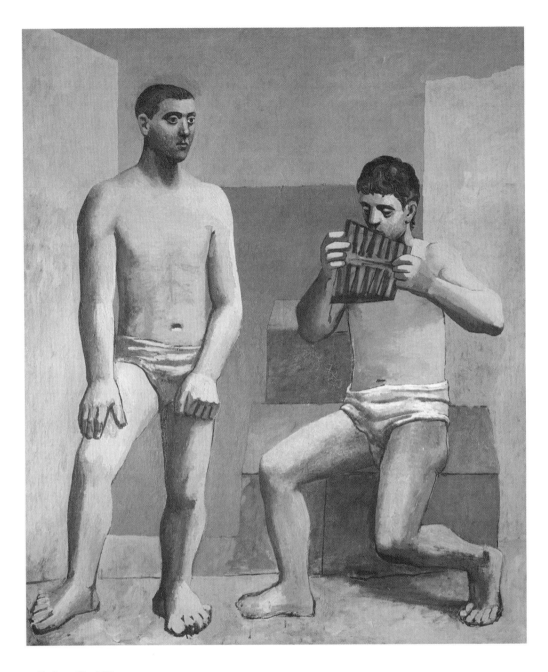

▲ *The Pipes of Pan*, 1923.

unfazed by the fact he was married to Olga and already had a mistress in Marie-Thérèse.

Dora would go on to document the creation of *Guernica*, photographing Picasso as he painted this anguished response to the fall of the Basque town to Republican forces in the Spanish Civil War. She was the model for *Weeping Woman*, superficially a portrait but another work commenting on the political events in Spain, as well as possibly the basis for one of the female figures pictured standing on the stone jetty in *Night Fishing at Antibes*. This eerie, luminous painting was to draw on a store of his impressions of the waterfront during his regular nocturnal strolls around the town's harbour. A vast canvas, almost filling an entire wall, *Night Fishing at Antibes* was completed during an intense period of activity for Picasso in late July and early August 1939; its execution fuelled by the artist's anxieties about the prospect of the outbreak of another world war. By the time war arrived in September, Picasso was back in Paris. Rejecting suggestions that he flee, he chose to remain in the French capital throughout the German occupation, despite the fact the Nazis banned him from exhibiting his art.

At the end of the war, the painter once again gravitated south. In 1946 he accepted an offer from Romuald Dor de la Souchère to spend some time painting in a large room above the museum housed in the Château Grimaldi in Antibes. By this point there was a new woman in Picasso's life, Françoise Gilot, a young painter some forty years his junior and now pregnant. The artist stayed in a house across the way in Golfe-Juan while he got down to work at his studio in the château. *The Joy of Life*, a picture as exuberant as its title suggests and indicative of Picasso's state of mind during this period, is among the canvases that resulted from this astonishingly productive spell in Antibes.

In just under two months, from 17 September to 10 November, he produced close to one hundred pieces, many featuring playful figures from antiquity and mythology, including fauns, centaurs and goats. There were still lifes too, depicting with obvious relish sumptuous arrays of seafood hauled out of the Mediterranean by local fisherfolk and spiky sea urchins washed up on the shore. Picasso delighted in the geometric possibilities the latter offered him.

If the fruits of the sea were plentiful in Antibes, oil paint and canvases were scarce in war-scarred France. Picasso resorted to reusing canvases in the museum's stores and painted on fibreboards and scrap wood using watercolour, inks and Ripolin, a shiny household paint with a limited colour range (Prussian blue, Naples yellow, Sienna red, earthy green and black and white), which he had previously used in his early Cubist phase in 1912. On his departure, the artist donated sixty-seven works to the museum. These pictures would form the basis of a permanent collection devoted to the artist and in 1966 Château Grimaldi became the first Picasso museum in the world.

For the last twelve years of his life, Notre-Dame-de-Vie, a thirty-five-room villa on a hillside above Mougins, was to serve as Picasso's home and studio. He shared the property with his final partner, the second Mrs Picasso, Jacqueline Roque. She was the subject of *Nude Woman with Necklace*, which was painted there, along with other late masterpieces. Although Mougins was to be his last address it was not his final resting place. Upon Picasso's death, the local mayor is said to have refused to allow the artist, who he decried as a 'billionaire communist' (Picasso had joined the party in 1944), to be buried anywhere in Mouglins. The painter was, therefore, laid to rest in the gardens of the Château of Vauvenargues, close to Aix-en-Provence.

John Singer Sargent Sinks into Venice

The society portraitist and painter John Singer Sargent (1856–1925) was the son of peripatetic American expatriates who shuffled around Europe living off a modest bequest for most of their lives. In the September of 1880, Sargent joined his parents and sisters in Venice. (He had visited Venice three times before – once as a baby and again aged fourteen and seventeen.) In the previous eighteen months, Sargent had already visited Spain, Morocco, Tunisia and Holland. These excursions were to furnish him with a store of ideas and the raw material for two paintings he subsequently exhibited favourably at the Salon in Paris: *Smoke of Ambergris* and *El Jaleo*. Venice presented itself as an equally ripe – perhaps even riper – prospect and when his family departed for Nice, France, he decided to stay on for the winter to find a suitable subject for a Salon study. He took lodgings in the Hotel dell'Orologio, 290 Piazza San Marco, near the clock tower as it name implies. He also acquired a studio in the Palazzo Rezzonico on the Grand Canal, a faded fifteenth-century palace that had been sliced up into a honeycomb of workrooms, memorably described as 'a veritable barracks of artists'.

Sargent was to remain in Venice for the next six months. Most likely he met James Abbott McNeill Whistler during this first extended spell in the city. He was back again in August 1882 and stayed on until that October. This time he was to live and work at the Palazzo Barbaro, where he shared a studio with his cousin Ralph Wormeley Curtis, a Harvard-educated painter. The Palazzo Barbaro on the Grand Canal was an imposing fleet of sumptuous upper-floor apartments owned and occupied by Curtis's Bostonian parents, Ariana and Daniel Sargent Curtis. With Daniel and Ariana famed for their hospitality, the Palazzo Barbaro was a first port of call for famous and artistically inclined Anglo-American visitors to Venice. Robert Browning, who lived nearby, came often to read his poems at their salons and Henry James immortalized Palazzo Barbaro in his novel *The Wings of the Dove*.

The attraction of Venice for James was both its splendour and its squalor. 'The misery of Venice', he wrote, 'stands there for all the world to see; it is part of the spectacle – a thoroughgoing devotee of local colour might consistently say it was part of the pleasure.' Sargent was just such a devotee, instantly magnetized by Venice's grubbier underbelly during these two pivotal stints here. He turned his back on its monumental architecture, thumbed his nose at its history and ignored its gleaming domes entirely. Instead, he devoted himself to its dingier canals, back-alleys with worn cobbles populated by layabouts and lone women and gloomy rooms occupied by smoking peasants and dark-eyed ladies threading beads.

If a Venetian opus for the Salon ultimately eluded him, Sargent experimented with painting *en plein air* from a gondola with watercolours. Even if he occasionally resorted to hiring models to pose

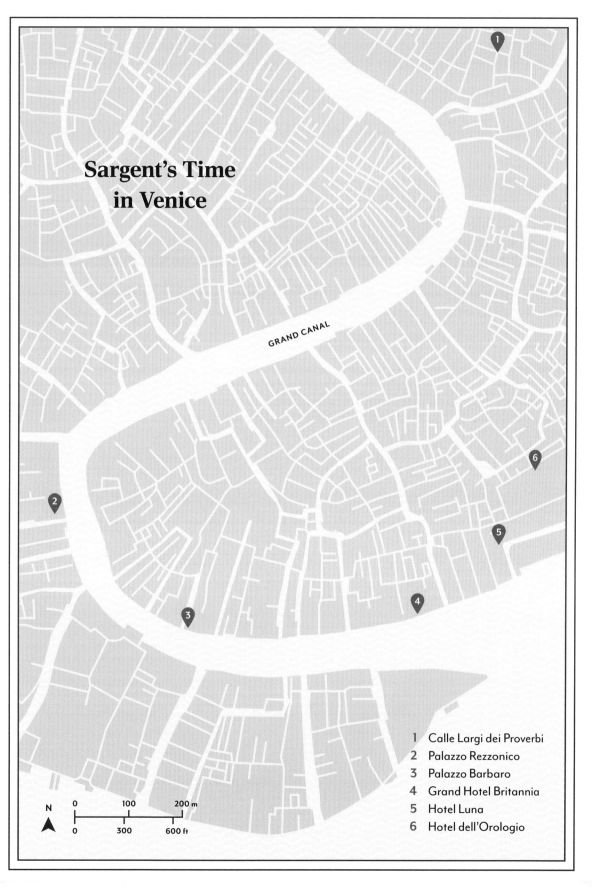

Sargent's Time
in Venice

GRAND CANAL

1 Calle Largi dei Proverbi
2 Palazzo Rezzonico
3 Palazzo Barbaro
4 Grand Hotel Britannia
5 Hotel Luna
6 Hotel dell'Orologio

N

0 100 200 m

0 300 600 ft

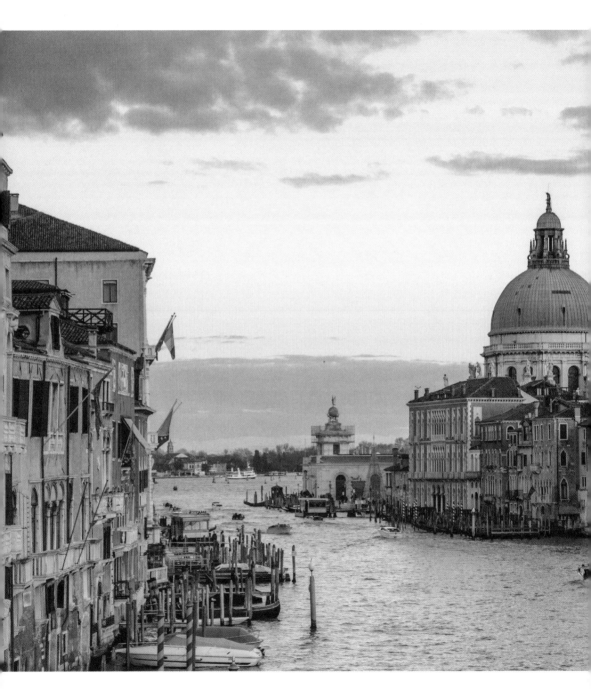

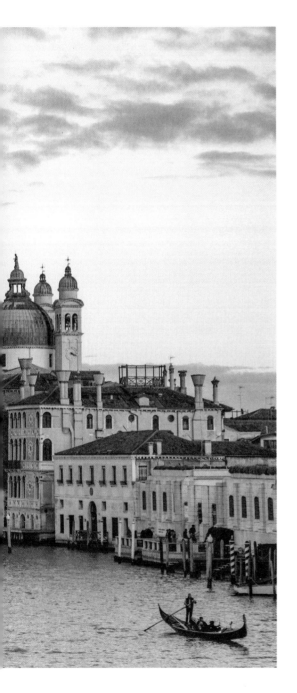

in watery locations, he caught the grit in this pearl-stuffed oyster of a city in a batch of quite revolutionary pictures. In the *Venetian Water Carriers* he documented the *bigolanti* (peasant water carriers), whose profession was soon rendered obsolete by civic improvements. *Street in Venice* offered a snapshot of the rundown Calle Larga dei Proverbi near the Campo San Canciano, while the black-clad subject of *Woman in a Gondola* appears adrift and alone in the canal.

In 1884, Sargent's painting *Madame X* (or *Madame Pierre Gautreau*) was exhibited at the Paris Salon. The painting, which depicted Gautreau in a coquettish pose and in a revealing gown, caused out-and-out scandal and Sargent was ostracized by Parisian society. Following this stormy reception the artist relocated to London. However, he continued to travel widely in Europe and beyond and returned to Venice many times. Between 1898 and 1913, he visited Venice close to annually, lodging mostly in the Palazzo Barbaro or, when that wasn't possible, the Grand Hotel Britannia in the San Marco neighbourhood. Both J.M.W. Turner and the French Impressionist Claude Monet had stayed in the latter establishment. After checking in for the first time, Monet's wife wrote home to report: 'We have finally arrived at the Hotel Britannia, with a view, if such a thing were possible, even more beautiful than that of Palazzo Barbaro.' The Hotel Luna, also in San Marco, was another establishment that Sargent and his sister Emily used.

◀ The Grand Canal, Venice.

On these later trips some of the artist's previous obsessions resurfaced in pictures such as *An Interior in Venice*, which he exhibited at the Royal Academy in London in 1900, and *Gondoliers' Siesta*, with its dozing boatmen from 1904. Sargent, who wearied of the portraiture that had brought him such fame, became more preoccupied with Venice's architecture and its topography. He was to produce over thirty watercolours of the canals, many of them of small architectural details, such as archways and bridge spans, that caught his eye. These pictures, in the opinion of the art historian Warren Adelsen 'create the illusion that we are exploring the city with the artist'. Although Venice is famed for its palaces and churches, Sargent, who managed to avoid painting Saint Mark's Basilica entirely, devoted equal attention to the humbler buildings of the Grand Canal, the Riva degli Schiavoni and the Zattere. The Libreria on the Piazzetta, for example, was of more interest to him than the Doge's Palace and the ships on Giudecca Canal, with their masts and rigging, were as fascinating to him as the church spires.

If regarded as something of relic of the pre-modernist age by the time of his death in 1925, Sargent managed to show sides of Venice that had evaded countless artists before him, his pictures of the city adding fresh layers of mystique to a watery metropolis that has long thrived on its own fairy tales.

▶ *Rio di San Salvatore, Venice,* 1906–11.

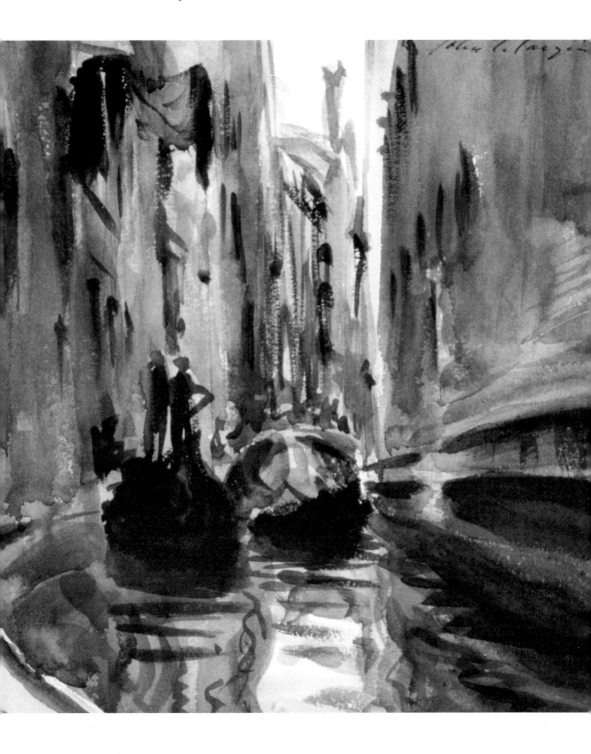

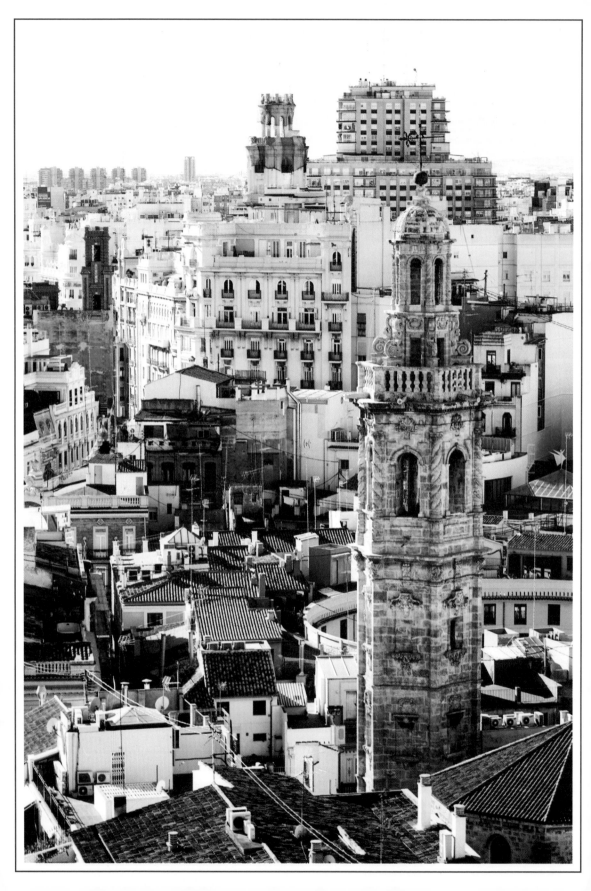

Joaquín Sorolla y Bastida Goes Canvassing across Spain

The belle époque, the era between about 1880 and the First World War, is sometimes referred to as the Gilded Age. Few painters of the era had such a gilded time or were as well regarded as the Spanish painter Joaquín Sorolla y Bastida (1863–1923), an artist whose portraits were favourably compared to John Singer Sargent. He had a unique feeling for light and excelled at painting landscapes, intimate domestic scenes and historical, mythological and social pictures on a grand scale.

Sorolla went to the United States in 1909 at the invitation of Archer Milton Huntington, the founder of the Hispanic Society of America, who'd organized a major exhibition of the artist's paintings in New York. The show was lavished with praise and Sorolla was asked to paint a portrait of the American president William Howard Taft. Sorolla had met Huntington two years earlier in London. The only son of one of the richest men in America, Huntington's interest in all things Spanish had first been ignited in 1882, at the age of twelve, after reading George Borrow's study of the Romany people, *The Zincali, or, An Account of the Gypsies in Spain*. Two years later he began to receive regular lessons in Spanish and in 1892 he embarked on his first visit to the country.

Huntington commissioned Sorolla to produce portraits of significant figures from his nation's cultural life for a public Spanish library and museum he was establishing in Upper Manhattan. The novelist Benito Pérez Galdós, the landscape painter Aureliano de Beruete and Manuel Pérez de Guzmán, the Marquis of Jerez de los Caballeros, were among those whose portraits Sorolla painted. Huntington also wanted Sorolla to undertake a mural depicting the milestones of Spanish history to run the length of a great gallery at the new institute. Sorolla suggested that instead of looking back to the past and a single frieze he should produce a series of pictures of contemporary life in Spain in all of its regional variety. Huntington deferred to the painter's idea and a commission for fourteen monumental pictures was agreed in 1911. The paintings were to be undertaken in the open air and they would, in Sorolla's words, 'truthfully capture, clearly and without the symbolism or literature, the psychology of each region'. Expanding on his ambition for the project, the painter said that he was seeking 'to give a representative view of Spain, searching not for philosophies but for the picturesque aspect of each region'.

The term 'picturesque' is widely used to refer to something attractive or eye-catching, like a mountain or country scene. However, it has quite a specific and historic meaning in art and aesthetics. Its chief progenitor in the late eighteenth century was the English clergyman and watercolorist William Gilpin, who defined

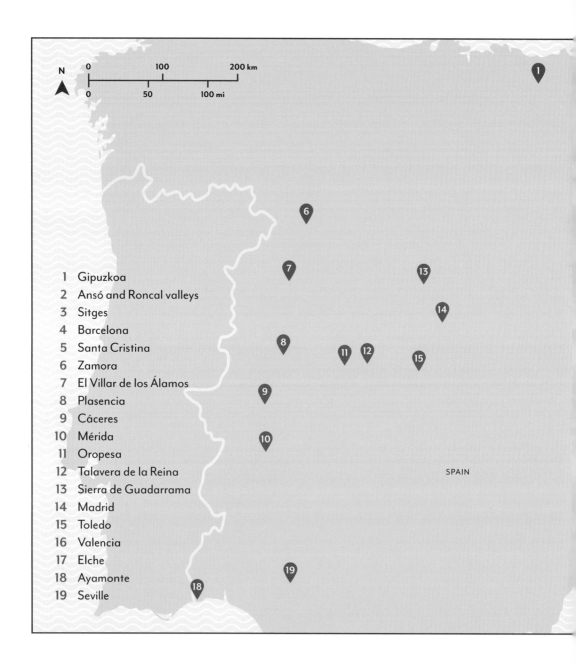

N

| 0 | 100 | 200 km |
| 0 | 50 | 100 mi |

1 Gipuzkoa
2 Ansó and Roncal valleys
3 Sitges
4 Barcelona
5 Santa Cristina
6 Zamora
7 El Villar de los Álamos
8 Plasencia
9 Cáceres
10 Mérida
11 Oropesa
12 Talavera de la Reina
13 Sierra de Guadarrama
14 Madrid
15 Toledo
16 Valencia
17 Elche
18 Ayamonte
19 Seville

SPAIN

◀ PREVIOUS PAGE Valencia,
Spain.

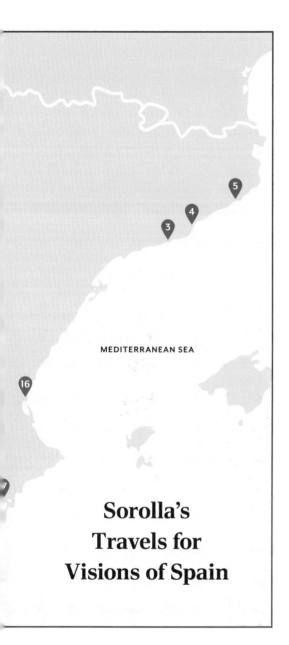

MEDITERRANEAN SEA

Sorolla's Travels for Visions of Spain

picturesque as 'a term expressive of that peculiar kind of beauty, which is agreeable in a picture'. Gilpin believed that one of the most picturesque places in England was the rugged landscape of the Wye Gorge in Herefordshire. But for Gilpin nature itself could, and indeed should, be improved upon in art and even in real life to make it look more agreeable. He famously suggested that a mallet judiciously used on the gable ends of the ruined Tintern Abbey would improve the scene.

If Sorolla went looking to capture Spain truthfully, his method of doing so involved a good deal of artifice and a monumental amount of effort on his part. He was to spend nearly ten years on the project; the final picture would not be completed until 1919 and he had little time for anything else during that time. In those years he travelled the length and breadth of Spain, from Ayamonte to Valle de Ansó and from Catalonia to Gipuzkoa.

His schedule was made even more gruelling by the means and methods he adopted to complete the series. He often spent weeks scouting for suitable subjects or characters to paint. In March 1912, for instance, he went to Oropesa in Toledo but failed to find anything that caught his eye. In the opening years of the project he undertook numerous studies that were subsequently discarded. He went to Zamora in Castile and León and only painted some flags. A panoramic work of Talavera de la Reina, an historic city by the Tagus, defeated him. As time passed, realizing that the clock was ticking, he became rather more expedient and resolved to finish as many paintings as he could *in situ* and on occasions worked from photographs. He also adopted the methods of historic studio genre paintings and found either willing volunteers or hired models to pose theatrically for him in local costume. Accordingly, his hosts at El Villar de los Álamos near La Fuente de San Esteban, the estate of the Pérez-Tabernero family, were to dress as chevaliers for a study for the series.

The seasons and the weather added to his woes. His depiction of a date harvest in Elche in Alicante had to be faked as it was painted in October when there was no crop to pick and when he travelled to Seville in January 1917, visiting Mérida, Cáceres and Plasencia along the way, the prevailing cold weather made him abandon any hope of painting anything.

Visions of Spain, as the series became known, opens with his most ambitious production, *Castile, The Bread Festival*. Based on several preliminary studies, the picture shows a Leónese procession led by musicians and girls carrying loaves, the parade cheered on by a group from Largartera wearing festive New Castile dress for the occasion. Hats and capes of the kind familiar from the Sandeman sherry and port logo are much in evidence. Elsewhere in the painting there's a grain market with carts laden with flour and its backdrop of the snow-capped mountains of Guadarrama and the tower of Toledo cathedral add to its geographical veracity.

For Navarre, Sorolla depicted the town mayors of the Pyrenean valley of Roncal (his hirelings garbed in ceremonial robes) in procession to a church service dating back centuries that forms part of an annual meeting to collect pasture rents from French herdsmen.

Neighbouring Aragon, also pictured with the peaks of the Pyrenees in the background, was represented by some cheerful rustics dancing the *jota*, the women in full-length skirts, their ballroom a threshing floor laden with sheaves of ripe grain. These figures were actually modelled after an earlier study he'd made in his studio in Madrid of a grandmother and her granddaughter from Ansó.

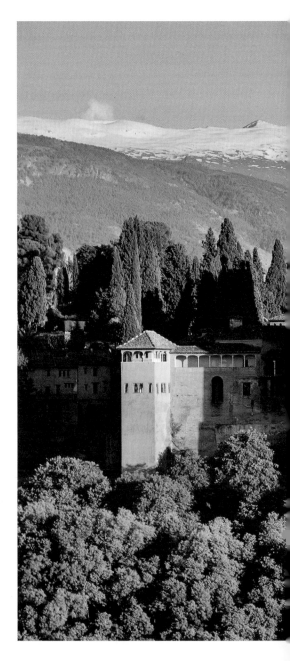

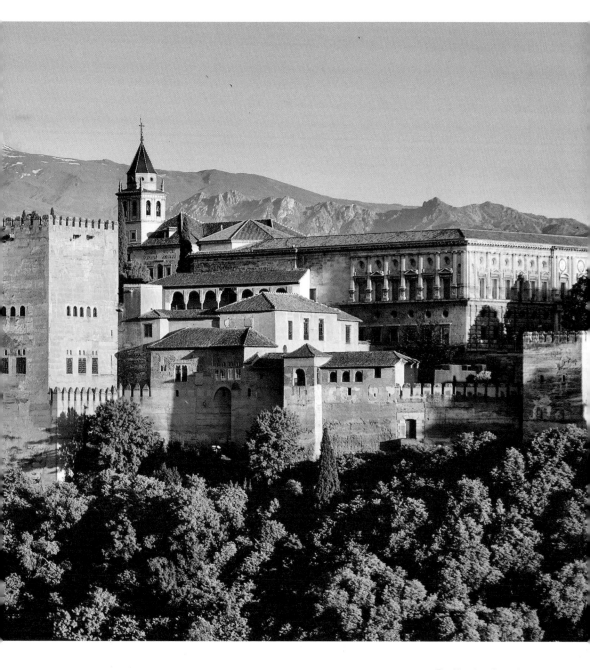

▲ The Alhambra, Granada,
Andalusia, Spain.

A fish market, meanwhile, represented Catalonia, with the proceedings overlooked by a top-hatted *mozo*, an officer in its regional police force. For this painting of Catalonia, Sorolla had initially gone to Barcelona and ventured along the coast to Sitges. However, it had singly failed to interest him. Two weeks later he discovered the perfect location, Santa Cristina in Lloret de Mar.

Valencia, where Sorolla was born and where he worked and studied until 1881, was shown in full celebration mode with another festival procession. The painting features men bearing branches of oranges, girls riding ponies and a canopied statue of the Virgen de los Desamparados (Our Lady of the Forsaken), the patroness of the city.

Andalusia, the region that runs along the whole of southern Spain, had five canvases devoted to it. Among them was a painting of the famous Maestranza bullring in Seville. Another depicted the tuna market at Ayamonte receiving fresh stock from the fishermen who plied the waters of the Gulf of Cádiz. Again, Sorolla spent weeks roaming the coast of Huelva until he eventually came upon Ayamonte on the border of Portugal.

Food was also the topic of Sorolla's tribute to Extremadura. In this picture aproned men and bonneted women in Plasencia are shown at a hog market where prime specimens of the local grey-black pigs are up for sale.

The final canvas was of Galicia, the damp corner of the country to the north between the Atlantic and the Cantabrian sea. This provice, much rained upon but abundant in fodder for cattle, shows cows awaiting their sale, with a man playing the native bagpipes adding to the gaiety of the event.

On finishing the commission and utterly broken by the physical and mental exertion it had required, Sorolla retreated to his house in Madrid where, like Monet, he'd made a garden that became his main

subject for the all too short period he had left. In June 1920, he suffered a stroke that robbed him of the ability to paint and he died three years later. The public gallery at the Hispanic Society of America, named in his honour and housing the Visions of Spain series, finally opened in 1926. By then sadly, Sorolla, who if an incredibly innovative painter, always stood aloof from the emerging avant garde, had come to be seen as rather old hat. But if modernism was to sweep aside for a time the likes of Sorolla (and Sargent) in its bid to remake the world after the First World War, Visions of Spain has come to be seen as a landmark of Spanish painting, albeit one that cost its author rather dearly.

◀ *The Jota, Aragon*, 1914.

▼ Joaquin Sorolla y Bastida painting in Salamanca, Spain, 1912.

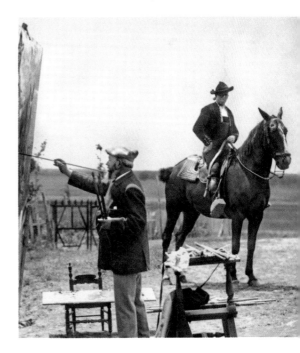

J.M.W. Turner Takes a Final Tour of Switzerland

In a line famously ad-libbed during the filming of *The Third Man*, Orson Welles was to malign Switzerland as a place so dull that its preeminent contribution to Western civilization was the cuckoo clock. As is often the case with such brilliantly memorable extemporized remarks, Welles was factually incorrect. For the time piece in question was first invented in Bavaria, as perhaps many an aggrieved clockmaker from southern Germany was keen to point out. And as for Switzerland as an irredeemable snoozefest, this would have come as a complete surprise to the poets, writers, painters, explorers and sportsmen of the late eighteenth and early nineteenth century. For them, its glaciers and mountains and alpine scenery represented one of the most forbidding and thrilling landscapes on earth. As the art historian Andrew Wilson has observed, the first ascent of Mont Blanc in 1786 was considered every bit as astonishing in its day as the first landing on the moon in more recent times. Here in spades, after all, was the 'agreeable horror' of sublime nature, as defined by Joseph Addison, the English critic, playwright and politician whose writings were to help crystallize the notion of Romanticism.

William Wordsworth, the lakeland poet at the vanguard of this artistic movement in Britain, would undertake a tour of Switzerland in 1790. Overwhelmed by what he saw there, Wordsworth described the experience in transcendent terms. Writing in a letter home to his sister Dorothy, he stated that 'among the awful scenes of the Alps, I had not a thought of a man, or a single created being; my whole soul was turned to Him who produced the terrible majesty before me'.

The French Revolution and the subsequent Napoleonic Wars put the Continent almost completely out of the reach of British travellers between 1793 and 1815. However, the signing of the Peace of Amiens in 1802, an interlude in Anglo-French hostilities that lasted less than a year, offered a brief window for Britons to visit Europe and vice versa. For those of an artistic inclination a further incentive, if it was needed, was the chance to go to Paris to see the vast collection of Old Masters that Bonaparte had pilfered from Italy and elsewhere, which were on public display in the Louvre. That summer and autumn, hundreds seized the opportunity to cross the Channel. The English painter J.M.W. Turner (1775–1851) was aboard one of the first boats to Calais. Turner, then aged just twenty-seven, had only recently become the youngest artist ever to be elected a full academician at the Royal Academy. Eager to record all that the Continent had to offer, he began sketching from the moment he landed on French soil and continued to fill notebooks with pictures throughout this tour.

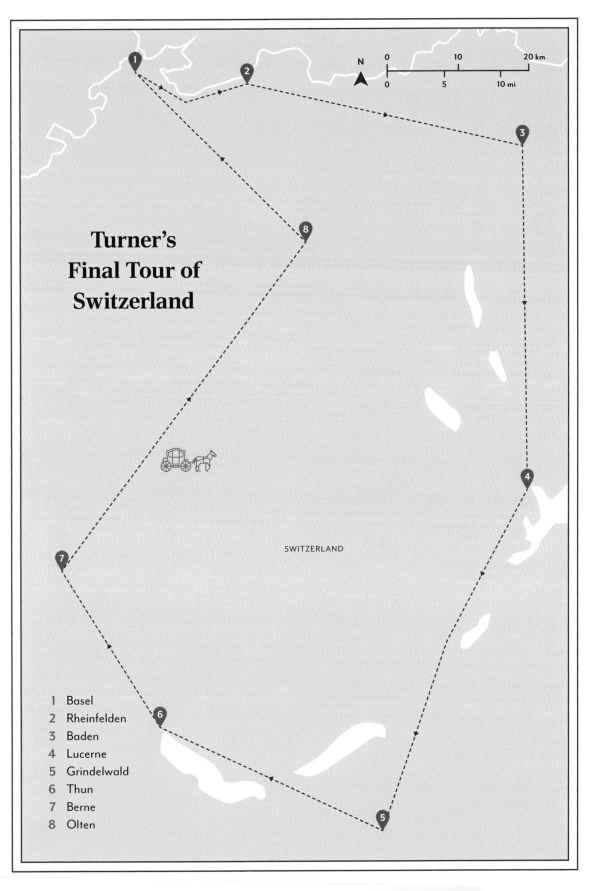

Turner's
Final Tour of
Switzerland

N

0 10 20 km

0 5 10 mi

SWITZERLAND

1 Basel
2 Rheinfelden
3 Baden
4 Lucerne
5 Grindelwald
6 Thun
7 Berne
8 Olten

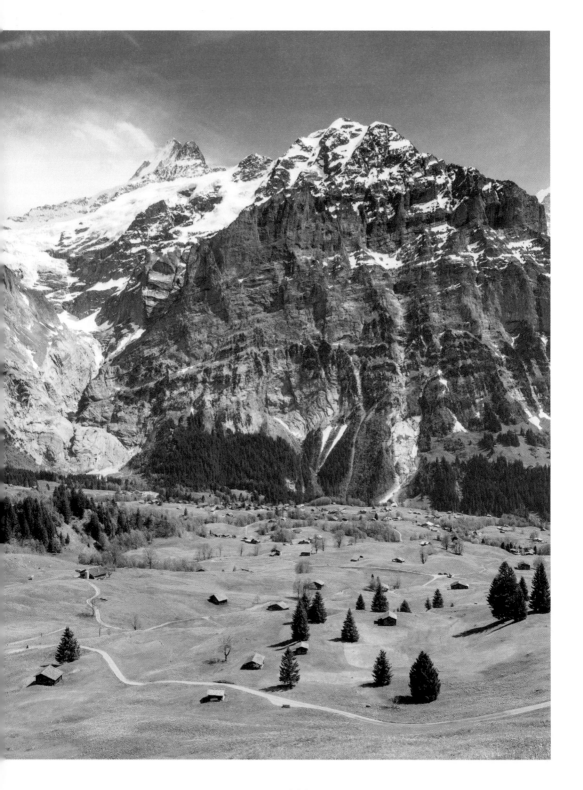

Turner was hell bent on seeing Switzerland on this opening European excursion – the first of no less than eighteen Continental journeys the artist is known to have made. After dutifully ticking off Paris and the Louvre, Turner headed to the Alps via Dauphiné and Savoy in south-east France, in no less haste. Once there he was enchanted by the people's traditional dress and the country's rugged terrain and low-lying lakes. He was to complete over 400 drawings of local scenery, recording facets of its rural life and its landscape of mountains, castles, bell towers and look-out posts. It was to be thirty-four years before Turner visited Switzerland again but he was to draw on this score of images in many subsequent paintings, notably *Snow Storm: Hannibal and His Army Crossing the Alps*, first exhibited in 1812.

In the opinion of Andrew Wilton, a leading Turner scholar, as the artist grew older the region of Switzerland and the Alps, from Austria to Savoy, was to become more and more important for Turner. The Rigi, the so-called Queen of the Mountains in the Schwyz Alps was one subject, for example, that he painted repeatedly toward the end of his life. However, the choice of Switzerland as a destination was just as much a matter of ageing as aesthetics. After 1840 the painter was simply no longer physically capable of enduring the longer journey to Italy. Switzerland's light, air and topography clearly fired his mature imagination and its spa resorts promised to ease age-related ills. While his health permitted it, he insisted on returning to central Switzerland, visiting it every year from 1841 to 1844, after which he was only able to make one further trip abroad. The remaining six years of his life were to be spent living rather squalidly in London until cholera eventually claimed him in December 1851.

Turner was sixty-nine when he embarked on his last voyage to the land of peaks and lakes in 1844. In the intervening decades since his first visit, Switzerland had, in the view of the contemporary American poet and physician Oliver Wendell Holmes, become 'a thoroughfare of travelling Europe, and especially of the English who swarm in it to the most outrageous extent'. The railways, whose progress Turner had documented in *Rain, Steam and Speed – The Great Western Railway* (a painting first displayed at the Royal Academy only a few months earlier), had begun to open up the country to tourists and mountaineers, large numbers of them coming from England. The painter took full advantage of these changes, travelling by train and lodging in the kind of hotels that catered to the needs of such sightseers.

Testy, intensely private, mostly solitary and slightly eccentric, Turner, in common with many British visitors to the Continent then and since, spoke only English. His sketchbooks contain jottings of useful phrases in French, German and Italian but it is doubtful his foreign vocabulary stretched much beyond these. This coupled with the artist's general caginess about his movements, at home and aboard, and the absence of written records means that the entire course of his journey cannot be charted. However, on the basis of his sketchbooks and the few surviving official documents from the period, scholars have pieced together an itinerary for certain stages of his last sojourn around Switzerland.

For instance, reports of guests arriving in the German city of Heidelberg on the River Neckar confirm that Turner and George Fownes, a Fellow of the Royal Society, checked into the Prinz Carl Hotel in the Corn Market on Saturday 24 August 1844. The art historian Prue Bishop notes that the Baedeker's guide then rated the Prinz Carl as the finest hotel in the city but also the most expensive.

◄ Grindelwald, Switzerland.

Four years earlier, Turner had sketched the Corn Market and Heidelberg's castle from the same establishment and he again drew these landmarks and finished some further studies of the River Neckar.

Bishop proposes Fownes as Turner's fellow guest and possible travelling companion. However, the painter appears to have continued on alone, leaving Heidelberg in the early morning of Monday 26 August and boarding a train to Kehl, a small town on the opposite side of the Rhine from Strasbourg. Turner, therefore, entered the Alsatian capital by boat after an hour-long crossing over the river. That afternoon he was on his way again, taking yet another train from Strasbourg to the Swiss border on the outskirts of Basel. Once he'd cleared the customs posts he entered the city that evening, checking into the Hotel de la Tête d'Or, an establishment commended to English visitors by Murray's *A Handbook for Travellers in Switzerland: and the Alps of Savoy and Piedmont* of 1838.

After a day in Basel, Turner was on the move once more, this time making a journey by horse-drawn diligence to Rheinfelden. The stop in Rheinfelden was just long enough for the artist to undertake some sketches of the bridges over the Rhine and then he continued on to Baden where he planned to take the waters. Baden's hot-water mineral springs had been considered a curative since Roman times but by the point of Turner's visit they were increasingly favoured by Europe's gout-ridden aristocrats and sickly elite. Turner reached Baden on Wednesday 28 August. Again his accommodation was distinguished. Of the eleven significant places that Murray's handbook listed for Baden, the Hotel Staadhof, where Turner chose to lodge for the next week, was deemed the very best.

▼ *The Lake of Thun, c.1844.*

A city on twin levels, dominated to the west by the ruined hill-top castle Stein, a former Habsburg fortress, Baden lies on the River Limmat. Its fashionable spa, the Grosse Bader (Great Baths) was tucked into a bend of the river on its left bank, while the Ennetbaden, a less-fashionable space, which Murray's handbook warned was frequented by 'the lower orders', was on the opposite bank. It's likely when it came to matters of personal hydrotherapy that Turner didn't slum it and stuck to the Great Baths. Turner drew a series of views of Baden, which he'd first visited back in 1802, from its northern vantage point. The spire of the city's Swiss Reformed Church is a striking feature of these particular surveys.

After Baden, Turner ventured to Lucerne, whose cathedral he'd previously sketched in 1841. From hereon, Turner was forced to revise his travel plans in the face of poor weather. Bishop has calculated from his subsequent sketches that his new route 'took him over the Brünig and Grosse Scheidegg Passes to Grindelwald, then on via Lake Thun and Berne back to the northern parts of Switzerland'. His course home was via Basel and Strasbourg; along the way Olten, a scenic small town near Aarburg, was another place that stirred him into artistic action.

Turner was to leave England only once more after his final tour of Switzerland, this time unable to travel further than the north coast of France. The artist continued to paint and draw until almost the last year of his life. Right up until the end it was, in the view of Wilton, still Switzerland that inspired him as he worked and reworked watercolours and sketches of scenes from his travels to the country.

◄ Thun, Switzerland.

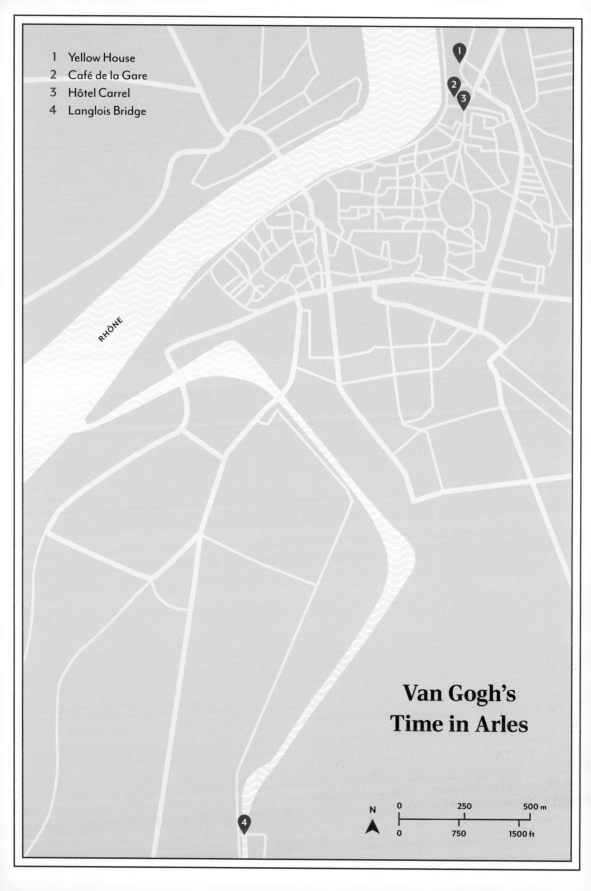

1 Yellow House
2 Café de la Gare
3 Hôtel Carrel
4 Langlois Bridge

RHÔNE

**Van Gogh's
Time in Arles**

N

0	250	500 m
0	750	1500 ft

Vincent van Gogh Has Quite a Year in Provence

In many respects Arles in Provence in southern France represented a final and slightly desperate throw of the dice for the Dutch artist Vincent van Gogh (1853–1890). In 1888, the painter was pinning all his hopes on establishing some kind of colony of arts there. He wanted a place where like-minded souls could gather and be warmed by the Mediterranean sun, far from the Parisian café society he'd been orbiting for the previous two years. A place where perhaps a whole new art movement might be born.

With this dream in mind, Van Gogh clambered aboard a southbound train from an icy Paris on 19 February. Fifteen hours later he stepped off the train at Arles station and was greeted by a blast of even icier air. The Rhône valley was enduring its coldest February since 1860. Van Gogh had to trudge through drifts of snow with his luggage to reach his hotel, the Hôtel Carrel on the rue de la Cavalerie. A room at the hotel cost the cash-strapped artist five francs a night and the bill would later become a matter of some contention between the artist and the hotel management. Convinced they were overcharging him, Van Gogh took them to a local arbitrator and was rewarded with a reduction of twelve francs. However, this proved something of a Pyrrhic victory. Relations between the artist and the hotelier soured and soon after this Van Gogh opted to leave, finding a room for a mere one and a half francs a night in the Café de la Gare with the rather more agreeable Joseph and Marie Ginoux.

All of this was to be funded by Van Gogh's loyal but long-suffering brother, Theo, who between March 1888 and April 1889 sent Vincent some 2,300 francs in letters or by telegram or postal order, along with rolls of canvas and paint and other sundries. It was Theo's money that in May allowed Van Gogh to move into the Yellow House, at 2 place Lamartine, outside the city's ancient ramparts, which was to serve as his home and studio. That October, Van Gogh was to be joined there by Paul Gauguin, Theo having agreed to accept two canvases a month in lieu of Gauguin's share of the rent.

A former sailor who'd climbed the greasy pole of the Paris stock exchange and went on to bag himself a salary of some 23,000 francs a year, Gauguin had been a keen amateur dauber. However, after losing his job in the fallout of the financial crash of 1881, he decided to make a go of it as a painter. The arrangement in Arles began well enough but famously turned bad quite dramatically. It was to conclude, after just nine weeks, with Van Gogh threatening Gauguin with a cut-throat razor, which he then used to cut off part of his own left ear. In turn, Van Gogh presented his severed ear as a gift to Gabrielle Berlatier, a prostitute at a brothel in the rue du Bout d'Arles. (The front parlour of the brothel, an establishment that both artists frequented, is immortalized in one of Van Gogh's paintings.) Meanwhile, Gauguin fled to the Hôtel Thévot, close to a café terrace in the place du Forum that

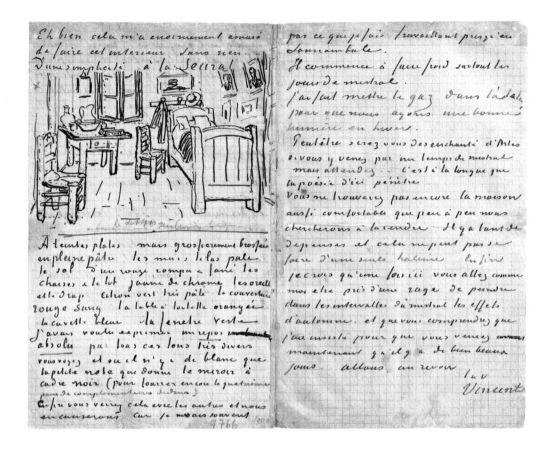

the Dutchman had also painted. Van Gogh was to suffer a second breakdown in February 1889 and eventually he voluntarily entered the asylum in Saint-Rémy on 8 May 1889.

The period in Arles between the thaw of the frosts and the onset of his mania saw Van Gogh at his most inspired and productive. Although he often felt isolated and lonely – he found the Provençal dialect incomprehensible, despaired at the lack of 'really strong soup' and macaroni in the local restaurants and denounced Arles as 'a filthy town, with old streets' – he started painting almost immediately. His first picture, *Landscape with Snow*, was completed within days of his arrival. It shows a figure with a dog walking through fields, where patches of brown, yellow and green are

emerging, most of the snow having already melted. In a sense, Van Gogh's own relationship to Arles would warm with the seasons – and, arguably, deteriorate with the onset of winter.

After spells in grey places such as Etten, The Hague, Drenthe and Nuenen in the Netherlands, as well as Brussels, London and Paris, the power of the Provençal sun, the quality of its light and the colours and vibrancy of the local countryside rejuvenated him. Taking Japanese prints as a model, pictures such as *Pink Peach Trees* and *Orchard in Blossom (Apricot Trees)* document the

◀ Arles, France.

▲ Letter to Paul Gauguin from Arles, Wednesday 17 October 1888.

arrival of spring blossom. As the seasons turned, he moved in phase with the agricultural year, producing a series of 'summer' and then 'harvest' studies. He filled his canvases with haystacks, meadows in bloom and cornfields. *Sower in the Setting Sun* would be the work of a week 'among the cornfields in the full sun'. He also produced views of the plain of Crau and local landmarks such as the ruined monastery of Montmajour and the Langlois Bridge (*Drawbridge with Carriage* and *Drawbridge with Lady with Parasol*) as well as paintings of a local butcher's shop, café and the brothel parlour. There were also portraits of Arles's local citizens, from weathered peasant women to a postal worker, Joseph Roulin, with whom Van Gogh had some of his lengthiest conversations while collecting mail and sending letters. There were even marine scenes from trips to Saintes-Maries-de-la-Mer on the Mediterranean. It must have seemed as if not even the Mistral could stem the tide of pictures that were flowing out of him. And then, of course, like all good things, it came to an end.

Without Arles, Van Gogh might never have painted his *Sunflowers*. Earlier versions attempted while he was still in Paris wilt in comparison to the work he achieved after experiencing the balm of the southern sun.

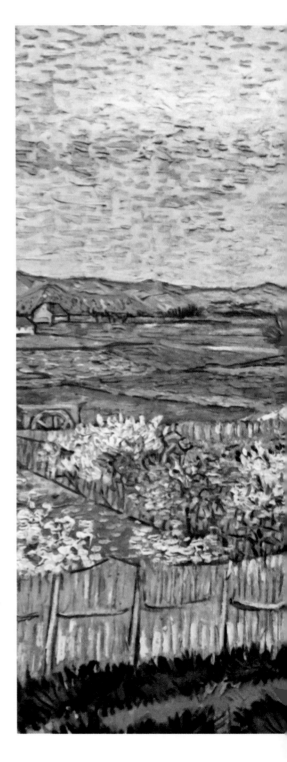

▶ *Peach Trees in Blossom near Arles*, 1889.

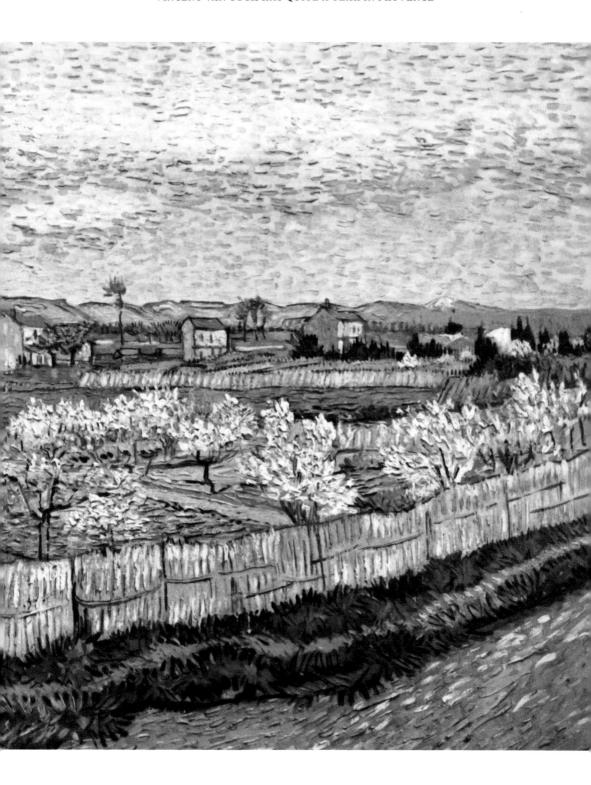

Selected Bibliography

This book owes an enormous debt to numerous other books and articles. This selected bibliography will, hopefully, give credit where credit is due and point those who want to know more in the right directions.

Jean-Michel Basquiat

Basquiat, Jean-Michel, *The Notebooks*, ed. Larry Warsh (Princeton University Press, 2015).

Buchhart, Dieter, Eleanor Nairne and Lotte Johnson, eds, *Basquiat: Boom for Real* (Prestel, in association with Barbican Art Gallery, 2017).

Clement, Jennifer, *Widow Basquiat: A Memoir* (Canongate, 2014).

Lurie, John, *The History of Bones: A Memoir* (Random House, 2021).

Caravaggio

Graham-Dixon, Andrew, *Caravaggio: A Life Sacred and Profane* (Allen Lane, 2010).

Hinks, R.P., *Michelangelo Merisi da Caravaggio: His Life, His Legend, His Works* (Faber, 1953).

Langdon, Helen, *Caravaggio: A Life* (Chatto and Windus, 1998).

Robb, Peter, *M* (Bloomsbury, 2000).

Sciberras, Keith, and David Stone, *Caravaggio: Art, Knighthood, and Malta* (Midsea Books, 2006).

Zuffi, Stefano, *Caravaggio: Masters of Art* (Prestel, 2012).

Mary Cassatt

Curie, Pierre, and Nancy Mowll Mathews, eds, *Mary Cassatt: An American Impressionist in Paris* (Yale University Press, 2018).

Garb, Tamar, *Women Impressionists* (Phaidon, 1986).

Lucie-Smith, Edward, *Impressionist Women* (Weidenfeld and Nicolson, 1989).

Mathews, Nancy Mowll, *Mary Cassatt* (Abrams, in association with the National Museum of American Art, Smithsonian Institution, 1987).

Pollock, Griselda, *Mary Cassatt: Painter of Modern Women* (Thames and Hudson, 1998).

Paul Cézanne

Andersen, Wayne, *The Youth of Cézanne and Zola: Notoriety at Its Source: Art and Literature in Paris* (Éditions Fabriart, 2003).

Athanassoglou-Kallmyer, Nina Maria, *Cézanne and Provence: The Painter in His Culture* (University of Chicago Press, 2003).

Conisbee, Philip and Denis Coutagne, *Cézanne in Provence* (Yale University Press, 2006).

Danchev, Alex, *Cezanne: A Life* (Profile Books, 2012).

Hanson, Lawrence, *Mountain of Victory: A Biography of Paul Cézanne* (Secker and Warburg, 1960).

Mack, Gerstle, *Paul Cézanne* (Jonathan Cape, 1935).

Perruchot, Henri, *Cézanne* (Perpetua Books, 1961).

Salvador Dalí

Dalí in New York, film, directed by Jack Bond (1965).

Dalí, Salvador, *The Secret Life of Salvador Dalí*, trans. Haakon M. Chevalier (Vision, 1976).

Etherington-Smith, Meredith, *Dalí: A Biography* (Sinclair-Stevenson, 1992).

Gibson, Ian, *The Shameful Life of Salvador Dalí* (Faber, 1997).

Marcel Duchamp

Brandon, Ruth, *Spellbound by Marcel: Duchamp, Love, and Art* (Pegasus Books, 2022).

Fiala, Vlastimil, *The Chess Biography of Marcel Duchamp* (Moravian Chess, 2002).

Kuenzli, Rudolf E., and Francis M. Naumann, *Marcel Duchamp: Artist of the Century* (MIT Press, 1990).

Naumann, Francis M., Bradley Bailey and Jennifer Shahade, *Marcel Duchamp: The Art of Chess* (Readymade Press, 2009).

Tomkins, Calvin, *Duchamp: A Biography* (Chatto and Windus, 1997).

Albrecht Dürer

Ashcroft, Jeffrey, *Albrecht Dürer: A Documentary Biography* (Yale University Press, 2017).

Conway, William Martin, *Albrecht Dürer: His Life and a Selection of His Works/with Explanatory Comments on the Various Plates by Dr Friedrich Nüchter*, trans. Lucy D. Williams (Ernst Frommann and Sohn, 1928).

Dürer, Albrecht, *Records of Journeys to Venice and the Low Countries*, ed. Roger Fry, trans. Rudolf Tombo (Merrymount Press, 1913).

Hoare, Philip, *Albert and the Whale* (Fourth Estate, 2021).

Wolf, Norbert, *Albrecht Dürer* (Prestel, London, 2019).

Helen Frankenthaler

Gabriel, Mary, *Ninth Street Women: Lee Krasner, Elaine de Kooning, Grace Hartigan, Joan Mitchell, and Helen Frankenthaler: Five Painters and the Movement That Changed Modern Art* (Little, Brown, 2018).

Nemerov, Alexander, *Fierce Poise: Helen Frankenthaler and 1950s New York* (Penguin Books, 2021).

Rose, Barbara, *Frankenthaler* (Harry N. Abrams, 1971).

Wilson, Reuel K., *To the Life of the Silver Harbor: Edmund Wilson and Mary McCarthy on Cape Cod* (University Press of New England, 2008).

Caspar David Friedrich

Asvarishch, Boris, Vincent Boele and Femke Foppema, *Caspar David Friedrich and the German Romantic Landscape* (Lund Humphries, 2008).

Borsch-Supan, Helmut, *Caspar David Friedrich* (Thames and Hudson, 1974).

Grave, Johannes, *Caspar David Friedrich* (Prestel, 2012).

Hofmann, Werner, *Caspar David Friedrich* (Thames and Hudson, 2000).

Koerner, Joseph Leo, *Caspar David Friedrich and the Subject of Landscape* (Reaktion Books, 1990).

David Hockney

Cusset, Catherine, *David Hockney: A Life*, trans. Teresa Lavender Fagan (Arcadia, 2020).

Starr, Kevin, and David L. Ulin, *Los Angeles: Portrait of a City*, ed. Jim Heimann (Taschen, 2009).

Sykes, Christopher Simon, *Hockney: The Biography* (Century, 2011).

Webb, Peter, *Portrait of David Hockney* (Chatto and Windus, 1988).

Katsushika Hokusai

Bouquillard, Jocelyn, *Hokusai's Mount Fuji: The Complete Views in Color*, trans. Mark Getlein (Abrams, 2007).

Calza, Gian Carlo, *Hokusai* (Phaidon, 2003).

Guth, Christine M.E., *Hokusai's Great Wave: Biography of a Global Icon* (University of Hawai'i Press, 2015).

Narazaki, Muneshige, *Hokusai: The Thirty-six Views of Mt. Fuji*, trans. John Bester (Kodansha International, 1968).

Tove Jansson

Jansson, Tove, *Sculptor's Daughter: A Childhood Memoir*, trans. Kingsley Hart (Sort of Books, 2013).

Jansson, Tove, and Tuulikki Pietila, *Notes from an Island*, trans. Thomas Teal (Sort of Books, 2021).

Karjalainen, Tuula, *Tove Jansson: Work and Love* (Particular Books, 2014).

Westin, Boel, *Tove Jansson: Life, Art, Words: The Authorised Biography* (Sort of Books, 2014).

Frida Kahlo and Diego Rivera

Alcántara, Isabel, and Sandra Egnolff, *Frida Kahlo and Diego Rivera* (Prestel, 1999).

Arteaga, Agustín, ed., *México 1900–1950: Diego Rivera, Frida Kahlo, José Clemente Orozco and the Avant-Garde* (Dallas Museum of Art, 2017).

Brand, Michael, et al., *Frida Kahlo, Diego Rivera and Twentieth-Century Mexican Art: The Jacques and Natasha Gelman Collection* (Museum of Contemporary Art, 2000).

Herrera, Hayden, *Frida: A Biography of Frida Kahlo* (Harper and Row, 1983).

Richmond, Robin, *Frida Kahlo in Mexico* (Pomegranate Artbooks, 1994).

Schaefer, Claudia, *Frida Kahlo: A Biography* (Greenwood/Harcourt Educational, 2009).

Wassily Kandinsky

Lindsay, Kenneth C., and Peter Vergo, eds, *Kandinsky: Complete Writings on Art* (De Capo, 1994).

Le Targat, François, *Kandinsky*, (Rizzoli, 1987).

Sers, Philippe, *Kandinsky: The Elements of Art*, trans. Jonathan P. Eburne (Thames and Hudson, 2016).

Turchin, Valery, *Kandinsky in Russia: Biographical Studies, Iconological Digressions, Documents* (The Society of Admirers of the Art of Wassily Kandinsky, 2005).

Weiss, Peg, *Kandinsky and Old Russia: The Artist as Ethnographer and Shaman* (Yale University Press, 1995).

Alexander Keirincx

Brotton, Jerry, *The Sale of the Late King's Goods: Charles I and His Art Collection* (Pan Macmillan, 2007).

Shawe-Taylor, Desmond, and Per Rumberg, eds, *Charles I: King and Collector* (Royal Academy of Arts, 2018).

Townsend, Richard P., 'Alexander Keirincx's Royal Commission of 1639–1640', in Juliette Roding et al., *Dutch and Flemish Artists in Britain 1550–1800* (Primavera Press, 2003).

Paul Klee

Baumgartner, Michael, et al., *The Journey to Tunisia, 1914: Paul Klee, August Macke, Louis Moilliet* (Hatje Cantz, 2014).

Benjamin, Roger, and Cristina Ashjian, *Kandinsky and Klee in Tunisia* (University of California Press, 2015).

Haxthausen, Charles Werner, *Paul Klee: The Formative Years* (Garland, 1981).

Klee, Paul, 'Diary of a Trip to Tunisia', in August Macke, *Tunisian Watercolors and Drawings: With Writings by August Macke, Günter Busch, Walter Holzhausen and Paul Klee* (Harry N. Abrams, 1959).

Wigal, Donald, *Paul Klee (1879–1940)* (Parkstone International, 2011).

Gustav Klimt

Dobai, Johannes, *Gustav Klimt: Landscapes*, trans. Ewald Osers (Weidenfeld and Nicolson, 1988).

Huemer, Christian, and Stephan Koja, *Gustav Klimt: Landscapes* (Prestel, 2002).

Rogoyska, Jane, and Patrick Bade, *Gustav Klimt* (Parkstone Press International, 2011).

Weidinger, Alfred, ed., *Gustav Klimt* (Prestel, 2007).

Whitford, Frank, *Klimt* (Thames and Hudson, 1990).

Oskar Kokoschka

Bultmann, Bernard, *Oskar Kokoschka*, trans. Michael Bullock (Thames and Hudson, 1961).

Calvocoressi, Richard, *Oskar Kokoschka* (Tate Gallery, 1986).

Schmalenbach, Fritz, *Oskar Kokoschka*, trans. Violet M. Macdonald (Allen and Unwin, 1968).

Schröder, Klaus Albrecht, et al., eds, *Oskar Kokoschka*, trans. David Britt (Prestel, 1991).

Henri Matisse

Cowart, Jack, et al., *Matisse in Morocco: The Paintings and Drawings, 1912–1913* (Thames and Hudson, 1990).

Essers, Volkmar, *Henri Matisse, 1869–1954: Master of Colour* (Taschen, 2012).

Spurling, Hilary, *Matisse the Master: A Life of Henri Matisse: Conquest of Colour, 1909–1954* (Hamish Hamilton, 2005).

Stevens, Mary Anne, ed., *The Orientalists: Delacroix to Matisse: European Painters in North Africa and the Near East* (Royal Academy of Arts, in association with Weidenfeld and Nicolson, 1984).

Claude Monet

Assouline, Pierre, *Discovering Impressionism: The Life and Times of Paul Durand-Ruel* (Vendome Press, 2004).

Bowness, Alan, and Anthea Callen, *The Impressionists in London* (The Arts Council of Great Britain, 1973).

Cogniat, Raymond, *Monet and His World* (Thames and Hudson, 1966).

Corbeau-Parsons, Caroline, ed., *Impressionists in London: French Artists in Exile, 1870–1904*, (Tate Publishing, 2017).

Seiberling, Grace, *Monet in London* (University of Washington, 1988).

Berthe Morisot

Garb, Tamar, *Women Impressionists* (Phaidon, 1986).

Higonnet, Anne, *Berthe Morisot: A Biography* (Collins, 1990).

Lucie-Smith, Edward, *Impressionist Women* (Weidenfeld and Nicolson, 1989).

Edvard Munch

Bischoff, Ulrich, *Munch* (Thames and Hudson, 2019).

Bjerke, Øivind Storm, *Edvard Munch, Harald Sohlberg: Landscapes of the Mind*, trans. Francesca M. Nichols and Pat Shaw (National Academy of Design, 1995).

Hulse, Michael, *Edvard Munch* (Taschen, 1992).

Müller-Westermann, Iris, *Munch by Himself* (Royal Academy of Arts, 2005).

Ustvedt, Øystein, *Edvard Munch: An Inner Life*, trans. Alison McCullough (Thames and Hudson, 2020).

Vaizey, Marina, and Edward Lucie-Smith, *Edvard Munch: Life – Love – Death* (Cv Publications, 2012).

Wright, Barnaby, ed., *Edvard Munch; Masterpieces from Bergen* (Courtauld/Paul Holberton Publishing, 2022).

Isamu Noguchi

Ashton, Dore, *Noguchi East and West* (Knopf, 1992).

Herrera, Hayden, *Listening to Stone: The Art and Life of Isamu Noguchi* (Thames and Hudson, 2015).

Hunter, Sam, *Isamu Noguchi* (Thames and Hudson, 1979).

Marianne North

North, Marianne, *A Vision of Eden: The Life and Work of Marianne North*, Graham Bateman ed., (The Royal Botanic Gardens, Kew, in association with Webb & Bower, 1980).

Georgia O'Keeffe

Bry Doris, and Nicholas Callaway, eds, *Georgia O'Keeffe: In the West* (Knopf, 1986).

Castro, Jan Garden, *The Art and Life of Georgia O'Keeffe* (Crown, 1985).

Corn, Wanda M., *Georgia O'Keeffe: Living Modern* (Prestel, in association with Brooklyn Museum, 2017).

Drohojowska-Philp, Hunter, *Full Bloom: The Art and Life of Georgia O'Keeffe* (W.W. Norton, 2004).

Lynes, Barabar Buhler, et al., *Georgia O'Keeffe and New Mexico: A Sense of Place* (Princeton University Press, 2004).

Roxana, Robinson, *Georgia O'Keeffe: A Life* (Bloomsbury, 2016).

Rubin, Susan Goldman, *Wideness and Wonder: The Life and Art of Georgia O'Keeffe* (Chronicle, 2010).

Pablo Picasso

Andral, Jean-Louis, et al., eds, *M. Pablo's Holidays: Picasso in Antibes Juan-les-Pins 1920–1946* (Éditions Hazan, in association with Musée Picasso, 2018).

Anon., *Picasso in Provence: Catalogue of an Exhibition of Works, 1946–48*, with illustrations, (The Arts Council, 1950).

Richardson, John, *Picasso: The Mediterranean Years (1945–1962)* (Rizzoli, in association with Gagosian Gallery, 2010).

Richardson, John, *The Sorcerer's Apprentice: Picasso, Provence and Douglas Cooper* (Jonathan Cape, 1999).

Widmaier Picasso, Olivier, *Picasso: An Intimate Portrait*, trans. Mark Harvey (Tate Publishing, 2018).

John Singer Sargent

Adelson, W., and E. Oustinoff, 'John Singer Sargent's Venice: On the Canals', in *The Magazine Antiques* (November 2006), 134–137.

Adelson, Warren, et al., *Sargent's Venice* (Yale University Press, 2006).

James, Henry, *Italian Hours* (Penguin, 1995).

Mount, Charles Merrill, *John Singer Sargent: A Biography* (Cresset Press, 1957).

Olson, Stanley, *John Singer Sargent: His Portrait* (Macmillan, 1986).

Ormond, Richard, and Elaine Kilmurry, *Sargent: The Watercolours* (Giles, in association with Dulwich Picture Gallery, 2017).

Robertson, Bruce, ed., *Sargent and Italy* (Princeton University Press, in association with Los Angeles County Museum of Art, 2003).

Joaquín Sorolla y Bastida

Anderson, Ruth Matilda, *Costumes Painted by Sorolla in His Provinces of Spain* (Hispanic Society of America, 1957).

Anon., *Provinces of Spain, by Joaquín Sorolla y Bastida* (Hispanic Society of America, 1959).

Faerna, José María, *Joaquín Sorolla*, trans. Richard Rees (Ediciones Polígrafa, 2006).

Garín Llombart, Felipe V., and Facundo Tomàs Ferré, *Sorolla: Vision of Spain* (Fundacion Bancaja, 2007).

Peel, Edmund, *The Painter Joaquin Sorolla y Bastida* (Sotheby's Publications, 1989).

Pons-Sorolla, Blanca, *Joaquín Sorolla*, ed. Edmund Peel, trans. Rice Everett (Philip Wilson, 2005).

J.M.W. Turner

Hamilton, James, *Turner: A Life* (Sceptre, 2014).

Moyle, Franny, *Turner: The Extraordinary Life and Momentous Times of J.M.W. Turner* (Viking, 2016).

Russell, John, and Andrew Wilton, *Turner in Switzerland,* ed. Walter Amstutz (De Clivo Press).

Wilton, Andrew, *Turner Abroad: France, Italy, Germany, Switzerland* (British Museum Publications, 1982).

Wilton, Andrew, *Turner in His Time* (Thames and Hudson, 1987).

Vincent van Gogh

Ash, Russell, *Van Gogh's Provence* (Pavilion, 1992).

Bailey, Martin, ed., *The Illustrated Provence Letters of Van Gogh* (Batsford, 2021).

Bailey, Martin, *Studio of the South: Van Gogh in Provence* (Frances Lincoln, 2021).

Leymarie, Jean, *Van Gogh: Arles, Saint-Rémy* (Methuen, 1956).

Nemeczek, Alfred, *Van Gogh in Arles* (Prestel, 1999).

Walker, John Albert, *In Search of Vincent van Gogh's Motifs in Provence* (Camden Libraries, 1969).

Welsh-Ovcharov, Bogomila, *Van Gogh in Provence and Auvers* (Hugh Lauter Levin Associates, 1999).

Index

Picture Credits

Author Acknowledgments

Thanks to Zara Anvari who commissioned this book in the first place, Clare Churly for her diligent editing of the manuscript and much else besides and Andrew Roff and Michael Brunström for further editorial input on its contents and the final text. This book could hardly dare to be called an atlas without its maps, which, along with the other cover art, were drawn by Hannah Naughton. And thanks too to Andrew Pinder for his marvellous illustrations.

Further thanks to Richard Green, Jessica Axe and everyone at White Lion and Aurum for their efforts on behalf of this book and previous atlases and especially Melody Odusanya for publicity.

Thanks to the staff and librarians at the British Library in St Pancras, The London Library in St James's and Hackney Libraries, Stoke Newington branch.

And in addition I'd like to thank friends (ancient and modern and absent and present), my folks and family on either side of the Atlantic, my brilliant and beautiful wife Emily Bick, and our cat Hilda. In memory of Kit, feline wrecker of sofas and worrier of page proofs.

Quarto

First published in 2023 by White Lion Publishing an imprint of Quarto.
One Triptych Place,
London SE1 9SH
United Kingdom.
T (0)20 7700 6700
www.Quarto.com

Copyright © 2023 Quarto
Text © 2023 Travis Elborough
Photographs and illustrations © as listed on page 223

Commissioning editor: Zara Anvari
Project editor: Clare Churly
Design and maps: Hannah Naughton

A catalogue record for this book is available from the British Library.

ISBN 978-0-7112-6869-2
eBook ISBN 978-0-7112-6871-5

10 9 8 7 6 5 4 3 2 1

Typeset in Mr Eaves Modern and Rocky.

Printed and bound in Malaysia.